The Best of WEDDING PHOTOGRAPHY

Third Edition

Bill Hurter

AMHERST MEDIA, INC. ■ BUFFALO, NY

ABOUT THE AUTHOR

Bill Hurter started out in photography in 1972 in Washington, DC, where he was a news photographer. He even covered the political scene—including the Watergate hearings. After graduating with a BA in literature from American University in 1972, he completed training at the Brooks Institute of Photography in 1975. Going on to work at *Petersen's PhotoGraphic* magazine, he held practically every job except art director. He has been the owner of his own creative agency, shot stock, and worked assignments (including a year or so with the L.A. Dodgers). He has been directly involved in photography for the last thirty years and has seen the revolution in technology. In 1988, Bill was awarded an honorary Masters of Science degree from the Brooks Institute. He has written more than a dozen instructional books for professional photographers and is currently the editor of *Rangefinder* magazine.

Front cover photograph by Tibor Imley.
Back cover photography by Dennis Orchard.

Published by:
Amherst Media, Inc.
P.O. Box 586
Buffalo, N.Y. 14226
Fax: 716-874-4508
www.AmherstMedia.com

Publisher: Craig Alesse
Senior Editor/Production Manager: Michelle Perkins
Assistant Editor: Barbara A. Lynch-Johnt

ISBN-13: 978-1-58428-208-2
Library of Congress Control Number: 2006937281

Printed in Korea.
10 9 8 7 6 5 4 3 2 1

TABLE OF CONTENTS

This is the third edition of *The Best of Wedding Photography*. A lot has happened since the first edition of this book appeared more than five years ago. Then, most wedding photographers shot with film. Those who shot with digital represented less than half of wedding photographers. Now, closer to 90 percent shoot digitally.

When the first edition appeared, about half of all weddings were also photographed in a traditional manner. That number has dwindled and now many other styles are seen influencing wedding photography. While photojournalism has, for a number of years, been principle among these, virtually dominating the industry, the work of today's most successful photographers shows us that the evolution of wedding photography is far from over.

As you will see, there are some surprising new twists. Unlike photojournalistic purists, the new breed of wedding photographer has no problem "directing" (i.e., pos-

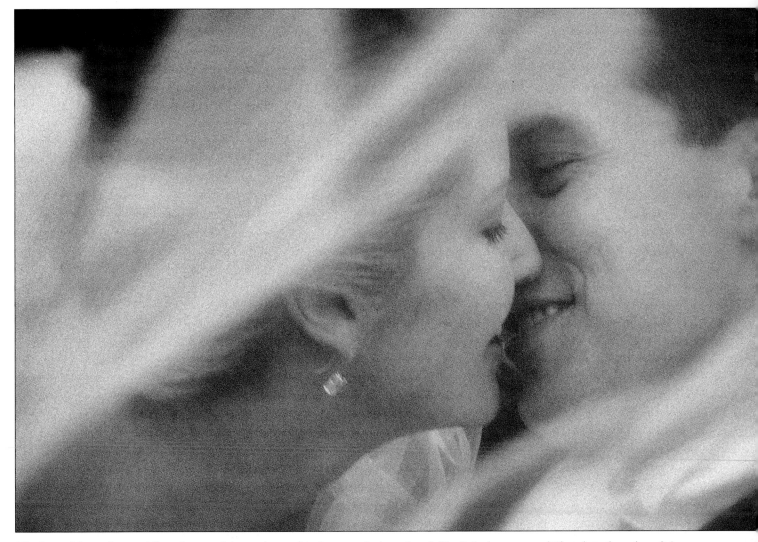

The focus of the modern wedding photograph is emotion and intimacy and, through tools like digital capture and Photoshop, the end result is romance. Photograph by Marcus Bell.

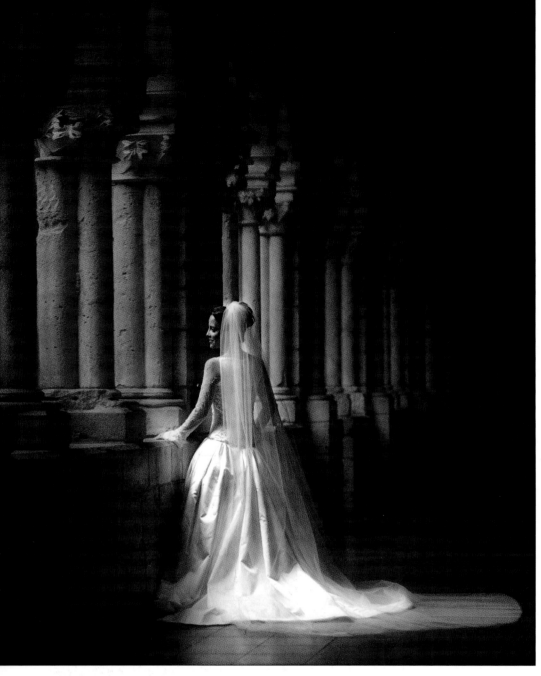

ing) an image, as long as the results look spontaneous and are emotion-filled. Also evident is a move towards fine-art imagery, complete with abstraction, symbolism, and the finer points of design. Filmmaking techniques have even begun to make their way into the wedding album as the world embraces the panoramic format as "normal."

And perhaps the most surprising recent development of all is a resurgence of formal posing techniques, particularly in group portraits. Group portraits sell because they are a record of all who attended the wedding. While there are some very creative methods of photographing groups in other styles, the tried and true methods of the traditionalists also seem to be regaining their popularity because they recall an era of elegance.

There is also a noticeable swing back toward formally posed bridal portraits, with their flawless lighting and beautiful posing. You can see the latest trends by looking at a handful of current bridal magazines. The range of styles is as diverse as the types of gowns worn by today's brides.

While nothing can equal years of wedding photography experience, it is my hope that you will learn from the masters whose images and techniques appear in this book how the best wedding photography is created—with style, artistry, technical excellence and professionalism.

—*Bill Hurter*

1. THE EVOLUTION OF WEDDING PHOTOGRAPHY

*L*ike all art forms, wedding photography has evolved over time. No era, however, has demonstrated a greater advance than that seen in recent years. The increased quality of the images produced by today's photographers has transformed the industry and elevated wedding photographers to the respected status of true artists. This has, in turn, raised the bar financially. For the best of the best, wedding photography can now be one of the most lucrative specialties in the industry—a far cry from the "weekend warriors" of forty years ago.

Today's wedding photographer works unobtrusively. While he or she may set up the situation, the participants define the action. Photograph by Becker.

■ TRADITIONAL WEDDING PHOTOGRAPHY

In the earliest days of photography, weddings were photographed in styles that captured the bride and groom in stuffy, overly formal poses. With the emergence of the wedding album, which incorporated group portraits of the wedding party and the bride and groom with family members, posing remained stiff and lifeless—no doubt a by-product of the required length of early exposures. As the style and variety of wedding photography progressed, posing techniques closely mimicked the classical arts, and there remain many flawless wedding portraits in evidence today from those early years.

It is against this backdrop that wedding photography evolved. In this early style, each shot was a check mark on

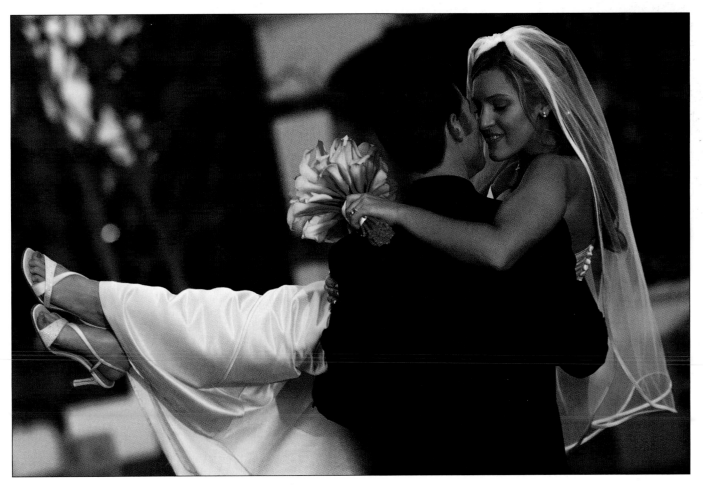

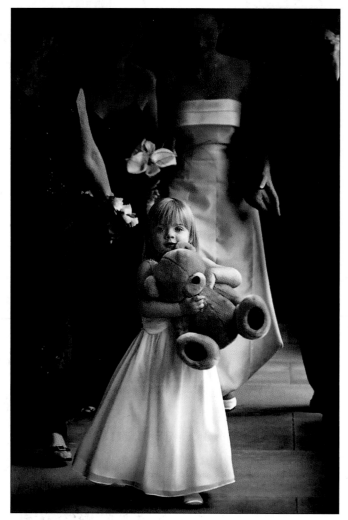

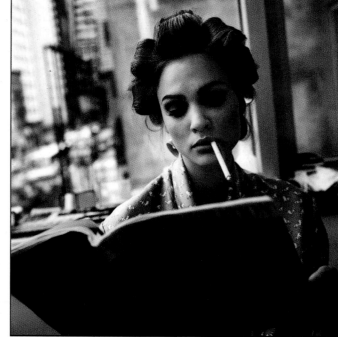

a long list of posed and often prearranged images. Even spontaneous events like the bouquet toss and cake cutting were orchestrated to reflect classical posing techniques. Spontaneity and the joy of the event all but disappeared from this most joyous of ceremonies!

■ WEDDING PHOTOJOURNALISM

Soon, a class of wedding photographers known as wedding photojournalists rebelled against the formality of the art form. Rather than carefully posing and lighting portraits of the wedding party, family, and couple, photojournalists strive to document the true story of the day without interfering as the events unfold. These photographers believe that capturing the emotion of the moment is the most important aspect of a good wedding image—and the best way to do that is to work unobstrusively.

This approach has a number of advantages that have made it popular among both brides and photographers. First, it emulates the style of editorial photography that is seen in contemporary bridal magazines. So, before brides

even interview photographers, they are familiar with this type of imagery.

Additionally, photojournalists tend to provide more unique images. When traditional coverage is employed, similar shots will often show up in albums done by different photographers. This is particularly true with group shots which, in the formal system, are often posed in a very static way that fails to capture the energy and personality of the group.

Finally, the photojournalistic approach takes less time. With formal wedding photography, the bride and groom can be missing for a good part of the wedding day while they are off working with the photographer. With the photojournalistic system, the bride has more time to enjoy her day and the photographer has more time to observe the subtleties.

■ WEDDING PHOTOJOURNALISM: A MODIFIED APPROACH

It should also be noted that, today, there are a growing number of new photographers who don't particularly care if they are "purists," in the photojournalistic sense. While they tend to work unobtrusively, they will sometimes set up moments between the couple or the members of the wedding party, pose images, or ask their subjects to repeat an appealing expression or gesture.

Greg Gibson, an award-winning photojournalist turned award-winning wedding photographer, respects the role of the wedding photojournalist, but is not trapped by the definition. He says, "My clients are professional people, they want to enjoy their day and not be encumbered by posing for pictures. They want to record the day, the real feelings they share with their friends and family members. My experience gives my work instant credibility. I try to take advantage of the resources at a wedding. If a bride is getting dressed in an area with bad light I may say, 'Can we come over here and do this?' But I don't try to create moments, or impose something on their day by saying, 'Let me get you and your mother hugging.' I try to let those

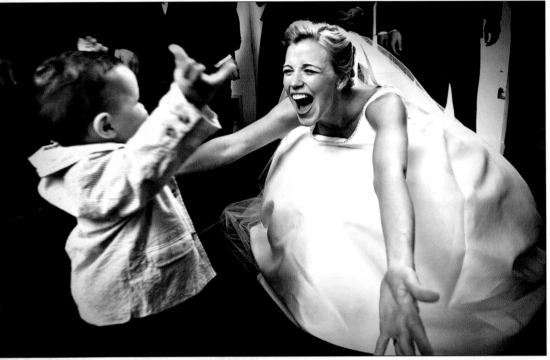

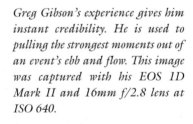

Greg Gibson's experience gives him instant credibility. He is used to pulling the strongest moments out of an event's ebb and flow. This image was captured with his EOS 1D Mark II and 16mm f/2.8 lens at ISO 640.

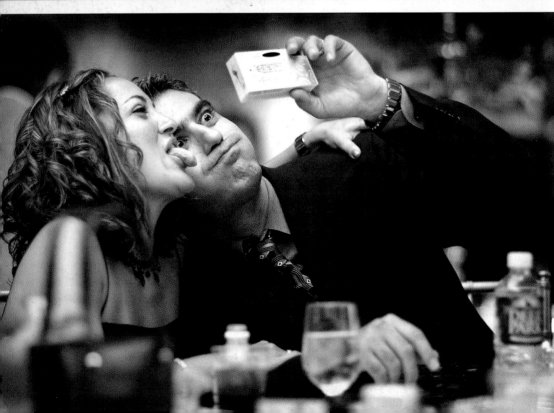

Greg Gibson is a master at isolating these wonderful moments at weddings. Image photographed with Canon EOS 1D Mark II and 85mm f/1.2 lens at ISO 400 at 1/60 second at f/1.2.

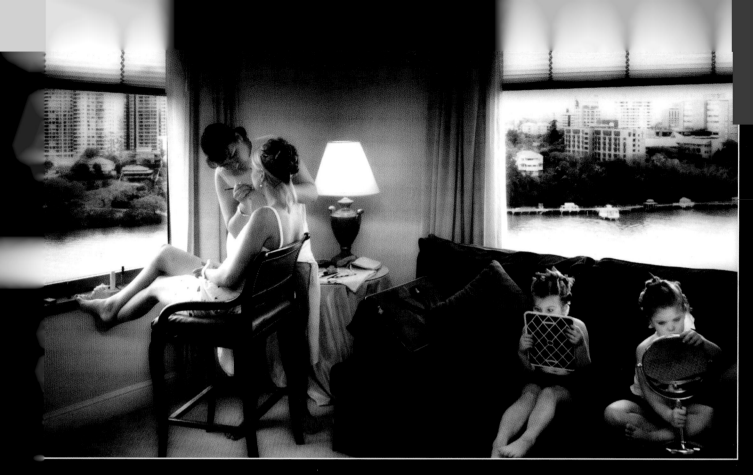

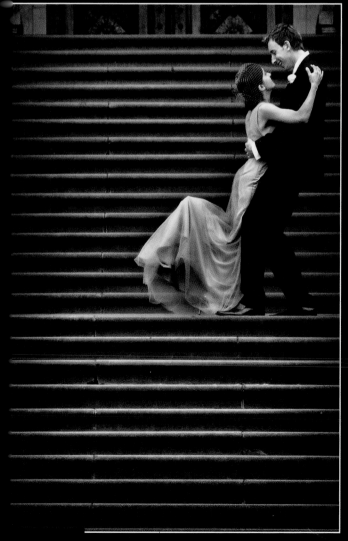

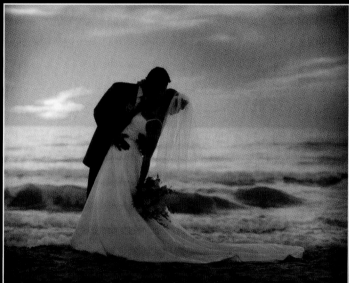

TOP—*Look at the stories going on in this Marcus Bell photograph. The relaxed bride gets her face on while her toenails dry on the window ledge. The young flower girls have become engrossed in other things. And all the while, the world outside the windows goes on in perfect harmony.* ABOVE—*This is a good example of a traditional portrait made with contemporary style and vision. This beach formal by Tibor Imely captures the emotion between the couple, yet relies on excellent posing and pinpoint control of exposure. The composition is dynamic and dramatic.* LEFT—*Masters of the medium, like Yervant Zanazanian from Australia, are gifted at creating the subtle intangibles in an image. In addition to flawless posing and design, note the hourglass-shaped highlight covering the steps. Artful burning and dodging on the digital file were required to produce such a skillful effect.*

things happen spontaneously and use my background and experience to put myself in the right position to anticipate those moments."

When asked about what kind of wedding photojournalist he is, Gibson responded, "I'm not a true fly on the wall. I laugh and joke with the client, getting them to relax with my presence. We're going to spend a lot of time together and I don't want them to feel like there's a stranger in the room. If I find myself constantly in conversations with the bride and family members, then I withdraw a bit. I don't want to be talking and not taking photos."

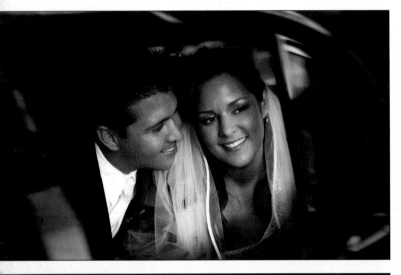

■ TRADITIONALISTS FIGHT BACK

Those photographers who still provide traditional coverage argue that the wedding photojournalist's coverage produces below-average photographs. In truth, the photojournalists (who do not disrupt the flow of the day to make pictures and don't isolate the bride and groom) can't possibly be as in tune with posing and lighting principles as the masters of the traditional style. They don't claim to be—nor do they stop the natural action to dictate posing, which, in their view, ruins the flow of things.

However, in the traditionalists' defense, one must acknowledge that the most elegant features of traditional portraiture *are* being thrown out in this "creative new" approach. Looking at a masterful bridal portrait taken by a photojournalist, the trained eye will often observe hands posed poorly (or not at all), a confused head and shoulder axis, unflattering overhead lighting, and so on. The photojournalistic portrait may be spontaneous and the expression full of life, but many feel the classic refinements still need to be preserved.

For example, in 1909 a Muñoz opened a small photography studio in Cuba. Nearly a hundred years later, the Muñoz family still takes pride in their history. Fathers taught sons, and grandfathers taught grandsons, the skill that it took to be known as a Muñoz photographer. Today, there are six independently owned Muñoz studios in the South Florida area.

Twenty-something Tom Muñoz, is a master wedding photographer who photographed his first full wedding alone at the age of twelve (even though he had to have the couple drive him everywhere as he had "no ride"). As a fourth-generation photographer, Tom appreciates and

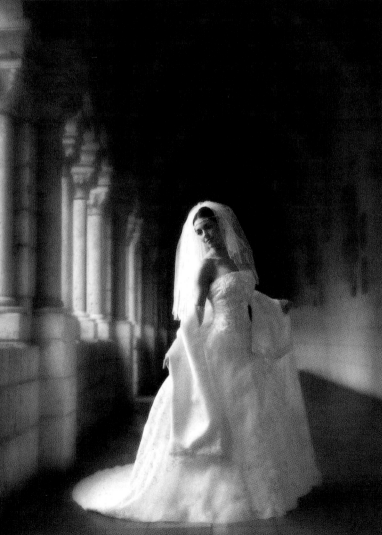

TOP—*Tom Muñoz believes in good solid posing and "treating his brides like princesses." Here Tom used a small softbox positioned to the right of camera to illuminate the couple with elegant studio light.* LEFT— *Tom Muñoz is a fourth-generation photographer and well schooled in the traditional techniques of posing and lighting. His images are a blend of traditional and modern as you can see here, where he combined Photoshop softening and grain effects with a beautiful, formally posed portrait.*

practices wedding photojournalism but believes that clients also want the formality of yesterday in their images.

■ THE RETURN OF GROUP PORTRAITS

Another aspect of traditional photography that is making a return to contemporary coverage is the formal group portrait. The main reason for this is that groups sell. In most cases, these portraits are still less formal than a true "traditional" group image, preserving the carefree, relaxed attitude found in the rest of the album. Still, these images display a greater attention to posing fundamentals than a purely photojournalistic image.

■ DIGITAL CAPTURE TAKES OVER

The move away from film and toward digital capture continues unabated, although the current breed of digital wedding photographers is aware of the increased time and effort involved in being a purely digital operation. New workflows and techniques for image editing continue to evolve and new software and hardware are helping to streamline the process.

It should especially be noted that Adobe Photoshop has permanently changed the style and scope of wedding imagery. In the comfort of their homes or studios, photographers can now routinely accomplish creative effects that previously could only be achieved by an expert darkroom technician. This has made wedding photography the most creative venue in all of photography.

Today's photographers spend a great deal of time perfecting each image that goes out to a client. Perhaps this aspect of contemporary wedding photography, more than any other, has accounted for the profound increase in the volume of truly artistic wedding images.

TOP—Steven Gross's work is so intimate sometimes, he seems not to have been there at all. Here, the photographer incorporated the powerful graphic lines of the circular staircase into a compelling portrait of the bride and groom. RIGHT— David Worthington created this formal portrait of the bride and groom using strobes carefully positioned to backlight the couple and another to fill the frontal planes of their faces. Perhaps the most interesting element of this portrait is the reflected image in the mirror finish of the piano lid.

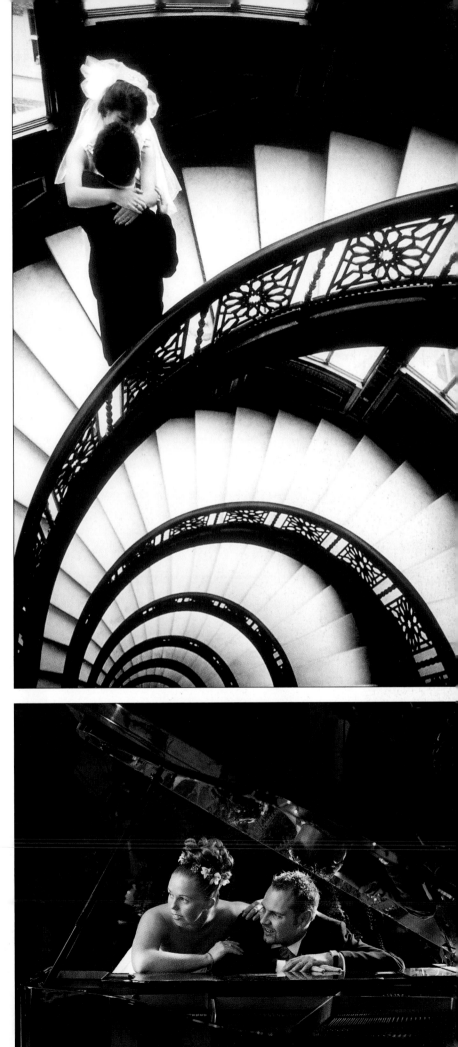

2. THE WEDDING PHOTOGRAPHER'S MINDSET

*T*he rewards of being a successful professional wedding photographer are great—not only financially, but also in terms of community status. The wedding photographer of the new millennium is not regarded merely as a craftsman, but as an artist and an important member of the community.

■ DEMANDS OF WEDDING PHOTOGRAPHY

Working Under Pressure. To be successful, wedding photographers must master a variety of styles and perform under pressure in a very limited time frame.

The wedding photographer is under a great deal of stress, as the couple and their families have made months of detailed preparations, and a considerable financial investment for this (hopefully) once-in-a-lifetime event. It is the day of dreams and, as such, the expectations of clients are high.

Couples don't just want a photographic "record" of the day's events, they want inspired, imaginative images and an unforgettable presentation, and should anything go wrong photographically, the event cannot be re-shot. Aside from the obvious photographic skills, achieving suc-

BOTTOM LEFT—*Formal wedding portraits, made on location more often than not, are a huge part of the standard wedding coverage. Here, Charles Maring created an elegant high-key portrait using available light and a reflector. By incorporating the veil into the composition, he has created a delicate, timeless image.* BOTTOM RIGHT—*A lyrical pose and flawless design helped create a signature wedding photograph for photographer David De Dios.* FACING PAGE, TOP—*Being attuned to subtleties is what makes the contemporary wedding photographer stand out. Here, Joe Photo noticed the bride's fascination with the wind blowing her veil. Although the moment lasted only a second, Joe made it timeless.*

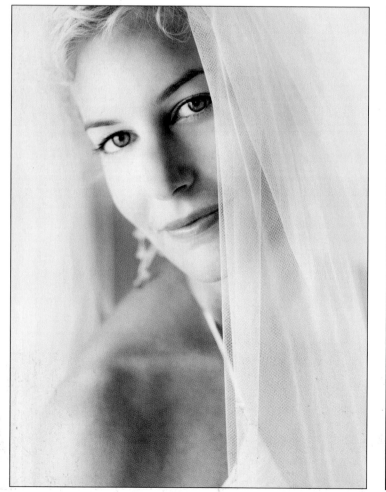

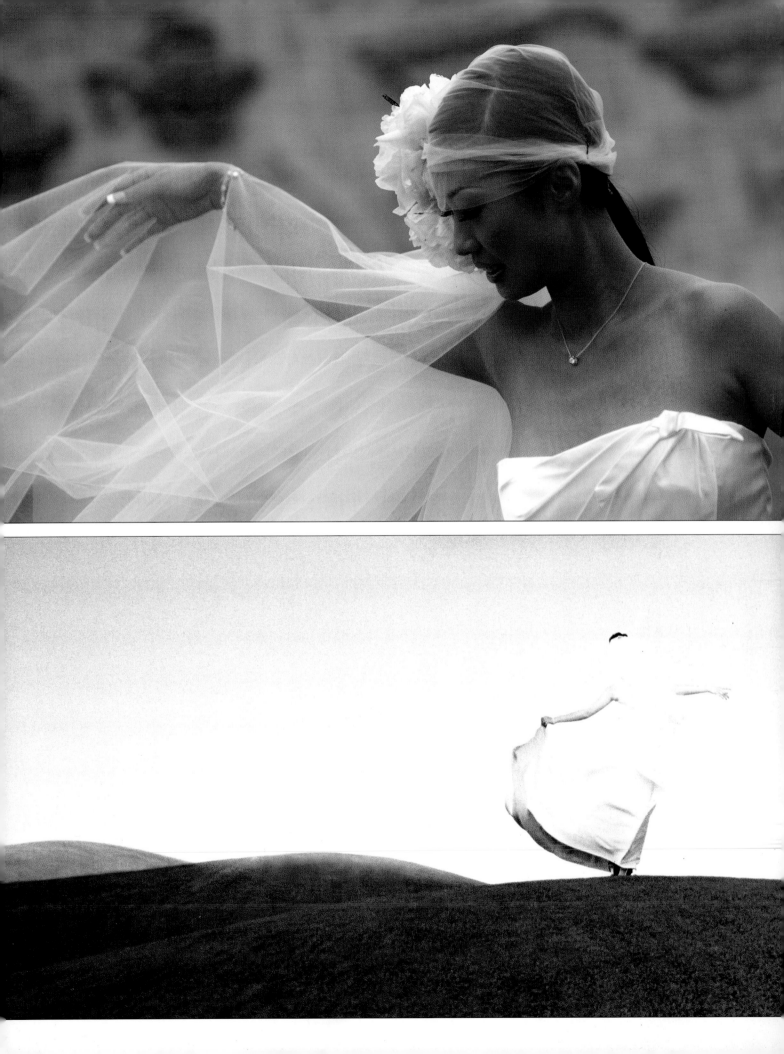

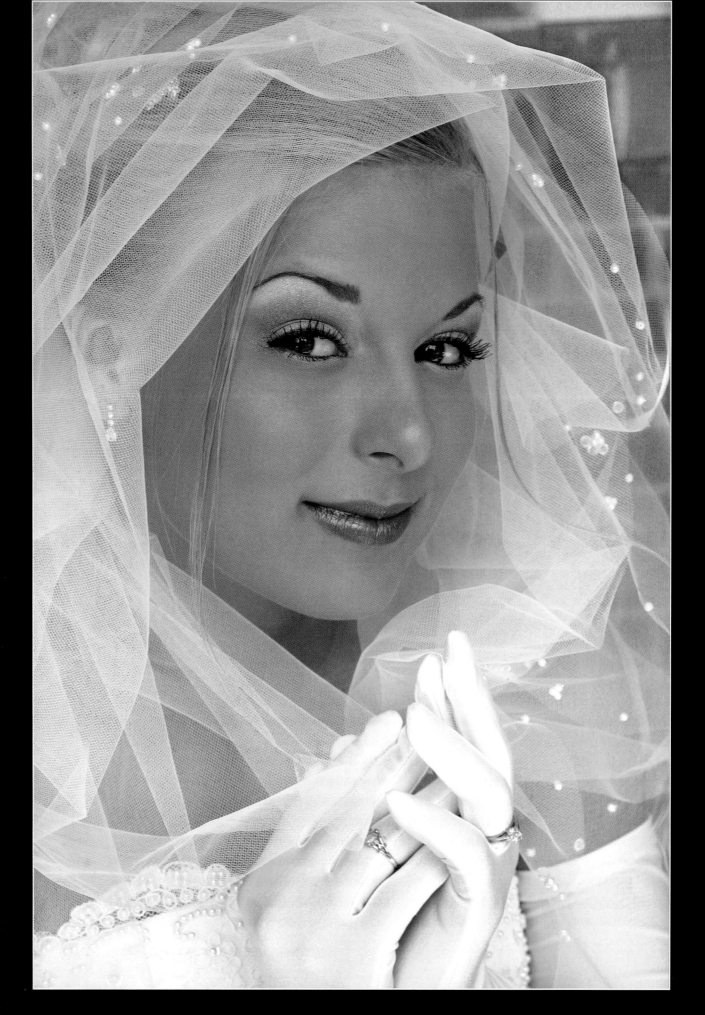

cess requires calm nerves and the ability to perform at the highest levels under stress. This pressure is why many gifted photographers do not pursue wedding photography as their main occupation.

A Sense of Style. Many wedding photographers religiously scour the bridal magazines, studying the various examples of editorial and advertising photography. Editorial style has become a huge influence on wedding photography, perhaps the single biggest influence at this writing. These magazines are what prospective brides look at and tend to want in their own images.

Skilled Observation. The truly gifted wedding photographer is a great observer. He or she sees and captures the fleeting moments that often go unrecorded. The professional knows that the wedding day is overflowing with these special moments and that memorializing them is the essence of great wedding photography.

The Ability to Idealize. One trait that separates the competent photographer from the great one is the ability to idealize. The exceptional photographer produces images in which the people look great. The photographer must be skilled at hiding pounds and recognizing a person's "best side." This recognition must be instantaneous and the photographer must have the skills to make any needed adjustments in the pictures. Through careful choice of camera angles, poses and lighting, many of these "imperfections" can be made unnoticeable.

It is especially important that the bride be made to look as beautiful as possible. Most women spend more time and money on their appearance for their wedding day than for any other day in their lives. The photographs should chronicle just how beautiful the bride really looked.

The truly talented wedding photographer will also idealize the events of the day, looking for opportunities to in-

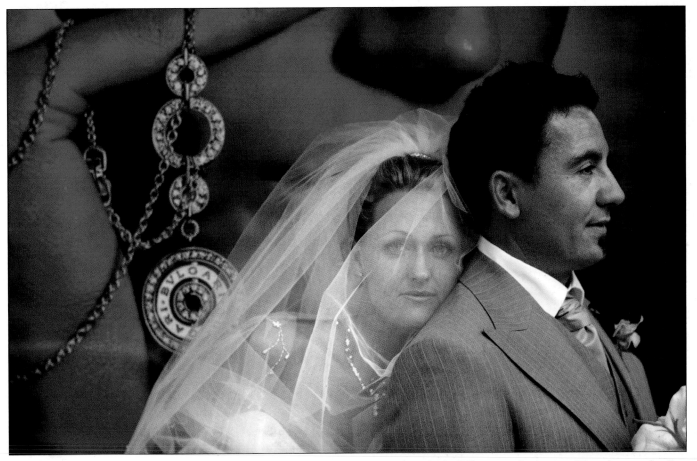

FACING PAGE—*Brides demand nothing less than perfection and photographers with multiple skill sets are winning out. Here photographer Ray Prevost has created a flawless bridal formal portrait with expert hair and makeup, perfect posing, and a timeless expression. This image could easily be on the cover of a bridal magazine. Believe it or not, Ray made this photo by available light on location. If you look closely, you can see his murky silhouette in the bride's eyes—what he calls a Hitchcockian presence in his images.* ABOVE—*David Williams maintains that good wedding photography isn't complicated, it's about expression, interaction, and life. Here, David combines an unusually posed portrait with an oversized Bulgari watch storefront display, which at first seems to be visually overwhelming. The juxtaposition of such dissimilar elements has a startling effect, yet seems somehow appropriate.*

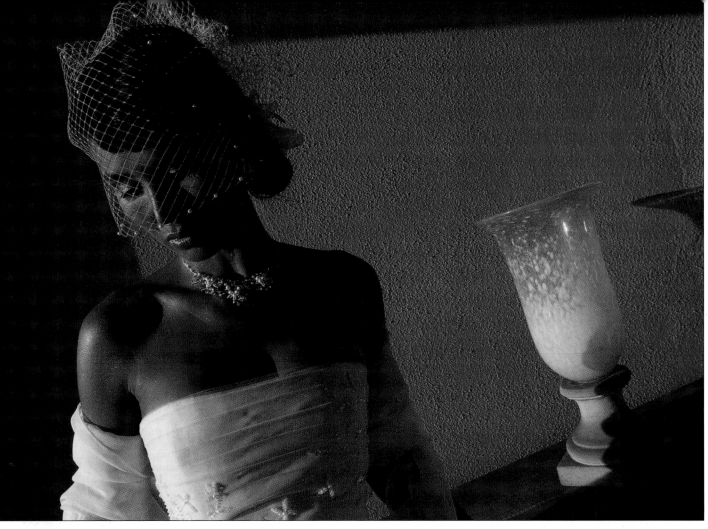

Joe Buissink has been known to work in a Zen-like state of concentration for hours at a time when photographing a wedding. This state of focus gives him potent powers of observation. He will observe nuances such as design elements and how background elements might mirror the texture of the bride's skin in skimming late afternoon light.

fuse emotion and love into the wedding pictures. In short, wedding photographers need to be magicians.

■ GREATNESS

In preparing the text for this book, I searched for the right words to define what makes "great" wedding photography and, consequently, "great" wedding photographers. Consistency is surely one ingredient of greatness. Those photographers who produce splendid albums each time out are well on their way to greatness. Great wedding photographers also seem to have top-notch people skills. Through my association with WPPI and *Rangefinder* magazine, I talk to hundreds of wedding photographers each year. A common thread among the really good ones is affability and likability. They are fully at ease with other people and more than that, they have a sense of personal confidence that inspires trust.

Seeing. David Anthony Williams, an inspired Australian wedding and portrait photographer, believes that

the key ingredient to great wedding photos is something he once read that was attributed to the great Magnum photographer Elliot Erwitt: "Good photography is not about zone printing or any other Ansel-Adams nonsense. It's about seeing. You either see or you don't see. The rest is academic. Photography is simply a function of noticing things. Nothing more."

Williams adds, "Good wedding photography is not about complicated posing, painted backdrops, sumptuous backgrounds, or five lights used brilliantly. It is about expression, interaction, and life! The rest is important, but secondary."

Immersion. In talking to Williams, and a great many other very successful wedding photographers, what seems to make them good (and an experience they all talk about) is total immersion. They involve themselves in the event and with the people. As Williams says, "I just love it when people think I'm a friend of the couple they just haven't met yet, who happens to do photography."

Interaction. Great wedding photographers can make anyone look good, but their real gift is that ability to create the animated, filled-with-life portrait. It is the best of both worlds—the real and the idealized. Certainly part of the success is good direction, but the less tangible ingredient is the interaction—the bringing out of the person who's alive and well in there. It's interaction and communication, but also a little magic.

■ PROACTIVE VS. REACTIVE

Traditional wedding coverage would feature dozens of posed pictures pulled from a "shot list." Such shot lists were passed down by generations of other traditional wedding photographers. There may have been as many as 75 scripted shots—from cutting the cake, to tossing the garter, to the father of the bride walking his daughter down the aisle. In addition to the scripted moments, traditional photographers fill in the album with "candids," many of which are staged or at least made when the subjects were aware of the camera.

The contemporary wedding photographer's approach is quite different. Instead of being a part of every event, moving people around, and staging the action, the photographer tends to be quietly invisible, choosing to fade into the background so the subjects are not aware of the photographer's presence. The photographer does not want to intrude on the scene, instead, documenting it from a distance with the use of longer-than-normal lenses and, usually, without flash. Because one can change ISOs instantly on digital cameras, the medium offers a completely self-contained means of documenting a wedding unobserved.

■ POWERS OF OBSERVATION

Like any form of reportage, whether one is a news photographer, a fashion photographer, or a sports photographer, one of the prerequisites to success is the skill of observation—an intense power to concentrate on the events occurring right in front of you. Through keen observation, a skill set that can be clearly enhanced through practice,

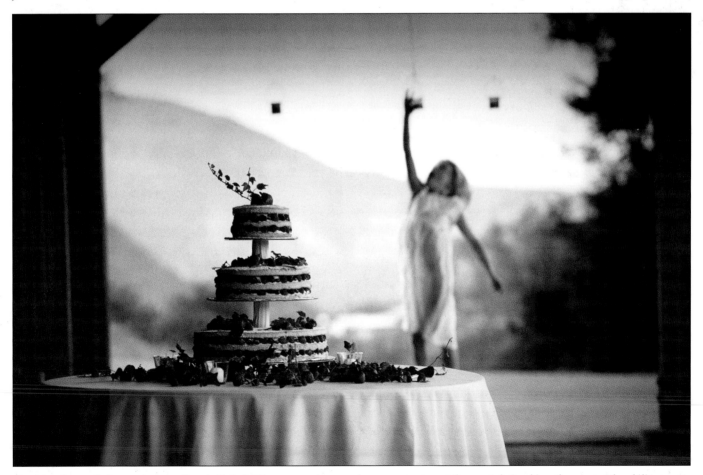

Anticipation and observation are directly linked. The more a photographer concentrates on the events before him, the greater the ability to capture minute moments from within that action with clarity and crispness. Joe Buissink had been observing this young girl's fantasy and assumed correctly a magical moment was about to happen.

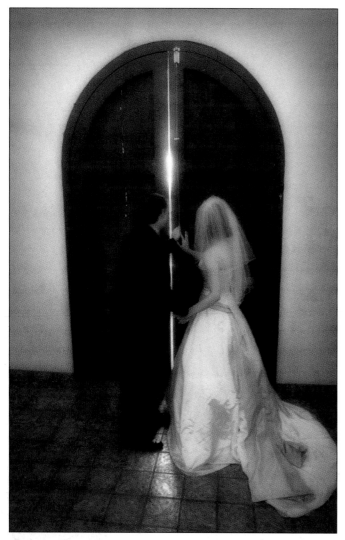

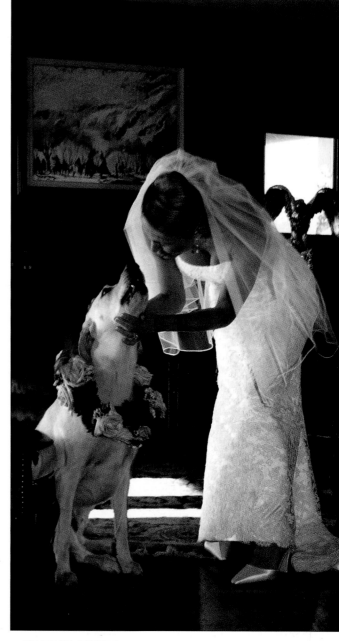

ABOVE—*The photographer must be alert to nuances in the scenes he sees. Here, David Beckstead caught the church doors about to be opened by the new bride and groom. The bright sunlight outside seems ready to burst onto this couple's lives, a symbolic moment captured from the tapestry of the day's events.* RIGHT—*Deanna Urs knew that this bride would spend some last-minute time with her long-time pal, so the photographer waited for the right moment. With a sun-filled room, Deanna fired a flash from camera position, set to a stop less than the available light reading, to fill in the shadows but preserve the ambient room light.*

the photographer begins to develop the knack of predicting what will happen next.

The skill of knowing what comes next is partially due to knowing the intricacies of the event and the order in which events will occur. It is also a result of experience; the more weddings one photographs, the more accustomed one becomes to their rhythm and flow. The sense of anticipation, however, is also a function of clearly seeing what is transpiring in front of you and reacting to it quickly.

■ **PREPARATION**

Knowing what course events will take is also a function of having done your homework—visiting with the banquet manager, caterer, florist, band director, and so on. This is all part of the basic preparation, and the more the photographer knows of the scheduled events and their order, the better he or she can be at predetermining the best ways to cover those events. This kind of detailed information will aid in not only being prepared for what's to come, but it will provide a game plan and specifics for where to best photograph each of the day's events. From such information the photographer will be able to choreograph his or her own movements to be in the optimum position for

each phase of the wedding day. The confidence that this kind of preparation provides is immeasurable.

Another good practice is to schedule an engagement portrait. This has become a classic element of modern day wedding coverage. The portrait can be made virtually anywhere, but it allows the couple to get used to the working methods of the photographer, so that on the wedding day they are accustomed to the photographer's rhythms and style of shooting. The experience also helps the threesome get to know each other better, so that on the wedding day the photographer doesn't seem like an outsider.

■ PEAK OF ACTION

There is an ebb and flow to every action—imagine a pole-vaulter, for example, who is ascending at one moment and falling the next. In every action there is an instant of peak interest that the photographer strives to isolate. The ability to do this is critical to success.

Great sports photographers learn to react to an event by anticipating where and when the exposure must be made. In the same way, the skillful wedding photographer is always watching and monitoring the events—and usually more than one event at a time. The camera, usually a 35mm DSLR, is always at the ready, usually in autofocus mode so there is no guesswork or exposure settings to be made. When the right moment unfold, they simply raise the camera, compose, and shoot.

With a refined sense of timing and good observation skills you will drastically increase your chances for successful exposures in wedding situations.

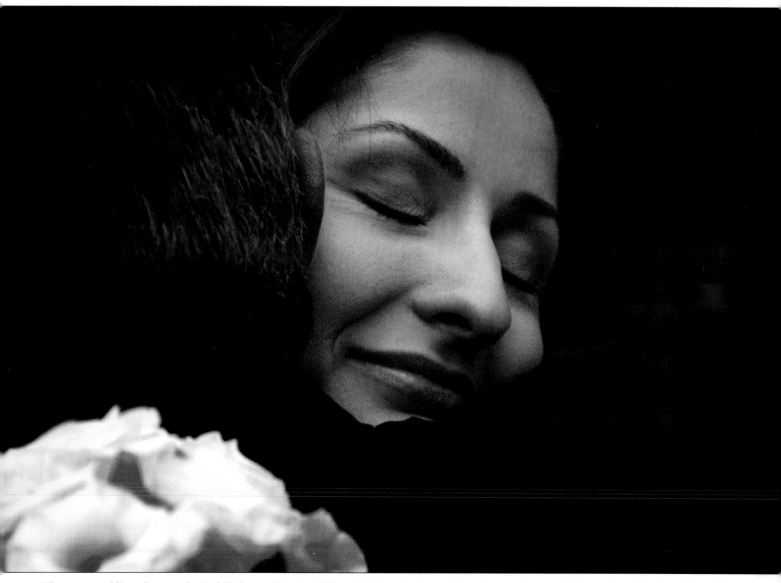

The expert wedding photographer is skilled at working invisibly so that he or she does not intrude on moments of deep emotion. Photograph by Anthony Cava.

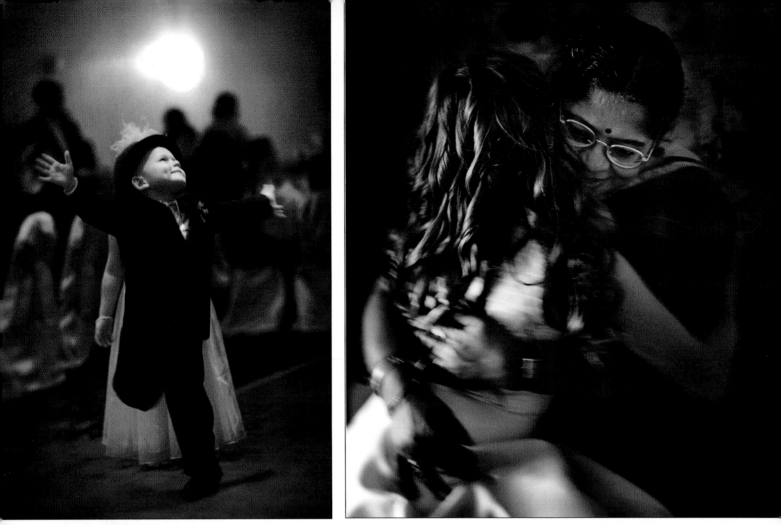

LEFT—*Greg Gibson has a finely honed knack of discovering great unobserved moments during the wedding day, a quality that gives his wedding coverage uniqueness.* RIGHT—*Images like this can't be staged, they must be captured with only one or two frames available in a brief window of time. Marcus Bell's sense of timing and composition are flawless in this wonderful wedding image.*

■ STORYTELLERS

The reality of the event is where the elements of the story will come from. By taking this mindset, the photographer becomes the storyteller. Linking the spontaneous events of the day forms the wedding day story, which is what the modern bride wants to see.

While such coverage reveals flaws, the savvy wedding photographer knows that these are part of reality. This is not to say that the reality captured by the wedding photojournalist is harsh or otherwise unappealing. To the contrary, the record of the day should be a sensitive portrayal of the events that highlight the emotion elicited.

■ REACTION TIME

The skills involved in good wedding photography are the same as for the photojournalist or sports photographer: preparation, observation, concentration, and anticipation. In short, the better you know the event, the better your reflexes will become. But there is an intangible aspect to re-

action time that all photographers must hone and that is instinct—the internal messaging system that triggers reaction. It is a function of trusting yourself to translate input into reaction, analyzing what you see and are experiencing into the critical moment to hit the shutter release. Master wedding photojournalist Joe Buissink trusts his analytical powers of concentration and observation, saying, "Trust your intuition so that you can react. Do not think. Just react or it will be too late."

■ THE EMOTION OF THE DAY

The photographer must be able to feel and relate to the emotion of the event. At the same time, you cannot be drawn into the events to the extent that you either become a participant or lose your sense of objectivity. All of one's photographic and storytelling skills go into making pictures that evoke the same emotion experienced on the wedding day. Celebrated wedding photographer Joe Buissink, who shoots about half of his wedding coverage

digitally, has described this as "being in the moment," a Zen-like state that at least for him is physically and emotionally exhausting. Buissink stays in the moment from the time he begins shooting and will stay in that mode for six to eight hours.

■ UNIQUENESS

While they may contain similar features, no two weddings are ever the same—and it is the photographer's responsibility to show what is unique about each wedding. Greg Gibson, a two-time Pulitzer-Prize winning journalist turned wedding photographer says, "All weddings are alike, there's a man and a woman in love, they're going to have this big party, there's the anticipation, the preparation, the ceremony, the party. It's like the movie *Groundhog Day*. But the challenge is to find the nuances in each one." That challenge is what keeps Gibson fresh—he does fifty weddings a year and says it's fun. "Yes, it's fun. When I go to a wedding people are always glad to see me. I'm welcomed in. As a journalist that isn't always the case. Monica [Lewinsky] wasn't happy to see me when I showed up at the Mayflower Hotel."

■ STYLE

Today's wedding coverage reflects an editorial style, pulled from the pages of bridal magazines. Noted Australian wedding photographer Martin Schembri calls the style of the contemporary wedding coverage a "magazine style" with a "clean, straight look." If you study these magazines you will notice that there is often very little difference between the advertising photographs and the editorial ones used to illustrate articles. The style may be natural or chic,

Yervant Zanazanian created this fabulous portrait of bride and groom in the shade of a house. Notice the beautifully content glow in the bride's expression. Yervant's skills, both as a photographer and with people, are evident in every frame of his wedding coverage.

high energy or laid-back, but uniqueness is critical—it's the real product people are buying.

■ PEOPLE SKILLS

While wedding photojournalists are generally more reactive than proactive, they cannot be flies on the wall for the entire day. Interaction with the participants is crucial, so you need to be a people person, capable of inspiring trust in the bride and groom.

Joe Buissink has been labeled a "salt of the earth" personality who makes his clients instantly like and trust him. That trust leads to complete freedom to capture the event as he sees it. He advises, "You must hone your communi-

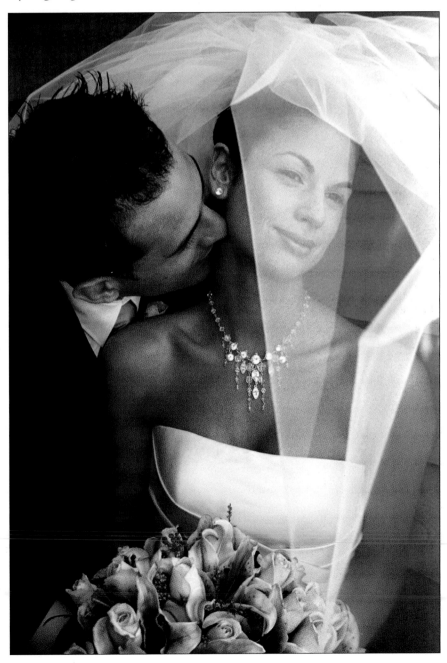

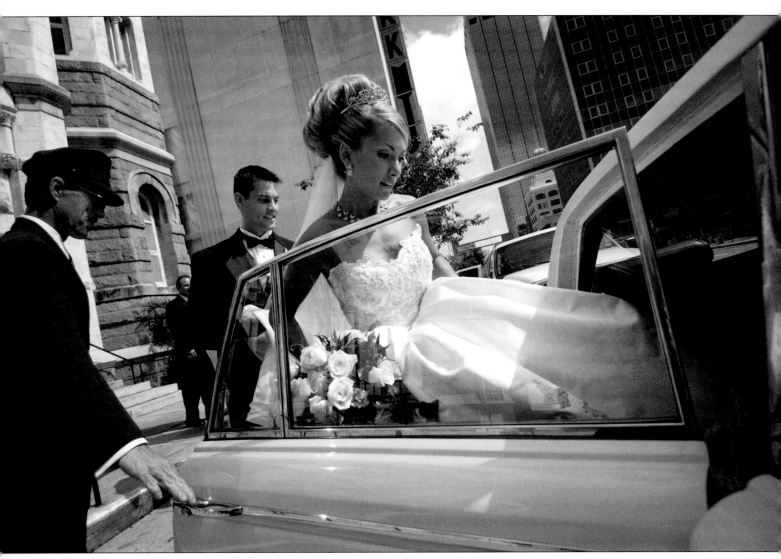

Michael Schuhmann created this wonderful yet very simple shot of the bride and groom entering the limo. Journalistic in nature, the wide-angle creates a panoramic effect, encompassing the cityscape, chauffeur, and groom. Aside from its pleasing design and organization, this image captures a unique emotion on the bride's face—that of anticipation and perhaps even concern. Interestingly, it matches the groom's expression.

cation skills to create a personal rapport with clients, so they will invite you to participate in their special moments." He also stresses the importance of being objective and unencumbered. "Leave your personal baggage at home," he says, "this will allow you to balance the three principle roles of observer, director, and psychologist."

Kevin Kubota, a successful wedding and portrait photographer from the Pacific Northwest, always encourages his couples to be themselves and to wear their emotions on their sleeves. This frees the couple to be themselves throughout the entire day. He also tries to get to know them as much as possible before the wedding and also encourages his brides and grooms to share their ideas as much as possible, opening up the dialog of mutual trust between client and photographer.

■ THE "HOPELESS ROMANTIC"

Perhaps because of the romantic nature of the event, it helps if the wedding photographer is a romantic. Michael Schuhmann explains, "I love to photograph people who are in love and are comfortable expressing it or they are so in love that they can't contain it, then it's real." If you're not a romantic by nature, don't despair—for many photographers the thrill is in the romance, but for others it's the ritual, and for some it is in the joy of the celebration.

Whether the images are traditional or photojournalistic, the equipment list for wedding coverage is extensive, including backup equipment and emergency supplies. Since so many different types of photography are required at a wedding, it's almost like outfitting oneself for safari. Today, advancements in digital technology have made all of this equipment more sophisticated and powerful than ever.

■ ADVANTAGES OF DIGITAL CAPTURE

Images in Hand. Perhaps the greatest advantage of shooting digitally is that when the photographer leaves the wedding, the images are already in hand—ready to be imported into Photoshop for retouching or special effects and subsequent proofing and printing. The instantaneous nature of digital even allows photographers to put together a digital slide show of the wedding ceremony that can be shown at the reception.

ISO Settings. One reason digital has become so popular with wedding photographers is that you can change your ISO on the fly. For example, if you are shooting a portrait of the bride and groom outdoors in shade, you might select an ISO 400 setting. Then you might move to the church, where the light level would typically drop off by two or more f-stops. In this case, you would simply adjust to a higher setting, like ISO 1600 or faster, to compensate for the lower light levels. Unlike film, where you would have to change rolls or cameras to accomplish this, the digital ISO setting you select only affects the individual frame being recorded.

Most digital camera systems feature a sensitivity range from ISO 100 to 800 (or, in some cases, ISO 1600). Some cameras also offer an ISO 3200 setting as a special custom function. Obviously, the wider the range of sensitivity, the more useful the camera system will be under a wider range of shooting conditions.

As with film ISOs, the digital ISO setting affects the image quality; the higher the ISO, the more noise (with

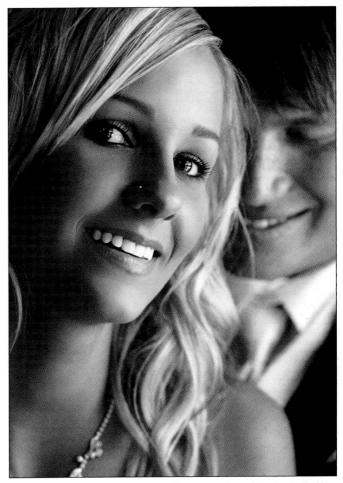

The convenience of on-demand ISO adjustments and automatic white balance make shooting spontaneous images infinitely easier than in days past. Photograph by Marc Weisberg.

digital) or grain (with film) will be recorded. The lower the ISO, the finer the image quality will be. The difference is that, with digital, much of the noise can be removed in image processing (if using RAW file capture) or with noise reduction filters or actions. Fred Miranda, a noted designer of Photoshop actions, has created an incredible Noise Reduction action that takes advantage of Photoshop's powerful image-processing functions. The action, called ISOxPro (available at www.fredmiranda.com), lets you reduce noise and other artifacts in any of ten different grades and calls on Photoshop's Smart Blur function to fuse to-

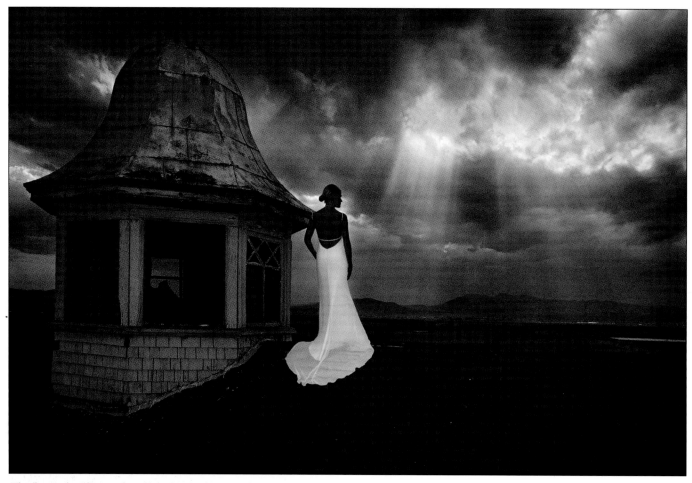

The slower the film speed or digital ISO, the more detail and less noise will be apparent. Such is the case in this striking image by John Poppleton, who often puts beautiful brides in industrial settings to produce visually incongruous images.

gether "scrubbed" layers. It's amazing to see what can be done with this action.

White Balance. Digital also allows you to change white balance on the fly, providing more accurate color balance from image to image. If you are shooting in deep afternoon shade, for instance, you can set your white balance appropriately. If you move indoors soon thereafter and are shooting by tungsten room light, you can quickly adjust the white balance to a tungsten or incandescent setting—or rely on the camera's auto white balance function to determine the optimal white-balance setting.

Some manufacturers offer a wide range of white-balance options that correspond to a range of color temperatures (measured in degrees Kelvin). Others use more photographer-friendly terms like "afternoon shade." Most also include settings for fluorescent and incandescent lighting. Additionally, custom functions allow you to create your own unique white-balance settings to correspond to certain known shooting conditions or mixed-light conditions.

Obviously, the more flexibility you have in accurate white-balance recording, the less color correction you will have to perform later in Photoshop. Some camera systems even offer a white-balance bracketing feature. The topic is covered in greater detail on pages 44–45.

Color and Black & White. With some DSLR models you can instantly shift back and forth between color and black & white capture, creating even more variety in your images. With film, this would require changing rolls or cameras.

Quality Reproductions. With film, the negative or transparency is the original image. When prints or copies are made from that original, these second-generation images suffer a falloff in sharpness and image quality. Digital copies, on the other hand, maintain the integrity of their data indefinitely and do not suffer any kind of degradation in subsequent generations. A copy is every bit as good as the original.

Reducing Costs. Bambi Cantrell, a noted wedding photojournalist from the San Francisco area, routinely

shoots over a thousand exposures at weddings. Having switched to digital makes this easier, since she can simply download memory cards to a laptop and then reuse them (or make sure to bring extra memory cards). Every wedding photographer who shoots film is wary of the number of rolls shot and the number remaining. It is human nature to, at some point during the day, calculate the cost of all that film and processing; with digital it's not an issue.

Creative Freedom. Noted wedding and portrait photographer Kevin Kubota hasn't shot a wedding on film since he purchased his Nikon D1X digital camera, saying that the quality is at least as good as 35mm film and that the creative freedom digital affords him is mind boggling. He can take more chances and see the results instantly, immediately knowing whether or not he got the shot. In addition, the digital tools he has mastered in Photoshop make him a better, more creative photographer.

■ THE DSLR

The 35mm-type DSLR (digital single-lens reflex) is the camera of choice for today's wedding photographer. The days when only medium-format cameras were used for wedding photography seem to be at an end. Fast, versatile, zoom lenses, cameras that operate at burst rates of up to eight frames per second, amazingly accurate autofocus lens performance, and incredible developments in imaging technology have led to the popularity of the DSLR.

BELOW—Great flexibility is afforded by the DSLR, as seen here in this bridal montage entitled Runaway Warhol *captured by J.B. Sallee. The individual variations were composited into a single Photoshop file.*
RIGHT—Images like this are fleeting—Marcus Bell quickly bounced a flash to light the little girl, keeping the focus just on her. Straight flash would have lit the foreground, distracting from the little one. The bounce flash exposure was matched to the ambient light exposure so the scene appears natural. The image was made with a Canon 1DS at ISO 400 at a 52mm focal length at ¹/₂₅₀ second at f/5.6.

Currently there are eight manufacturers of full-fledged systems: Canon, Nikon, Olympus, Fuji (which uses Nikon autofocus lenses), Pentax, Sony, Minolta/Konica, and Sigma (which uses the radically different Foveon X3 image sensor). Each manufacturer has several models within their product line to meet varying price points. Many of the predigital lenses available from these manufacturers for their film cameras also fit the digital cameras, although sometimes with a corresponding change in focal length, depending on the size of the imaging sensor. In addition, a number of lens manufacturers also make AF (autofocus) lenses to fit various brands of DSLRs. These include Tokina, Tamron, and Sigma.

AF Technology. Autofocus (AF), once unreliable and unpredictable, is now extremely advanced. Some cameras feature multiple-area autofocus so that you can, with a touch of a thumbwheel, change the AF sensing area to one

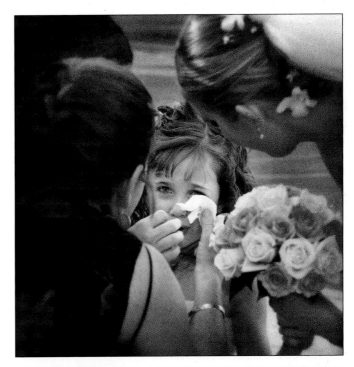

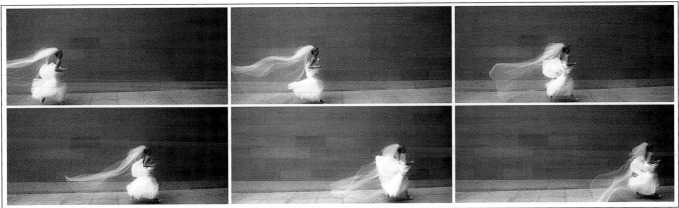

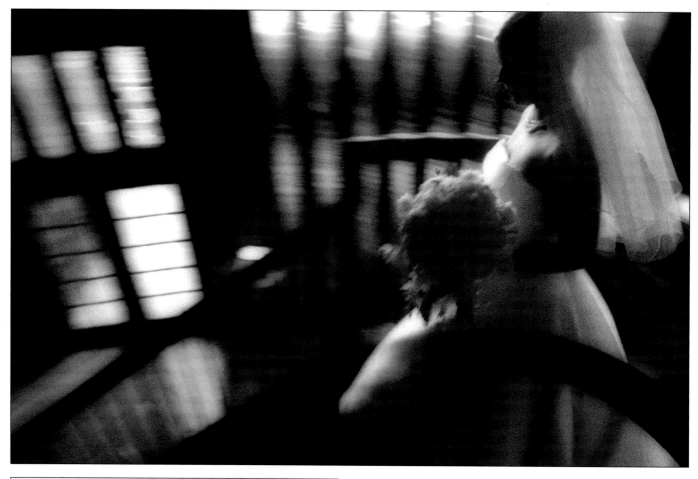

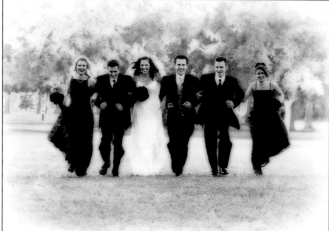

ABOVE—*Predictive autofocus allows the photographer to choose the zone of the viewfinder from where the AF is active and focus on a moving subject. The camera's software takes over, predicting the rate of movement and focusing accordingly. In this image by David Beckstead, a slow shutter speed was used to blur regions around the bride, enhancing the sense of motion. Additional effects were added in Photoshop.* LEFT—*Like shooting sports, sometimes you have to blanket a moving group like this with exposures to get the great expressions. Focus can be a problem, but when a group is moving toward you, the movement is fairly predictable and constant. Also, most predictive AF systems will handle this kind of movement easily. Note the priceless expression on the bride's face. Photograph by Tibor Imely.*

of four or five areas of the viewfinder (the center and four outer quadrants). This allows you to "decenter" your images and create more dynamic compositions. Once accustomed to quickly changing the AF area, this feature becomes an extension of the photographer's technique.

Autofocus and moving subjects used to be an almost insurmountable problem. While you could predict the rate of movement and focus accordingly, the earliest AF systems could not. Now, however, most AF systems use a form of predictive autofocus, meaning that the system senses the speed and direction of the movement of the main subject and reacts by tracking the focus of the moving subject. This is an ideal feature for wedding photojournalism, which is anything but predictable.

A new addition to autofocus technology is dense multi-sensor-area AF, in which an array of AF sensor zones (up to 45 at this writing) are packed within the frame, making precision focusing much faster and more accurate. These AF zones are user-selectable or can all be activated at the same time for the fastest AF operation.

■ LENSES

Whether film or digital, another reason the 35mm format is preferred by today's wedding photographers is the range and quality of ultrafast zoom lenses available.

Zoom Lenses. A popular lens choice seems to be the 80–200mm f/2.8 (Nikon) or the 70–200mm f/2.8 (Canon and Nikon). These are very fast, lightweight lenses that offer a wide variety of useful focal lengths for both the ceremony and reception. They are internal focusing, meaning that autofocus is lightning fast and the lens does not change length as it is zoomed or focused. At the shortest range, 80mm, this lens is perfect for creating full- and three-quarter-length portraits. At the long end, the 200mm setting is ideal for tightly cropped, candid shots or head-and-shoulders portraits.

Wide-Angle Lenses. Other popular lenses include the range of wide angles, both fixed focal length lenses and wide-angle zooms. Focal lengths from 17mm to 35mm are ideal for capturing the atmosphere as well as for photographing larger groups. These lenses are fast enough for use by available light with fast ISOs.

Fast Lenses. Fast lenses (f/2.8, f/2, f/1.8, f/1.4, f/1.2, etc.) will get lots of work on the wedding day, as they afford many more "available light" opportunities than slower speed lenses. Marcus Bell, an award-winning wedding photographer from Australia, calls his Canon 35mm f/1.4L USM lens his favorite. Shooting at dusk, with a high ISO setting, he can shoot wide open and mix lighting sources for unparalleled results.

High-Speed Telephotos. Another favorite lens is the high-speed telephoto—the 300mm f/2.8 or f/3.5. These lenses are ideal for working unobserved and can isolate some wonderful moments, particularly of the ceremony. Even more than the 80–200mm lens, the 300mm throws

MARCUS BELL'S THREE CAMERA BAGS (AND WHAT'S IN THEM)

Marcus Bell is experienced and prepared. As Bruce Dorn has said on numerous occasions, "Luck favors the prepared." And so it is Bell's motto also. He uses three small-sized bags of varying age, including what he calls a "bum bag," which he wears about his waist most of the day.

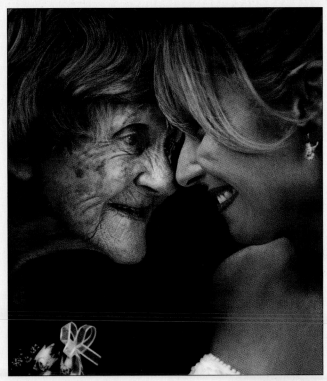

Working with two camera bodies all day gives Marcus Bell the flexibility to change viewpoints quickly so that shots like this fleeting moment don't get missed.

MAIN BAG
1. *Spare batteries*
2. *Air brush and lens cleaning cloth*
3. *Two Canon EOS 5Ds with two main lenses (28–70mm f/2.8 and 85mm f/1.2)*
4. *Epson P4000 downloader, carried in pocket*
5. *Point-and-shoot 8MP camera for backup (surprisingly, some of the album images get made with this camera)*
6. *Digital flashmeter*
7. *70–200mm f/2.8 lens for ceremony*
8. *Flashlight for looking through the three bags*
9. *Stain stick and cloth to remove virtually any stain from the wedding dress*
10. *Breath freshener ("a courtesy," he says)*

WAIST BAG (WORN THE ENTIRE DAY)
1. *Secondary lenses (35mm f/1.4, 17–35mm f/2.8)*
2. *Crochet hook (sometimes needed to help a bride fasten her dress)*
3. *Arctic Butterfly (battery-powered sensor brush that is used to remove dust)*
4. *Small battery-powered, handheld video light*
5. *Extension tube for close-ups*
6. *More spare batteries*
7. *30GB worth of cards (4GB each)*

BACKUP BAG
1. *EOS 1D Mark II*
2. *85mm f/1.8 and 50mm f/1.4 lenses*
3. *Tele-extender (rarely used)*
4. *More spare batteries*
5. *Charger for batteries*
6. *Timetable and driving directions*

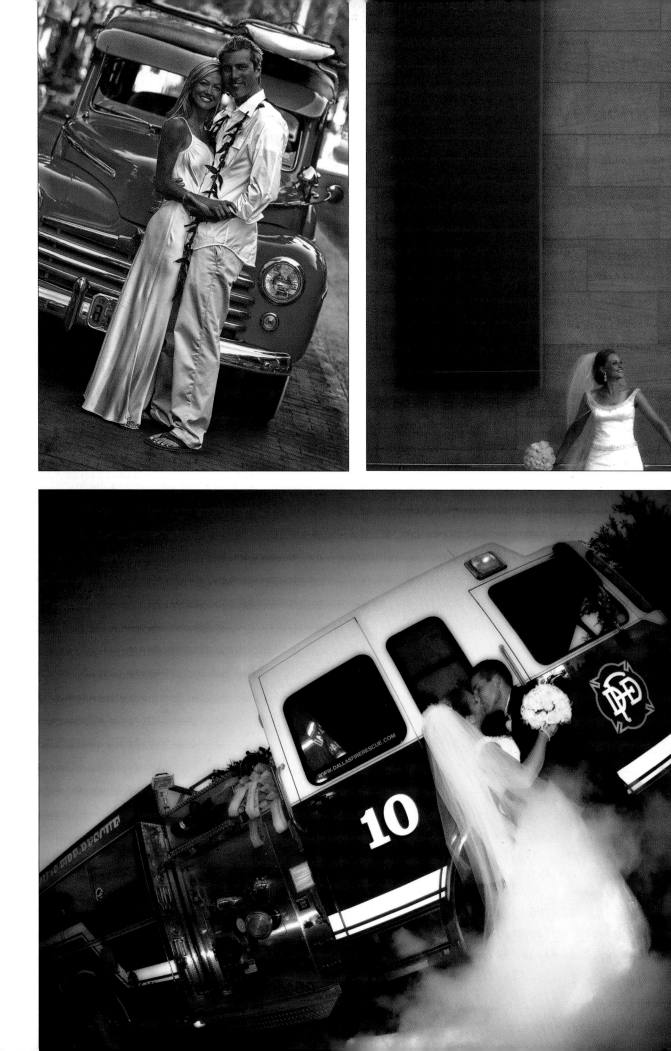

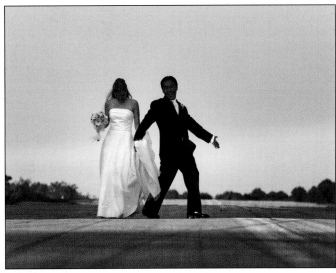

FACING PAGE, TOP LEFT—*With an EF 70–200mm f/2.8L USM lens on his Canon EOS 1D, Marc Weisberg shot wide open at ISO 100. This might be the poster for Southern California weddings.* **ABOVE AND FACING PAGE, BOTTOM**—*Today, wide-angles are used as much as any other lens and mostly for dramatic effect. Both images here are by J.B. Sallee. The fire-truck image is titled* They Call Me a Fireman. *To create it, a 10.5mm f/2.8 Nikkor DX fisheye lens was used very close for optimal distortion at the frame edges. A balanced fill-flash was fired to give the bride and groom some main light. For the image of the bride in the art museum, titled* The $2.3 Million Dollar Bride, *Sallee used a 17mm f/2.8 and carefully aligned his verticals and horizontals to minimize distortion.* **LEFT**—*Telephoto lenses compress the perspective of the scene as is seen here. The bands of light and shadow look right on top of one another and the subjects stand out boldly from the background. This image by Cal Landau was made with a Canon EOS 10D and 70–200mm lens at the 200mm setting. The image was made on a landing strip at a small airport. Exposure was* ¹/₁₀₀₀ *second at f/5.0.*

backgrounds beautifully out of focus and, when used wide open, provides a sumptuously thin band of focus, which is ideal for isolating image details.

Another popular choice is the 85mm (f/1.2 for Canon; f/1.4 or f/1.8 for Nikon), which is a short telephoto with exceptional sharpness. This lens gets used frequently at receptions because of its speed and ability to throw backgrounds out of focus, depending on the subject-to-camera distance. It is one of Marcus Bell's preferred lenses for the majority of his wedding day coverage.

Normal Lens. One should not forget about the 50mm f/1.2 or f/1.4 "normal" lens for digital photography. With a 1.4x focal-length factor, for example, that lens becomes a 70mm f/1.2 or f/1.4 lens that is ideal for portraits or groups, especially in low light. And the close-focusing distance of this lens makes it an extremely versatile wedding lens.

Sensor Size. Most digital imaging sensors are smaller than the full-size 1x1.5-inch (24x36mm) 35mm frame. While the chip size does not necessarily affect image qual-

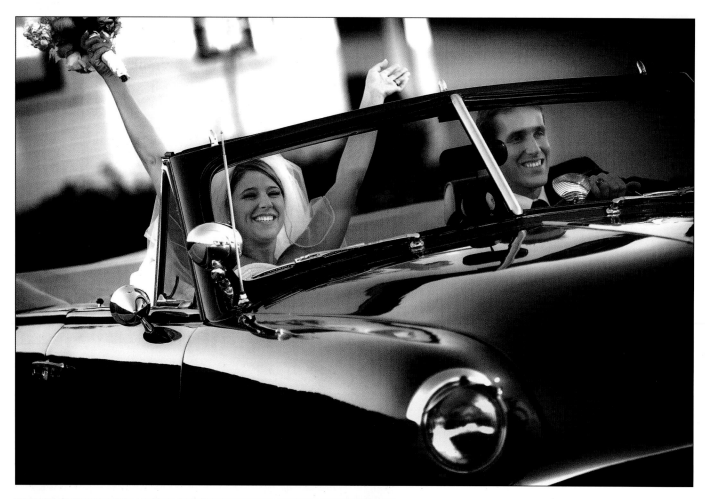

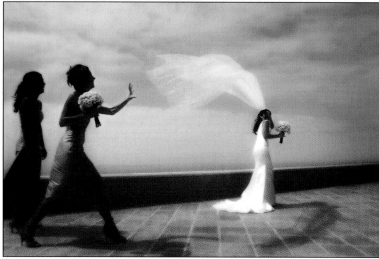

ABOVE—*Wife of J.B. Sallee, DeEtte made this fantastic image, entitled* Joy Ride, *with a Nikon D2X and 80–200mm f/2.8 lens at the 175mm setting. The digital sensors in today's DSLRs are so incredibly sharp that you almost need to apply some minor diffusion to every image.* LEFT—*Joe Photo made this delightful image with his Nikon D1X and 17mm f/2.8 lens at ¹⁄₆₀₀₀ second at f/2.8. Because of the focal length factor, the 17mm lens functioned like a 25mm wide-angle.*

ity or file size, it does affect lens focal length. With sensors smaller than 24x36mm, lenses get effectively longer.

This is not usually a problem where telephotos and telephoto zooms are concerned, but when your expensive wide-angles or wide-angle zooms become significantly less wide on the digital camera body, it can be somewhat frustrating. For example, with a 1.4x focal-length factor, a 17mm lens becomes a 24mm lens.

There are several DSLRs from Canon with full-size 24x36mm imaging chips, meaning that there is no change to your lenses' effective focal lengths. Camera manufacturers who have committed to chip sizes that are smaller than full-frame 35mm have started to introduce lens lines specifically designed for digital imaging. The circle of coverage (the area of focused light falling on the film plane or digital-imaging chip) is smaller and more collimated to

compensate for the smaller chip size. Thus, the lenses can be made more economically and smaller in size, yet still offer as wide a range of focal lengths as traditional lenses.

■ MEDIA

Memory Cards. Instead of film, digital cameras store digital image files on portable digital media, such as CompactFlash (CF) cards, Memory Sticks, microdrives, and xD cards. The camera writes the image data to the removable storage media as photographs are captured. When the media becomes full, you simply eject it and insert a new card or microdrive just like you would change film at the end of the roll.

Removable media are rated and priced according to storage capacity; the more storage, the higher the price. There are two types: microdrives and flash memory. Microdrives are miniature, portable hard drives. Flash memory, which uses no moveable parts, tends to perform better than mechanical hard drives under adverse shooting conditions. The latest memory card format, at this writing, is the xD card, developed jointly by Fuji and Olympus. By the time you read this, the maximum xD card capacity will be up to 8GB.

Film. Because a significant number of wedding photographers still shoot with film, this section remains intact from the first edition.

ISO. Ultrafast films in the ISO 1000–3200 range offer an ability to shoot in very low light and produce a larger-than-normal grain pattern and lower-than-normal contrast, ideal characteristics for photojournalistic wedding coverage. Many photographers use these films in color and black & white for the bulk of their photojournalistic coverage. Usually, a slower, finer-grain film will be used for

Featuring a high capacity 80GB hard drive and 3.8-inch LCD, the EPSON P-4000 enables users to view, store and playback photos, videos and music—all without a computer. This compact battery-operated hard drive/viewer is ideal for downloading and previewing images on site. It is also an excellent way to clear memory cards for continued use.

the formals and groups. These ultrafast films used to be avoided for wedding coverage because of excessive grain, but the newer films have vastly improved grain structure—and many brides and photographers have come to equate grain with mood, a positive aesthetic aspect.

Color negative films in the ISO 100–400 range have amazing grain structure compared to films of only a few years ago. They also possess mind-boggling exposure latitude, from –2 to +3 stops under or over normal exposure. Of course, optimum exposure is still (and will always be) recommended, but to say that these films are forgiving is an understatement.

Film Families. Kodak and Fujifilm offer "families" of color negative films. Within these families are different speeds and varying contrast or varying color saturation—but with the same color palette. Kodak's Portra films include ISOs from 160 to 800 and are available in NC (natural color) or VC (vivid color) versions. Kodak even offers an ISO 100 tungsten-balanced Portra film. Fujicolor Portrait films, available in a similar range of speeds, offer similar skin-tone rendition among the different films as well as good performance under mixed lighting conditions because of a fourth color layer in the emulsion. These films are ideal for weddings, since different speeds and format sizes can be used with minimal differences in the prints.

Black & White Films. Many wedding photojournalists shoot color film and convert it later to black & white. That way there is always a color original. With digital, this is a simple matter of changing the image mode in Photoshop or in the camera at capture. However, many photographers prefer the emulsions offered in black & white films. Kodak T-Max, a notable example, is available in a variety of speeds (ISO 100, 400, and 3200), is extremely sharp, and offers fine grain even in its fastest version. Black & white coverage is almost a necessity for today's wedding photographers, providing a welcome relief from all-color coverage and numerous creative opportunities.

■ FLASHMETER

A handheld incident flashmeter is essential for work indoors and out, but it is particularly useful when mixing flash and daylight. It is also helpful for determining lighting ratios. Flashmeters will prove invaluable when using multiple strobes and when trying to determine the overall evenness of lighting in a large room. Flashmeters are also ambient light meters of the incident type, meaning that

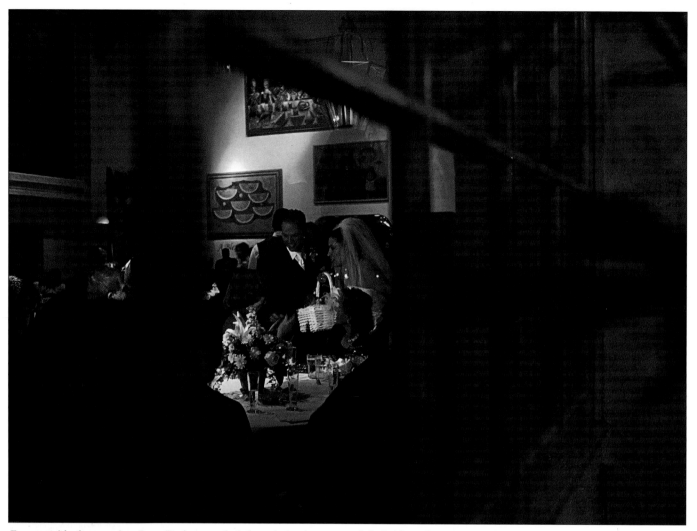

From outside the reception, Jerry D photographed through the glass to record the bride and company at the reception. Often remote triggering devices are used to fire a remote strobe—in this case inside the restaurant/reception. Jerry dragged the shutter to record the low-light exterior on the same frame as the strobe-lit interior.

they measure the light falling on them and not the light reflected from a source or object.

■ REMOTE TRIGGERING DEVICES

If using multiple flash units (to light the dance floor, for instance), some type of remote triggering device will be needed to sync all the flashes at the instant of exposure. There are a variety of devices available. Light-actuated slaves are sensitive to the light of a flash unit being fired and fire the flash they are attached to at the same instant they sense a flash going off. Unfortunately, this can be your flash or someone else's—a real drawback. Infrared remote flash triggers are more reliable. Since many monolight-type flash units come equipped with an infrared sensor built in, it is a simple matter of syncing the flashes with the appropriate transmitter. A third type, the radio remote triggering device, uses a radio signal that is transmitted when you press the shutter release and then picked up by individual receivers mounted to or in each flash. While good, these units are not foolproof—a cordless microphone may trigger them accidentally. Radio remotes transmit signals in either digital or analog form. Digital systems, like the Pocket Wizard, are much more reliable and are not affected by local radio signals. Some photographers will use, as part of the standard equipment, a separate transmitter for as many cameras as are being used (for instance, an assistant's camera), as well as a separate transmitter for the handheld flashmeter, allowing you to take remote flash readings from anywhere in the room.

■ FLASH

On-Camera Flash. On-camera flash is used sparingly because of the flat, harsh light it produces. As an alternative, many photographers use on-camera flash brackets, which

TOP—*Remote triggering devices such as the Pocket Wizard radio re-mote can be used to trigger strobes located around the room or hand-held by an assistant. Here, the main flash was behind the couple so their silhouettes and all the bubbles could be backlit for an unusual image. Photograph by Tom Muñoz.* CENTER—*When direct flash is used with a slow shutter speed, it's known as "dragging the shutter." Cliff Maut-ner wanted the ambient lights of the ballroom to show up, and he also wanted a bit of blur to the image, so he chose a slow shutter speed of ½ second and moved the camera too, knowing the flash would freeze the main subjects.* BOTTOM—*Tibor Imely says of this shot, "It all happened really quickly. Everyone was waiting for the bride and groom to enter the reception for the introduction. I looked behind me and three feet away were these three little girls with their arms around each other. When I aimed the camera at them they came up with these incredible expressions. I made only one shot." The image was made with a Canon EOS 10D, 16–35mm f/2.8 zoom and bounce flash.*

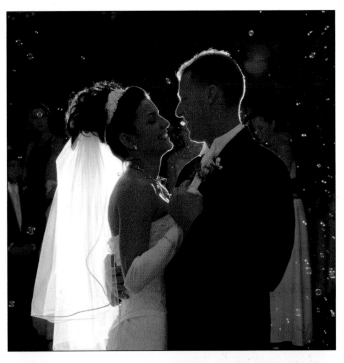

position the flash over and away from the lens, thus mini-mizing flash red-eye and dropping the harsh shadows be-hind the subjects—a slightly more flattering light. On-camera flash is often used outdoors, especially with TTL-balanced flash-exposure systems. With such systems, you can adjust the flash output for various fill-in ratios, thus producing consistent exposures. In these situations, the on-camera flash is most frequently used to fill in the shadows caused by the daylight, or to match the ambient light output in order to provide direction to the light.

Bounce-Flash Devices. Many photographers use their on-camera flash in bounce-flash mode. A problem, how-ever, with bounce flash is that it produces an overhead soft light. With high ceilings, the problem is even worse—the light is almost directly overhead. A number of devices on the market, like the Lumiquest ProMax system, offer a way to direct some of that bounce light directly toward the subject. They offer accessories that mount to the flash housing and transmit 10 to 20 percent of the light forward onto the subject, with the remainder of the light being aimed at the ceiling. This same company also offers de-vices like the Pocket Bouncer, which redirects light at a 90-degree angle from the flash to soften the quality of light and distribute it over a wider area. No exposure com-pensation is necessary with automatic and TTL systems, although operating distances will be reduced.

Barebulb Flash. Perhaps the most frequently used handheld flash at weddings is the barebulb flash. These units are powerful and use, instead of a reflector, an up-right mounted flash tube sealed in a plastic housing. Since there is no reflector, barebulb light goes in all directions. It acts more like a large point-source light than a small

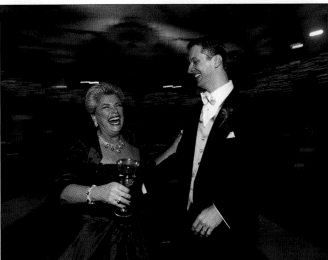

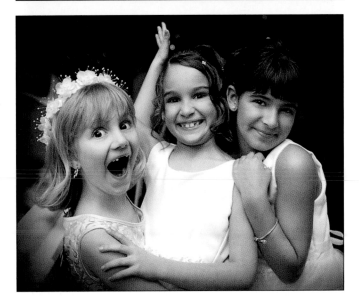

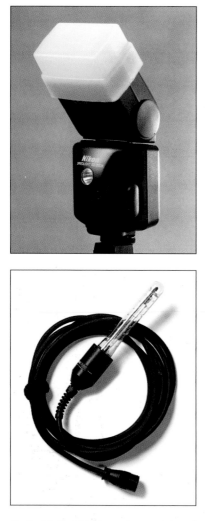

TOP LEFT—*Diffusers such as the Omni-bounce attach to the Speedlight and soften the light emitted.* LEFT—*The Profoto StickLight is a small and handy lamp head ideally suited for a multitude of photographic subjects including: automotive, furniture, interiors and portraiture. The unique design and small size allow the unit to be placed behind or sometimes inside the subject to create unparalleled lighting effects. An integrated clear glass cover protects the head even if used outside the studio.* ABOVE—*Joe Photo covers a wedding with speed and thoroughness and almost never lets a photo opportunity like this one get away. He uses a Nikon D1X and Nikon SB Speedlites in bounce mode with the strobe's internal white fill card extended so that some of the bounce flash is directed forward onto the subjects. His flash technique is flawless as you never see flash in the final results. He vignetted the frame later in Photoshop.*

flash. Falloff is less than with other handheld units, making these units ideal for flash-fill situations.

These units are predominantly manual, meaning that you must adjust their intensity by changing the flash-to-subject distance or by adjusting the flash output. Many of the outdoor pictures in this book were created using barebulb flash. Many photographers even mount a sequence of barebulb flash units on light stands at the reception for doing candids on the dance floor.

Studio-Flash System. You may find it useful to have a number of studio flash heads with power packs and umbrellas. You can set these up for formals or tape the light stands to the floor and use them to light the reception. Either way, you will need enough power (at least 50 watt-seconds per head) to light large areas or allow you to work at small apertures at close distances.

The most popular of these lights is the monolight type, which has a self-contained power pack and usually has an on-board photo cell that triggers the unit to fire when it senses a flash burst. All you need is an electrical outlet and

the flash can be positioned anywhere. Be sure to take along plenty of gaffers' tape and extension cords.

Studio flash units can also be used with umbrellas for lighting large areas of a room. Be sure, however, to focus the umbrella—adjusting the cone of light that bounces into and out of the umbrella surface by moving the umbrella closer and farther away from the light source. The ideal position is when the light fills the umbrella, but does not exceed its perimeter. Focusing the umbrella also helps eliminate hot spots and maximize light output.

■ REFLECTORS

When photographing by window light or outdoors, it is a good idea to have a selection of white, silver, gold, and black reflectors. Most photographers opt for the circular disks that unfold to produce a large reflector. These are particularly valuable when making portraits by available light. It is wise to have an assistant along to precisely position reflectors, since it is nearly impossible to position a reflector correctly without looking through the viewfinder.

■ BACKUP AND EMERGENCY EQUIPMENT

Wedding photographers live by the expression, "If it can go wrong, it will go wrong." That is why most pros carry backups—extra camera bodies, flash heads, transmitters, batteries, cords, twice the required amount of film or memory cards, etc. For AC-powered flash, extra extension cords, several rolls of duct tape (for taping cords to the floor), power strips, flash tubes, and modeling lights also need to be on hand. Other items of note include the obligatory stepladder for making groups shots (renowned photographer Monte Zucker even has a black "formal" stepladder for use at weddings), flashlights, a mini tool kit (for mini emergencies), and quick-release plates for your tripods (these always seem to get left behind on a table or left attached to a camera).

■ SPARE BATTERIES

One of the drastic improvements in DSLR design, is the improved life of batteries. Camera batteries should now last all day without replacement. However, it's always a good idea to bring extra batteries and a charger or two. Spare packs should be fully charged and ready to go and you should have enough to handle your cameras as well as your assistant's cameras and the backup gear. If downloading images to a laptop, do not forget spare laptop batteries or the computer's AC adapter.

Charles and Jennifer Maring are sticklers for their interiors done at weddings. They use the lowest ISO (highest quality) and a tripod. They will balance exposure throughout and where needed, may bring in hot lights to boost the overall light level. Often shutter speeds will be in the ⅛- to ¹⁄₁₅- second range in aperture-priority mode. In Photoshop, the Marings will straighten walls and burn and dodge the image as if they were lighting each individual table. Many times each napkin or place setting, and floral arrangements gets dodged or burned in.

4. CAMERA TECHNIQUE

Whether you've grouped your subjects and posed them beautifully or are shooting candids from across the dance floor, using good camera technique can make or break your images. From lens selection, to depth of field, to exposure, there's a lot to keep in mind as you capture each important frame.

■ FOCAL LENGTH AND PERSPECTIVE

If you use a "normal" lens (35–50mm in the digital 35mm format), you often need to move in too close to the subject to attain an adequate image size. Because this alters the perspective, close proximity to the subject exaggerates subject features—noses appear elongated, chins jut out and the backs of heads may appear smaller than normal. This phenomenon is known as foreshortening.

Short- to medium-length telephotos, on the other hand, provide normal perspective without distortion. They provide a greater working distance between camera and subject, while increasing the size of the subject in the frame.

For groups, some photographers prefer long lenses; for example, a 180mm lens on a 35mm camera. The longer

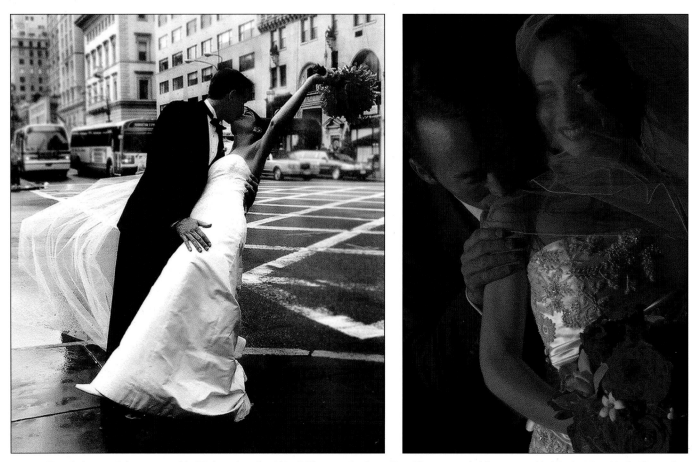

LEFT—*Reminiscent of the memorable VJ day photo by Alfred Eisenstaedt, Ron Capobianco posed this memorable kiss in New York City trying to mimic the focal length and angle of that famous shot. Using a short focal length, he was able to incorporate the background into the scene, as well as widen the foreground portion of the image.* RIGHT—*The use of a short telephoto lens creates good perspective and no distortion even when working at close distances. Joe Buissink made this wonderful image with 67mm (equivalent) lens on Nikon D2H in late afternoon light. He helped out the glow of the light in Adobe Camera Raw.*

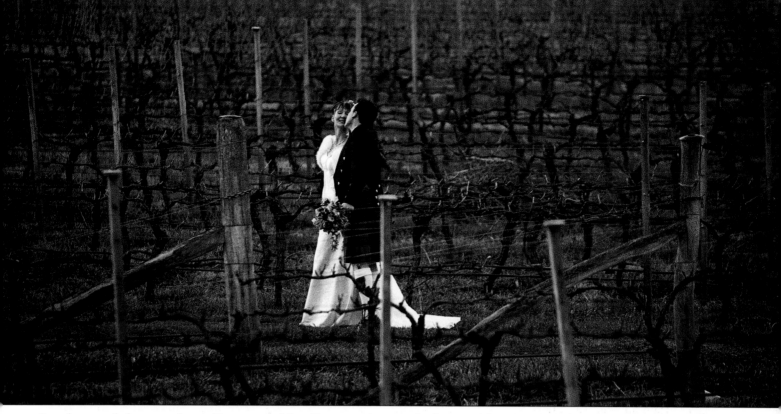

Long lenses stack the perspective, making near and far objects seem closer together because of the narrower angle of view. Here Mercury Mega-loudis photographed bride and groom strolling through a vineyard in winter. The effect is a dreary scene made joyful by the couple's presence.

lens keeps people in the back of the group the same relative size as those in the front of the group.

When space doesn't permit the use of a longer lens, short lenses must be used, but you should be aware that the subjects in the front row of a large group will appear larger than those in the back—especially if you get too close. Extreme wide-angle lenses will distort the subjects' appearance, particularly those closest to the frame edges. Raising the camera height, thus placing all subjects at the same relative distance from the lens, can minimize some of this effect. Also, the closer to the center of the frame the people are, the less distorted they will appear.

Conversely, you can use a much longer lens if you have the working room. A 200mm lens, for instance, is a beautiful portrait lens for the 35mm format because it provides very shallow depth of field and throws the background completely out of focus, providing a backdrop that won't distract viewers from the subjects. When used at wider apertures, this focal length provides a very shallow band of focus that can be used to accentuate just the eyes, for instance, or just the frontal planes of the faces.

Very long lenses (300mm and longer for 35mm) can sometimes distort perspective. With them, the subject's features appear compressed. Depending on the working distance, the nose may appear pasted onto the subject's face, and the ears may appear parallel to the eyes. While lenses this long normally prohibit communication in a posed portrait, they are ideal for working unobserved as a wedding photojournalist often does. You can make head-and-shoulders images from a long distance away.

When making three-quarter- or full-length group portraits, it is best to use the normal focal length lens for your camera. This lens will provide normal perspective because you will be at a greater working distance from your subjects than you would be when making a close-up portrait. It is tricky sometimes to blur the background with a normal focal length lens, since the background is in close proximity to the subjects. If forced to use a normal or short lens, you can always blur the background elements later in Photoshop using selective blurring. With longer lenses you can isolate your subjects from the background because of the working distance and image size.

When making group portraits, you are often forced to use a wide-angle lens. In this case, the background problems noted above can be even more pronounced. Still, a wide angle is often the only way you can fit the group into the shot and maintain a decent working distance. For this reason, many group photographers carry a stepladder or scope out the location in advance to find a high vantage point, if called for.

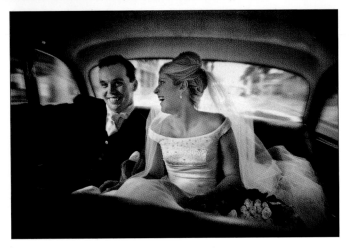

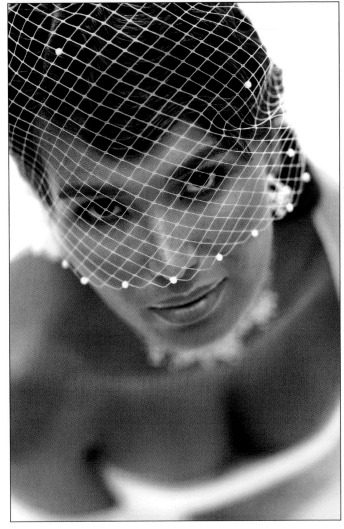

TOP—*J.B. Sallee used a 70mm lens to provide a good working distance and make all the verticals straight.* ABOVE—*When using a wide-angle lens you must center the subjects or they will distort, the closer they are positioned to the frame edges. A relatively slow shutter speed like ¹/₃₀ second sharply captures the couple inside the car but blurs the scene outside the moving car. Photograph by Marcus Bell.* RIGHT—*Short, fast telephotos produce "strands" of focus when used wide open. Here, Joe Buissink wanted only the bride's eyes and some of the veil to be sharp.*

■ DEPTH OF FIELD

The closer you are to your subjects with any lens, the less depth of field you will have at any given aperture. When you are shooting a tight image of faces, be sure that you have enough depth of field at your working lens aperture to hold the focus on all the faces.

Learn the characteristics of your lenses. You should know what to expect in the way of depth of field, at your most frequently used lens apertures, which for most group shots will be f/5.6, f/8, and f/11. Some photographers tend to use only one or two favorite apertures when they shoot. Norman Phillips, for instance, prefers f/8 over f/11 (for shooting group portraits), even though f/11 affords substantially more depth of field than f/8. He prefers the relationship between the sharply focused subject and the background at f/8, saying that the subjects at f/11 look "chiseled out of stone."

■ DEPTH OF FOCUS

When working close at wide lens apertures, where depth of field is reduced, you must focus carefully to hold the eyes, lips, and tip of the nose in focus. This is where a good working knowledge of your lenses is essential. Some lenses will have the majority (two thirds) of their depth of field behind the point of focus; others have the majority (two thirds) in front of the point of focus. In most cases, depth of field is split more evenly, half in front of and half behind the point of focus. It is important that you know how your different lenses operate and that you check the depth of field with the lens stopped down to the taking aperture, using your camera's depth-of-field preview control. One of the benefits of shooting with DSLRs is the large LCD panel. Most cameras allow you to inspect the sharpness of the image by zooming in or scrolling across the image—a dramatic improvement over the depth-of-field preview.

With most lenses, if you focus one-third of the way into the group or scene, you will ensure optimum depth of focus at all but the widest apertures. Assuming that your depth of field lies half in front and half behind the point of focus, it is best to focus on the eyes. The eyes are the region of greatest contrast in the face, and thus make focusing easier. This is particularly true for autofocus cameras that often seek areas of highest contrast on which to focus.

Focusing a three-quarter- or full-length portrait is a little easier because you are farther from your subjects, where depth of field is greater. With small groups, it is essential that the faces fall in the same plane. This is accomplished with careful posing and adjustments of camera position.

■ CAMERA BACK PARALLEL TO THE SUBJECT

Suppose your wedding group is large and you have no more room in which to make the portrait. One easy solution is to raise the camera, angling it downward so that the film plane is more parallel to the plane of the group. This optimizes the plane of focus to accommodate the depth of the group. By raising the camera height, you are effectively shrinking the depth of the group, making it possible to get the front and back rows in focus at the same time. Focus midway into the group and use the smallest aperture permissible without compromising shutter speed.

■ SHIFTING THE FOCUS FIELD

Lenses characteristically focus objects in a more or less straight line—but not completely straight. If you line your

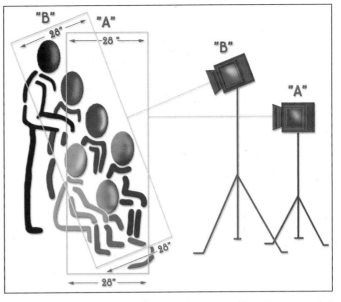

In this example, the depth of field at the given taking distance and f-stop is 28 inches, which is not enough to cover the group from front to back. By raising the camera and tilting it down, the depth of field now covers the same 28 inches, but a different plane in the subject, thus reapportioning your depth of field to cover the subject. Diagram concept by Norman Phillips; diagram by Shell Dominica Nigro.

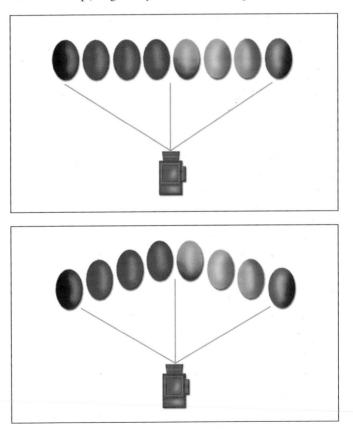

When you photograph a group in a straight line, those closest to the center of the line are closest to the lens. Those on the ends of the line are farther away from the lens. When you "bend" the group, you can make each person the same distance from the lens, thus requiring the same amount of depth of field to render them sharply. Diagram concept by Norman Phillips; diagram by Shell Dominica Nigro.

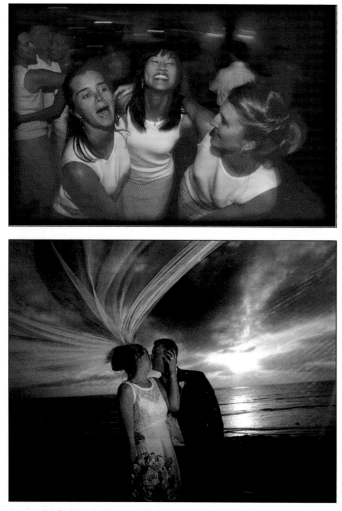

TOP—*With a 17mm lens on his D1X, Michael Schuhmann created this wonderful image of wedding guests dancing by using a ⅒ second shutter speed at f/3.5. This was the exposure of the ambient light. Using the strobe at that shutter speed/aperture allowed the two exposures to match. The reason the faces are red is because the flash exposure is mixing with the ambient light exposure, which is a much warmer color temperature due to the tungsten room lights.* ABOVE—*One of the benefits of the newer DSLRs is the higher flash-sync speeds—up to ⅟₅₀₀ second. Scott Eklund created this wonderful wide-angle shot of the bride and groom with the bride's veil blowing in the breeze and in front of the lens. Scott simply matched his flash output to his daylight exposure to record both exposures simultaneously.*

subjects up in a straight line and back up so that you are far away from the group, all subjects will be rendered sharply at almost any aperture. At a distance, however, the subjects are small in the frame. For a better image, you must move closer to the group, making those at the ends of the group proportionately farther away from the lens than those in the middle of the lineup. Those farthest from the lens will be difficult to keep in focus. The solution is to bend the group, making the middle of the group step back and the ends of the group step forward so that all of the

people in the group are the same relative distance from the camera. To the camera, the group looks like a straight line, but you have actually distorted the plane of sharpness to accommodate the group.

■ THE RIGHT SHUTTER SPEED

You must choose a shutter speed that stills both camera and subject movement. If using a tripod, a shutter speed of ⅟₁₅ to ⅟₆₀ second should be adequate to stop average subject movement. If you are using electronic flash, you are locked into the flash-sync speed your camera calls for—unless you are "dragging" the shutter. Dragging the shutter means working at a slower-than-flash-sync speed to bring up the level of the ambient light. This effectively creates a balanced flash exposure with the ambient exposure.

35mm SLRs and DSLRs use a focal-plane shutter, which produces an X-sync speed for electronic flash use of ⅟₆₀ to ⅟₅₀₀ second. Using the technique of "dragging the shutter" you can shoot at any shutter speed slower than the X-sync speed and still maintain flash synchronization. If you shoot at a shutter speed faster than the X-sync speed, the flash will only partially expose the film frame.

Outdoors, you should normally choose a shutter speed faster than ⅟₆₀ second, because even a slight breeze will cause the subjects' hair to flutter, producing motion during the moment of exposure.

When handholding the camera, you should use the reciprocal of the focal length of the lens you are using for a shutter speed. For example, if using a 100mm lens, use ⅟₁₀₀ second (or the next highest equivalent shutter speed, like ⅟₁₂₅ second) under average conditions. If you are very close to the subjects, as you might be when making a portrait of a couple, you will need to use an even faster shutter speed because of the increased image magnification. When working farther from the subject, you can revert to the shutter speed that is the reciprocal of your lens's focal length.

A great technical improvement is the development of image stabilization lenses, which correct for camera movement and allow you to shoot handheld with long lenses and slower shutter speeds. Canon and Nikon, two companies that currently offer this feature in some of their lenses, manufacture a wide variety of zooms and long focal length lenses with image stabilization. If using a zoom, for instance, which has a maximum aperture of f/4, you can still shoot handheld wide open in subdued light at ⅒ or ⅟₁₅ second and get dramatically sharp results. The benefit is

that you can use the light longer in the day and still shoot at low ISO settings for fine grain. It is important to note, however, that subject movement will not be quelled with these lenses, only camera movement.

When shooting groups in motion, use a faster shutter speed and a wider lens aperture. It's more important to freeze subject movement than it is to have great depth of field for this kind of shot. If you have any question as to which speed to use, always use the next fastest speed to ensure sharpness.

Some photographers are able to handhold their cameras for impossibly long exposures, like ¼ or ½ second. They practice good breathing and shooting techniques to accomplish this. With the handheld camera laid flat in the palm of your hand and your elbows in against your body, take a deep breath and hold it. Do not exhale until you've "squeezed off" the exposure. Use your spread feet like a tripod and if you are near a doorway, lean against it for additional support. Wait until the action is at its peak (all subjects except still lifes are in some state of motion) to make your exposure. I have seen the work of photographers who shoot in extremely low-light conditions come back with available-light wonders by practicing these techniques.

■ EXPOSURE

When it comes to exposure, the wedding day presents the ultimate in extremes: a black tuxedo and a white wedding dress. Both extremes require the photographer to hold the image detail in them, but neither is as important as proper exposure of skin tones. Although this will be discussed later in the section on lighting, most professionals opt for an average lighting ratio of about 3:1 so that there is detail in both facial shadows and highlights. They will fill the available light with flash or reflectors in order to attain that medium lighting ratio and this frees them to concentrate on exposures that are adequate for the skin tones.

Metering. The preferred type of meter for portraiture is the handheld incident light meter. This does not measure the reflectance of the subjects, but measures the amount of light falling on the scene. Simply stand where you want your subjects to be, point the hemisphere (dome) of the meter directly at the camera lens and take a reading. This type of meter yields extremely consistent results, because it is less likely to be influenced by highly reflective or light-absorbing surfaces.

When you are using an incident meter but can't physically get to your subject's position to take a reading, you can meter the light at your location if it is the same as the lighting at the subject position.

It is advisable to run periodic checks on your meter if you base the majority of your exposures on its data. You should do the same with any in-camera meters you use frequently. If your incident meter is also a flashmeter, you should check it against a second meter to verify its accu-

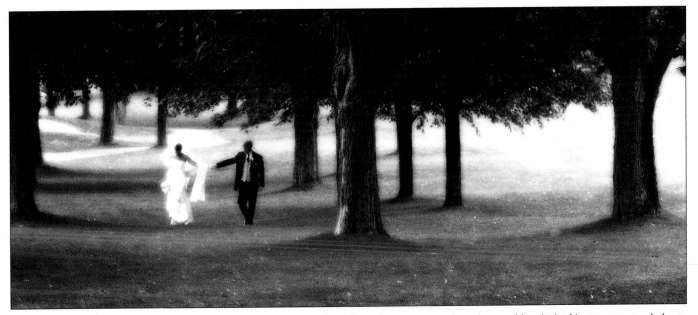

Knowing that he would make a large image file for the album, Parker Pfister chose camera settings that would optimize his camera system's sharpness. One of the sharper lenses around, the Nikkor 85mm f/1.8, was focused at close to infinity and the taking aperture set to f/4—the lens's optimum aperture for image sharpness. A ¹/₁₂₅ second shutter speed was sufficient to quiet camera and subject motion. Parker added grain/noise to the image later in Photoshop to create a painterly feeling.

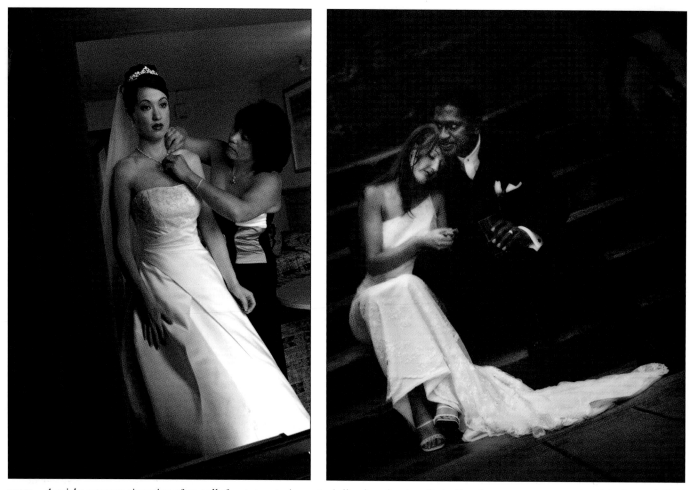

LEFT—*A tricky exposure situation often calls for spot metering, especially when shooting digitally, where correct exposure is critical, especially if shooting JPEGs. This is what photographer Becker did for this low-light scene. He spot-metered the scene and came up with a perfect exposure: ¹/₄₅ second at f/5.0 with a 28mm lens on his Fuji FinePix S2 Pro.* RIGHT—*One of Marcus Bell's favorite lenses is his Canon EF 35mm f/1.4L, which he uses in near-dark situations. Here he photographed a bride and groom in twilight under mixed lighting. The exposure was ¹/₁₅ second at f/1.4 using an ISO of 800. The effect of this lens is remarkable, as it is extremely sharp—even wide open—because of its floating aspheric element.*

racy. Like all mechanical instruments, meters can get out of whack and need periodic adjustment.

Exposure Latitude. Working with digital files is much different than working with film. For one thing, the exposure latitude, particularly in regard to overexposure, is virtually nonexistent. Some photographers liken shooting digital to shooting transparency film: it is unforgiving. The upside of this is that greater care taken in creating a proper exposure only makes you a better photographer. But for those used to –2/+3 stops of exposure latitude, this is a different game altogether.

Proper exposure is essential because it determines the range of tones and the overall quality of the image. Underexposed digital files tend to have an excessive amount of noise; overexposed files lack image detail in the highlights. You must either be right on with your exposures or, if you make an error, let it be only slightly underexposed, which

is survivable. Overexposure of any kind is a deal breaker. With digital capture, you must also guarantee that the dynamic range of the processed image fits that of the materials you will use to exhibit the image (i.e., the printing paper and ink or photographic paper).

■ WHITE BALANCE
White balance is the digital camera's ability to correct color when shooting under a variety of different lighting conditions, including daylight, strobe, tungsten, and fluorescent lighting.

White balance is particularly important if you are shooting highest-quality JPEG files; it is less important when shooting in RAW file mode, since these files contain more data than the compressed JPEG files and are easily remedied later. While this would seem to argue for shooting exclusively RAW files, it's important to note that these files

take up more room on media storage cards and they take longer to write to the cards. As a result, many wedding photographers find it more practical to shoot JPEGs and perfect the color balance when creating the exposure, much like shooting conventional transparency film with its unforgiving latitude. This topic is covered in greater detail below.

A system that many pros follow is to take a custom white balance of a scene where they are unsure of the lighting mix. By selecting a white area in the scene and neutralizing it with a custom white-balance setting, you can be assured of an accurate color rendition.

Others swear by a device known as the Wallace Expo-Disc (www.expodisc.com), which attaches to the the lens like a filter. You take a white-balance reading with the disc in place and the lens pointed at your scene. It is highly accurate in most situations and can also be used for exposure readings.

■ SHARPENING AND CONTRAST

Image sharpening should be set to off or minimal. Sharpening is usually the last step before output and should be done in Photoshop where there is optimum control. Contrast should also be adjusted to the lowest setting. According to California wedding photographer Becker, "It's always easy to add contrast later, but more difficult to take away."

■ FILE FORMAT

RAW retain the highest amount of image data from the original capture. While not as forgiving as color negative film, RAW files can be "fixed" to a much greater degree than JPEGs. If you shoot in RAW mode, you should back up the RAW files as RAW files; these are the original images and contain the most data. Shooting in the RAW mode has several drawbacks, however. First, it requires the use of RAW file-processing software to translate the file information and convert it to a useable format. Also, if you are like most wedding photographers and need fast burst rates, RAW files will definitely slow you down. In addition, they will fill up your storage cards or microdrives much more quickly than JPEGs because of their larger file size.

Your other file option is shooting in the JPEG Fine mode (sometimes called JPEG Highest Quality mode). Shooting in JPEG mode creates smaller files, so you can save more images per media card or microdrive. It also does not take as long to write the JPEG files to memory and allows you to work much more quickly. The biggest drawback to JPEG files is that they are a "lossy" format, meaning that since the JPEG format compresses file information, these files are subject to degradation by repeated saving. Most photographers who shoot in JPEG mode either save the file as a copy each time they work on it, or save it to the TIFF format, which is "lossless," meaning it can be saved again and again without degradation.

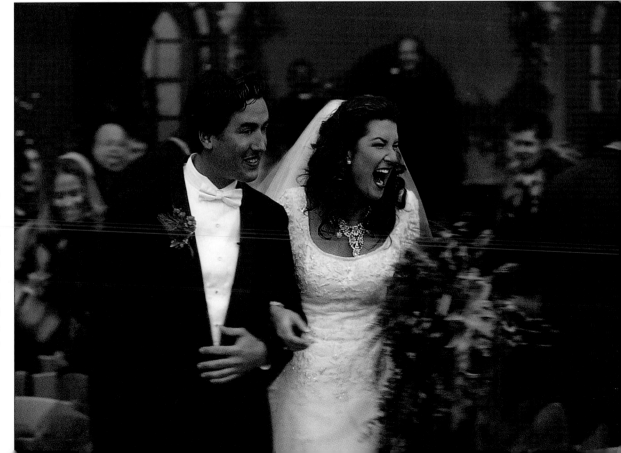

White balance is crucial to good exposure technique, particularly when shooting JPEG files. A situation like this, with mixed lighting in varying degrees, calls for a custom white balance to be sure your colors are accurate. Photograph by Tibor Imely.

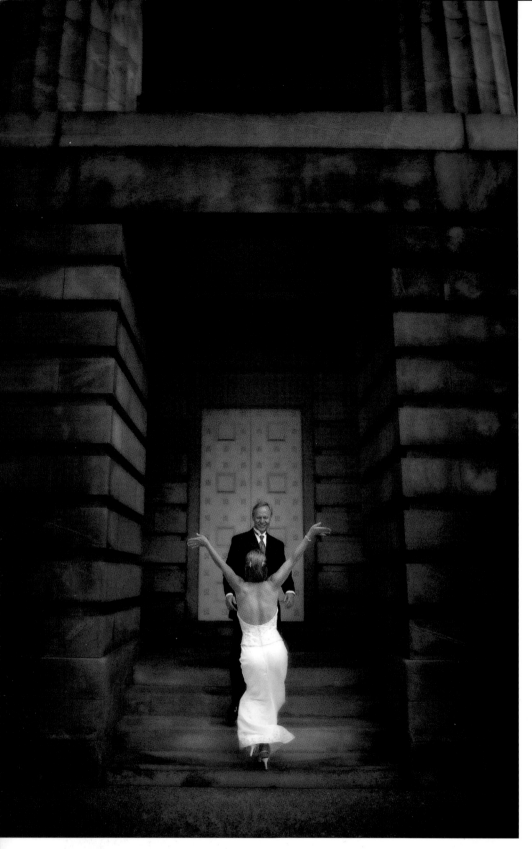

David Williams made this beautiful image with a fixed focal length Sigma 15mm f/2.8 EX DG fisheye lens and a Fujifilm Finepix S2 Pro camera. There are many pros that maintain that, because a fixed focal length lens is optimized for one focal length, it provides the optimal optical results.

■ FILE MAINTENANCE

It is extremely important to back up your original (source) files before you reuse your CF cards. A good friend of mine, who shall remain nameless, asked his assistant to download and reformat the cards at the wedding only to find out later that the cards had been reformatted but the image files had not been saved. There were no wedding pictures except for the cards still in the cameras.

A good rule of thumb is to backup the files to CDs or DVDs as soon as possible. Avoid reformatting the CF cards until that has been done and verified. After you backup your source files, it's a good idea to erase all of the images from your CF cards and then reformat them. It simply isn't enough to delete the images, because extraneous data may remain on the card causing data interference. After reformatting, you're ready to use the CF card again.

Some photographers shoot an entire job on a series of cards and take them back to the studio prior to performing any backup. Others refuse to fill an entire card at any time; instead opting to download, back up, and reformat cards directly during a shoot. This is a question of preference and security. Many photographers who shoot with a team of shooters train their assistants to perform these operations to guarantee the images are safe and in hand before anyone leaves the wedding.

Since most wedding photographers opt for speed and flexibility, most shoot in the JPEG Fine mode. Because there is less data preserved in this format, however, your exposure and white balance must be flawless. In short, the JPEG format will reveal any weakness in your technique.

*T*here are some formals that must be made at almost every wedding. These are posed portraits in which the subjects are aware of the camera, and the principles of good posing and composition are essential. Even in so-called photojournalistic wedding coverage, there is an absolute necessity for posed images and not just formals. For those times—and because any good wedding photographer who is not aware of the traditional rules of posing and composition is deficient in his or her education—the basics are included here.

The rules of posing are not formulas; like all good rules, they should be understood before they can be effectively broken. Posing standards offer ways to show people at their best—a flattering likeness.

No matter what style of photography is being used, there are certain posing essentials that need to be at work—otherwise your technique (or lack of it) will be obvious. The more you know about the rules of posing, and particularly the subtleties, the more you can apply to your wedding images. And the more you practice these principles, the more they will become second nature and a part of your overall technique.

■ GIVING DIRECTIONS

There are a number of ways to give posing instructions. You can tell your subjects what you want them to do, you can gently move them into position, or you can demonstrate the pose. The latter is perhaps the most effective, as it breaks down barriers of self-consciousness on both sides of the camera.

■ SUBJECT COMFORT

Your subjects should be made to feel comfortable. A subject who feels uncomfortable will most likely look uncomfortable in the photos. After all, these are normal people, not models who make their living in front of the camera. Use a pose that feels good to the subject, then make it your job to refine it—adding a turn of a wrist, shifting their

weight to their back foot, the angling their body away from the camera, etc.

■ HEAD-AND-SHOULDERS AXIS

One of the basics of flattering portraiture is that the subject's shoulders should be turned at an angle to the camera. With the shoulders facing the camera straight on to the lens, the person looks wider than he or she really is. Additionally, the head should be turned in a different direction than the shoulders. This provides an opposing or complementary line within the photograph that, when

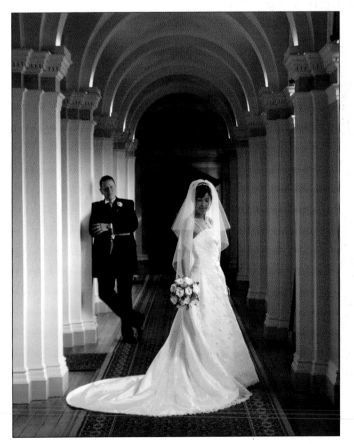

David Worthington is very skillful at traditional poses, such as this formal portrait of the couple. This location provides beautiful soft side lighting. The bride is holding her bouquet out from her hip in the classic style, keeping her arm from touching her body by extending the bouquet. Her eyes are looking down, but her head is not lowered. There are many excellent posing aspects in this image.

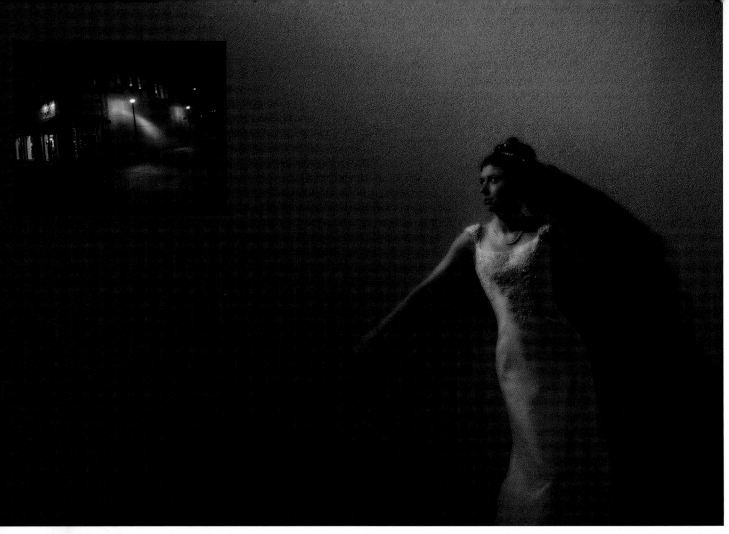

This is a beautiful pose created by Kevin Jairaj. To create it, he used the overhead light of a street light shining onto a stucco wall (see inset). No fill was used. He simply had the bride look up into the light. Note the dynamic lines created by the arms and also the almost straight-on view of her body (not normally recommended because it adds pounds to the bride). Also note that her head and neck axis are very much different, creating an interesting pose. In this instance, the lighting, because it couldn't be altered, dictated the pose.

seen together with the line of the body, creates a sense of tension and balance. With men, the head is often turned the same general direction as the shoulders (but not at exactly the same angle); with women, the head is usually at an angle that opposes the line of the body.

■ THE ARMS

Subjects' arms should generally not be allowed to fall to their sides, but should project outward to provide gently sloping lines and a "base" to the composition. This is achieved in a number of ways. For men, ask them to put their hands in their pockets; for women, ask them to bring their hands to their waist (whether they are seated or standing). Remind them that there should be a slight space between their upper arms and their torsos. This triangular base in the composition visually attracts the viewer's eye upward, toward the face, and also protects subjects from appearing to have flat and flabby arms.

■ HANDS

Posing hands can be difficult because, in most portraits, they are closer to the camera than the subject's head and thus appear larger. To give hands a more natural perspective, use a longer-than-normal lens. Although holding the focus on both the hands and face is more difficult with a longer lens, the size relationship between them will appear more natural. If the hands are slightly out of focus, this is not as crucial as when the eyes or face are soft.

One basic rule is never to photograph a subject's hands pointing straight into the camera lens. This distorts their size and shape. Instead, have the hands at an angle.

Another basic is to photograph the outer edge of the hand when possible. This gives a natural line to the hand and wrist and eliminates distortion that occurs when the hand is photographed from the top or head-on. Try to raise the wrist slightly so there is a gently curving line where the wrist and hand join. Additionally, you should

always try to photograph the fingers with a slight separation in between them. This gives the fingers form and definition. When the fingers are closed, there is no definition.

Hands in Groups. Hands can be a problem in group portraits. Despite their small size, they attract attention—especially against dark clothes. They can be especially troublesome in seated groups, where at first glance you might think there are more hands than there should be.

A general rule of thumb is to either show all of the hand or show none of it. Don't allow a thumb or half a hand or only a few fingers to show. Hide as many hands as you can behind flowers, hats, or other people. Be aware of these potentially distracting elements and look for them as part of your visual inspection of the frame before you make the exposure.

Hands with Standing Subjects. When some of your subjects are standing, hands are an important issue.

If you are photographing a man, folding his arms across his chest produces a good, strong pose. Remember, however, to have the man turn his hands slightly, so the edge of the hand is more prominent than the top of the hand. In such a pose, have him lightly grasp his biceps, but not too hard or it will look like he's cold. Also, remember to instruct the man to bring his folded arms out from his body a little bit. This slims down the arms, which would otherwise be flattened against his body, making them (and him) appear larger. Separate the fingers slightly.

Men can also put their hands in their pockets, either completely or with their thumb hitched up over the outside of the pocket. Preventing the hand from going all the

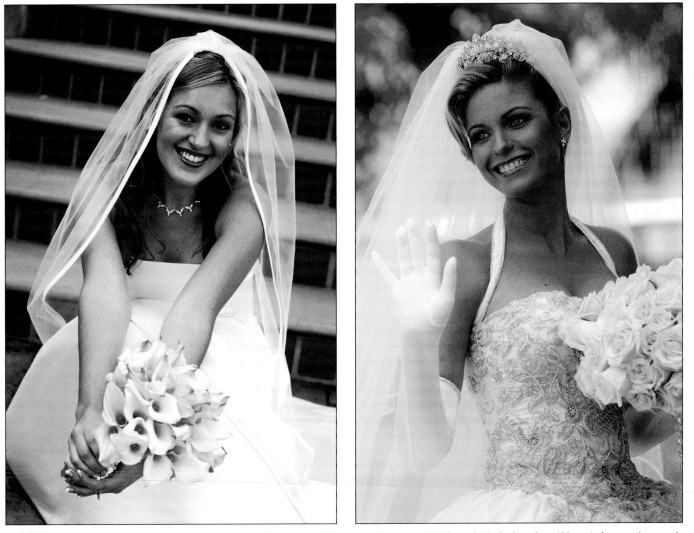

LEFT—*This is an uncharacteristic pose in that the hands are extended toward the camera. With a relatively short lens (50mm) they attain prominence by proximity. However, because the overall pose and attitude of the bride is relaxed and fun, it is a highly effective portrait. Also notice that the hands are indeed posed to reveal the ring and "French tips"—and they are at an angle so that the edges are visible. Photograph by Becker.*
RIGHT—*Charles Maring created this excellent bridal portrait. The lines of the shoulders are at angles to the camera and the head is tilted toward the near shoulder in a "feminine" pose. Her weight is on her back foot for perfect posture and an elegant line through the composition.*

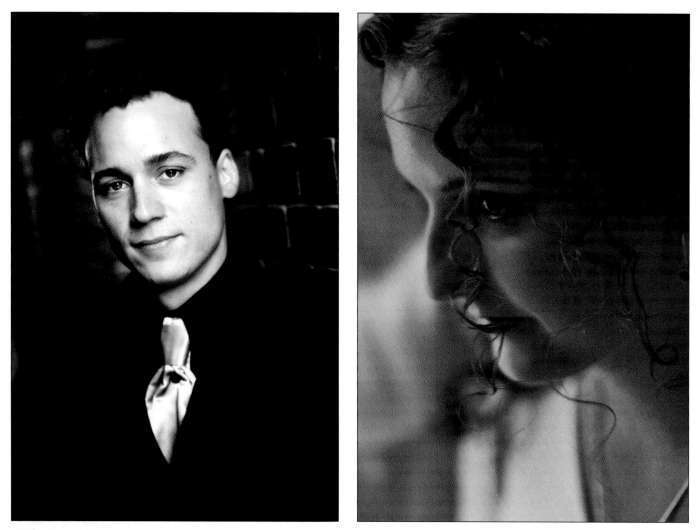

LEFT—*Marcus Bell created this handsome portrait of the groom using available light from both directions. The backlight creates delicate highlights on the forehead and cheekbone. Notice that the pose is in the seven-eighths view, where the far ear is just out of view of the camera lens. The lighting, for available light, is quite elegant.* RIGHT—*The profile is one of the most fascinating and dramatic posing positions. Here Becky Burgin front-focused so that the near eye and ringlets of the bride's hair are in focus but everything past the bridge of the nose is pleasantly soft. The result is a telling and insightful portrait of the bride. Notice that the camera angle is above eye height, accentuating the bride's beautiful hair.*

way into the pocket puts a space between the elbow and the torso. This creates a flattering line and helps to prevent your subject(s) from looking overly "thick."

With a standing woman, one hand on a hip and the other at her side is a good standard pose. Don't let the free hand dangle, but rather have her twist the hand so that the outer edge shows to the camera. Always create a break in the wrist for a more dynamic line.

As generalizations go, the hands of a woman should have grace, and the hands of a man should have strength.

■ WEIGHT ON THE BACK FOOT

The basic rule of thumb is that no one should be standing at attention with both feet together. Instead, the shoulders should be at a slight angle to the camera, as previously

described, and the front foot should be brought forward slightly. The subject's weight should always be on the back foot. This has the effect of creating a bend in the front knee and dropping the rear shoulder to a position lower than the forward one. When used in full-length bridal portraits, a bent forward knee will lend an elegant shape to the dress. With one statement—"Weight on your back foot, please"—you can introduce a series of dynamic lines into an otherwise average composition

■ JOINTS

Never frame the portrait so that a joint—an elbow, knee, or ankle, for example—is cut off at the edge of the frame. This sometimes happens when a portrait is cropped. Instead, crop between joints, at mid-thigh or mid-calf, for

example. When you break the composition at a joint, it produces a disquieting feeling.

■ FACE POSITIONS

As mentioned previously, the head should be at a different angle than the shoulders. There are three basic head positions (relative to the camera) found in portraiture.

The Seven-Eighths View. If you consider the full face as a head-on "mug shot," then the seven-eighths view is when the subject's face is turned just slightly away from the camera. In other words, you will see a little more of one side of the subject's face. You will still see the subject's far ear in a seven-eighths view.

The Three-Quarters View. This is when the far ear is hidden from camera and more of one side of the face is visible. With this pose, the far eye will appear smaller because it is farther away from the camera than the near eye. Because of this, it is important when posing subjects in a three-quarters view to position them so that the subject's smallest eye (people usually have one eye that is slightly smaller than the other) is closest to the camera. This way, the perspective makes both eyes appear to be the same size in the photograph. This may not be something you have time to do when posing groups of people at a wedding, but when photographing the bride and groom, care should be taken to notice these subtleties.

Profile. In the profile, the head is turned almost 90 degrees to the camera. Only one eye is visible. When posing your subjects in profile, have them turn their heads gradually away from the camera position until the far eye and eyelashes just disappear.

Knowing the different head positions will help you provide variety and flow to your images, and you can incorporate the different head positions within group portraits. You may, at times, end up using all three head positions in a single group pose. The more people in the group, the more likely that becomes.

■ THE EYES

The best way to keep your subjects' eyes active and alive is to engage the person in conversation. Look at the person while you are setting up and try to find a common frame of interest. Inquire about the other person—almost everyone loves to talk about themselves! If the person does not look at you when you are talking, he or she is either uncomfortable or shy. In either case, you have to work to relax the person. Try a variety of conversational topics until you find one he or she warms to and then pursue it. As you gain their interest, you will take the subject's mind off of the photograph.

The direction the person is looking is important. Start the formal session by having the person look at you. Using a cable release with the camera tripod-mounted forces you to become the host and allows you to physically hold the subject's gaze. It is a good idea to shoot a few frames of the person looking directly into the camera, but most people will appreciate some variety.

One of the best ways to enliven your subject's eyes is to tell an amusing story. If they enjoy it, their eyes will smile—a truly endearing expression.

This is an incredible portrait by Erika Burgin. The pose, which uses a three-quarters view of the bride's face and frontal lighting from camera right, produces beautiful roundness and sculpting. The bride's eyes, which are turned away from the light, are mysterious. This is a beautiful example of split toning, where the highlights have a rich warm tint and the shadows have a cool blue-gray tint. This is an award-winning image. Fine art print made by Robert Cavalli.

Tom Muñoz has a great deal of respect for the bride and for the wedding as an event. "When we're photographing the bride, we treat her like she's a princess. There are no unattractive brides," Muñoz says sincerely, "some merely reflect light differently than others. Besides knowing how to pose a woman, one of the biggest things that changes her posture and expression is what you tell her. "We're not dealing with models," Muñoz stresses, "and as stupid as it sounds, telling a bride how beautiful she looks changes how she photographs and how she perceives being photographed. It becomes a positive experience rather than a time-consuming, annoying one. Same thing goes for the groom," Tom states. "His chest pumps up, he arches his back; they fall right into it. It's very cute."

Tom Muñoz current style of bridal portraiture is a lot looser than when he photographed with film only. He is all digital now, and customarily shoots at wider apertures using available light. This image was shot with a Canon EOS 1DS Mark II and a 90mm lens at f/4. Note the wonderful "old school" pose of the bride.

■ THE SMILE

One of the easiest ways to produce a natural smile is to praise your subject. Tell her how good she looks and how much you like a certain feature of hers—her eyes, her hair style, etc. Simply saying "Smile!" will produce a lifeless expression. By sincere confidence building and flattery, you will get the person to smile naturally and sincerely and their eyes will be engaged by what you are saying.

Remind the subject to moisten her lips periodically. This makes the lips sparkle in the finished portrait, as the moisture produces tiny specular highlights on the lips.

Pay close attention to your subject's mouth, making sure there is no tension in the muscles around it, since this will give the portrait an unnatural, posed look. Again, an air of relaxation best relieves tension, so talk to the person to take his or her mind off the photo.

One of the best photographers I've ever seen at "enlivening" total strangers is Ken Sklute. I've looked at literally hundreds of his wedding images and in almost every photograph, the people are happy and relaxed in a natural, typical way. Nothing ever looks posed in his photography—it's almost as if he happened by this beautiful picture and snapped the shutter. One of the ways he gets people "under his spell" is his enthusiasm for the people and for the excitement of the day. His enthusiasm is contagious and his affability translates into attentive subjects.

Another gifted wedding photographer is a Southern Californian who goes by his last name only: Becker. He is a truly funny man and he always seems to find a way to crack up his subjects.

While it helps any wedding photographer to be able to relate well to people, those with special gifts—good storytellers or people, like Becker, who have really good senses of humor—should use those skills to get the most from their clients.

■ CAMERA HEIGHT

When photographing people with average features, there are a few general rules that govern camera height in relation to the subject. These rules will produce normal (not exaggerated) perspective.

For head-and-shoulders portraits, the camera height should be the same height as the tip of the subject's nose. For three-quarter-length portraits, the camera should be at a height midway between the subject's waist and neck. In full-length portraits, the camera should be the same height as the subject's waist. In each case, the camera is at a height that divides the subject into two equal halves in the viewfinder. This is so that the features above and below the lens/subject axis will be the same distance from the lens, and thus recede equally for "normal" perspective.

When the camera is raised or lowered, the perspective (the size relationship between parts of the photo) changes. This is particularly exaggerated with wide-angle lenses. By controlling perspective, you can alter the subject's traits.

By raising the camera height in a three-quarter- or full-length portrait, you enlarge the head-and-shoulders region of the subject, but slim the hips and legs. Conversely, if you lower the camera, you reduce the size of the head, but enlarge the size of the legs and thighs. Tilting the camera down when raising the camera (and up when lowering it) increases these effects. The closer the camera is to the subject, the more pronounced the changes are. If, after you adjust camera height for a desired effect, you find that there is no change, move the camera in closer to the subject and observe the effect again.

When you raise or lower the camera in a head-and-shoulders portrait, the effects are even more dramatic. Raising or lowering the camera above or below nose height is a prime means of correcting facial irregularities. Raising the camera height lengthens the nose, narrows the chin and jaw line and broadens the forehead. Lowering camera height shortens the nose, de-emphasizes the forehead and widens the jaw line, while accentuating the chin.

While there is little time for many such corrections on the wedding day, knowing these rules and introducing them into the way you photograph people will help make many of these techniques second nature.

■ EYEGLASSES

Eyeglasses can present major problems on the wedding day, especially in group pictures. When working with bounce flash or when using flash-fill outdoors, you can pick up specular reflections on eyeglasses and not even notice the problem until later. The best bet is to ask the person to remove their glasses—but don't be surprised if they decline. Many people wear glasses all the time and they may feel extremely self-conscious without them.

One rule of light to remember when you encounter eyeglasses is this: the angle of incidence equals the angle of reflection. Light directed head-on toward a group will more than likely produce an unwanted eyeglass reflection. Instead, move the main light to the side and raise it so that the angle of reflection is directed away from the camera lens. Any fill light should be adjusted laterally away from the camera until its reflection disappears. If you cannot eliminate the fill light's reflection, try bouncing the fill light off the ceiling. Another trick is to ask the person to tilt his or her glasses down slightly. This should solve most problems with reflections.

When your subject is wearing thick glasses, it is not unusual for the eyes to record darker than the rest of the face.

The colors and contrast are loud and brassy in this cross-processed David De Dios bridal "formal" made in a deserted swimming pool. All of loud color contrasts with the sweet simplicity of the pose. Notice that with all good full-length posing, a triangle base is formed by the basic arrangement of the forms.

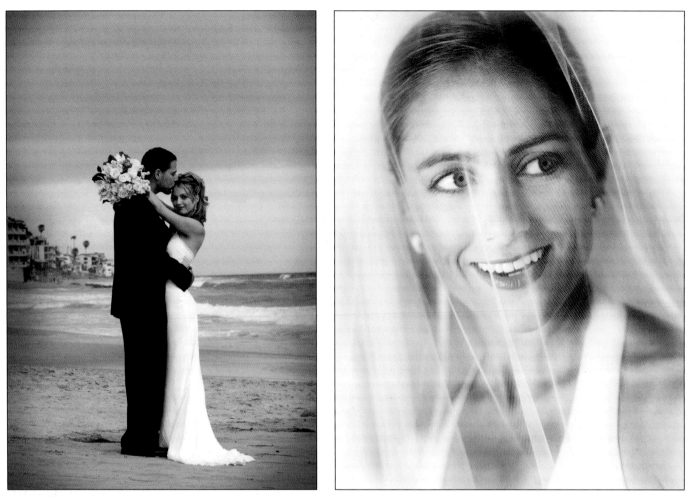

LEFT—*There is something special about a portrait where one person turns back to the camera. The wry grin tells you she is very happy. The tonality is made richer by the use of a vignette added in Photoshop. Photograph by Joe Photo.* RIGHT—*Charles Maring created this head-and-shoulders portrait using a Nikon D1X and 85mm f/1.4 lens. The exposure was ¹/₂₅₀ second at f/1.4 and the focus was on her eyes, letting almost everything else fall out of focus. Notice how many diagonal lines are introduced by the angle of her shoulders and the tilt of her head and veil.*

If this happens, there is nothing you can do about it during the photography, but the eyeglasses can be dodged during printing or in Photoshop to restore the same print density as the rest of the face.

Any type of "photo-gray" or self-adjusting lenses should be avoided. Outdoors, they will photograph like sunglasses. Indoors, under normal room light, they won't present much of a problem. A trick is to have the person keep their glasses in a pocket until you are ready to shoot. This will keep the lenses from getting dark prematurely from the ambient or shooting lights.

■ PORTRAIT LENGTHS
Three-Quarter and Full-Length Poses. When you employ a three-quarter-length pose (showing the subject from the head to below the waist) or a full-length pose (showing the subject from head to toe), you have more of the body to contend with.

As noted above, it is important to angle the person to the lens. Don't photograph the person head-on, as this adds mass to the body. Also, your subject's weight should be on the back foot rather than distributed evenly on both feet—or worse yet, on the front foot. There should be a slight bend in the front knee if the person is standing. This helps break up the static line of a straight leg. The feet should also be at an angle to the camera; feet look stumpy when shot straight on.

When the subject is sitting, a cross-legged pose is effective. Have the top leg facing at an angle and not directly into the lens. When posing a woman who is seated, have her tuck the calf of the leg closest to the camera in behind the leg farthest from the camera. This reduces the size of the calves, since the leg that is farther from the camera becomes more prominent. Whenever possible, have a slight space between the subject's leg and the chair, as this will slim down thighs and calves.

Head-and-Shoulder Portraits. With close-up portraits of one or more people, it is important to tilt the head and retain good head-and-shoulder axis positioning. The shoulders should be at an angle to the camera lens and the angle of the person's head should be at a slightly different angle. Often, head-and-shoulders portraits are of the face alone—as in a beauty shot. In such an image, it is important to have a dynamic element, such as a diagonal line, which will create visual interest.

In a head-and-shoulders portrait, all of your camera technique will be evident, so focus is critical (start with the eyes) and lighting must be flawless. Use changes in camera height to correct any irregularities (see page 53). Don't be afraid to fill the frame with the bride or bride and groom's faces. They will never look as good again as they do on their wedding day!

■ GROUP PORTRAITS

Noted group portrait specialist Robert Love has a simple rule for photographing groups: each person must look great—as if the portrait were being made solely of that individual. Achieving this ideal means calling on both compositional and posing skills.

Form, Line, and Direction. Designing groups depends on your ability to manage the implied and inferred lines and shapes within a composition. Line is an artistic element used to create visual motion within the image. It may be implied by the arrangement of the group, or inferred, by grouping various elements within the scene. It might also be literal, as well, like a fallen tree used as a posing bench that runs diagonally through the composition.

Shapes are groupings of like elements: diamond shapes, circles, pyramids, etc. It is usually a collection of faces that

Norman Phillips created this romantic pose by having the couple lean in to kiss. The connection is intimate and the moment is memorable. Note that each person's shoulders are angled in toward each other.

back. This promotes good posture and narrows the lines of the waist and hips for both men and women.

With a couple, seat one person (usually the man) and position the other person close to or on the arm of the chair, leaning on the far armrest. This puts their faces in close proximity but at different heights. A variation of this is to have the woman seated and the man standing. If their heads are far apart, you should pull back and make the portrait full-length.

Couples. The simplest of groups is two people. Whether it's a bride and groom, mom and dad, or the best man and maid of honor, the basic building blocks call for one person slightly higher than the other (note how this objective is achieved using an armchair in the section above). A good starting point is to position the mouth of the lower person even with the forehead of the higher person. Many photographers recommend this "mouth to eyes" strategy as the ideal starting point.

form the pattern. They are used to produce pleasing forms that guide the eye through the composition. The more you learn to recognize these elements, the more they will become an integral part of your compositions.

These are the keys to making a dynamic group portrait. The goal is to move the viewer's eye playfully and rhythmically through the photograph. The opposite of a dynamic image is a static one, where no motion or direction is found, and the viewer simply "recognizes" rather than enjoys all of the elements in the photograph.

Enter the Armchair. An armchair is the perfect posing device for photographing from three to eight people. The chair is best positioned at about 30 to 45 degrees to the camera. Regardless of who will occupy the seat, they should be seated laterally across the edge of the seat cushion so that all of their weight does not rest on the chair

Although they can be posed in parallel position, a more interesting dynamic with two people can be achieved by having them pose at 45-degree angles to each other, so their shoulders face in toward one another. With this pose you can create a number of variations by moving them closer or farther apart.

Another intimate pose for two is to have two profiles facing each other. One should still be higher than the other, as this allows you to create an implied diagonal between their eyes, which also gives the portrait direction.

Since this type of image is fairly close up, make sure that the frontal planes of the subjects' faces are roughly parallel so that you can hold focus on both faces.

Adding a Third Person. A group portrait of three is still small and intimate. It lends itself well to a triangle-

shaped or inverted triangle composition, both of which are pleasing to the eye. Don't simply adjust the height of the faces so that each is at a different level; turn the shoulders of those at either end of the group in toward the central person as a means of looping the group together.

Once you add a third person, you will notice the interplay of lines and shapes inherent in group design. As an exercise, mentally plot the implied line that goes through the shoulders or faces of the three people in the group. If the line is sharp or jagged, try adjusting the composition so that the line is more flowing, with gentler edges.

Try different configurations. For example, create a diagonal line with the faces at different heights and all the people in the group touching. It's a simple yet pleasing design. The graphic power of a well-defined diagonal line in a composition will compel the viewer to keep looking at the image. Adjust the group by having those at the ends of the diagonal tilt their heads slightly in toward the center of the composition.

Try a bird's-eye view. Cluster the group together, grab a stepladder or other high vantage point, and you've got a lovely variation on the three-person group. It's what photographer Norman Phillips calls "a bouquet." For a simple variation, have the people turn their backs to each other, so they are all facing out of the triangle.

Adding a Fourth and Fifth Person. This is when things really get interesting. As you photograph more group portraits, you will find that even numbers of people are harder to pose than odd. Three, five, seven, or nine people seem much easier to photograph than similarly sized groups of an even number. The reason is that the eye and brain tend to accept the disorder of odd-numbered objects more readily than even-numbered objects.

Ken Sklute is a master at large wedding groups. Here he has used two arm chairs and a lovely garden to create this elegant group portrait. Notice that the posing is impeccable—shoulders turned away from the lens axis, hands either hidden or well posed, nice expressions, and great lighting.

As you add more people to a group, remember to do everything you can to keep the film plane parallel to the plane of the group's faces in order to ensure that everyone in the photograph is sharply focused.

With four people, you can simply add a person to the existing poses of three described above—with the following advice in mind. First, be sure to keep the eye height of the fourth person different from any of the others in the group. Second, be aware that you are now forming shapes within your composition. Think in terms of pyramids, extended triangles, diamonds, and curved lines. Finally, be aware of lines, shapes, and direction as you build your groups.

An excellent pose for four people is the sweeping curve of three people with the fourth person added below and between the first and second person in the group.

The fourth person can also be positioned slightly outside the group for accent, without necessarily disrupting the harmony of the rest of the group.

When Monte Zucker has to pose four people, he sometimes prefers to play off of the symmetry of the even number of people. He'll break the rules and he'll seat two and

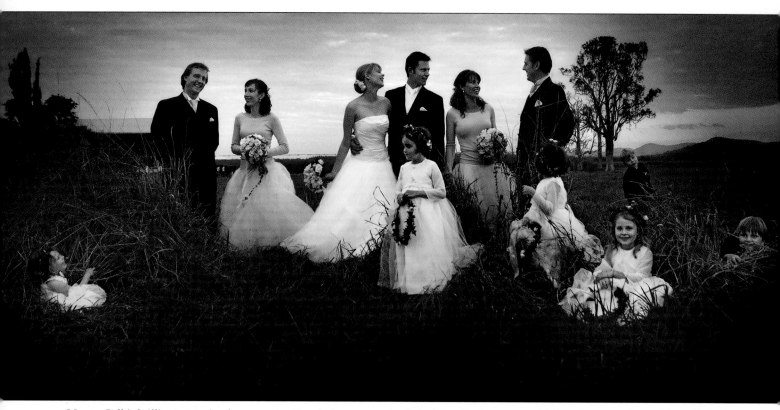

Marcus Bell is brilliant at posing large groups. Here he has composed a lyrical free-flowing group with lots of spontaneity and fun. Notice how the "end pieces" of the group, the two kids on either edge of the composition, help keep your eye returning to the central members.

stand two and, with heads close together, making the line of the eyes parallel with both the top two and bottom two. Strangely, this seems to work, without the monotony one would expect.

Bigger Groups. Compositions will always look better if the base is wider than the top, so the final person in a large group should elongate the bottom of the group.

Each implied line and shape in the photograph should be designed by you and should be intentional. If the arrangement isn't logical (i.e., the line or shape doesn't make sense visually), then move people around and start again.

Try to coax "S" shapes and "Z" shapes out of your compositions. They form the most pleasing shapes to the eye and will hold a viewer's eye within the borders of the print. Remember that the diagonal line also has a great deal of visual power in an image and is one of the most potent design tools at your disposal.

The use of different levels creates a sense of visual interest and lets the viewer's eye bounce from one face to another (as long as there is a logical and pleasing flow to the arrangement). The placement of faces, not bodies, dictates how pleasing and effective a composition will be.

When adding a sixth or an eighth person to the group, the group should still retain an asymmetrical look for best effect. This is best accomplished by creating elongated, sweeping lines and using the increased space to slot in extra people.

As your groups get bigger, keep your depth of field under control. The stepladder is an invaluable tool for larger groups, because it lets you elevate the camera position and keep the camera back (or film plane) parallel to the group for optimal depth of field. Another trick is to have the last row in a group lean in while having the first row lean back, thus creating a shallower subject plane, making it easier to hold the focus across the entire group.

As your grouping exceeds six people, you should start to base the composition on linked shapes—like linked circles or triangles. What makes combined shapes work well is to turn them toward the center. Such subtleties unify a composition and make combining visually appealing design shapes more orderly.

ecause the contemporary wedding encompasses so many different types of photography, it is essential for wedding photographers to be well versed in all of these disciplines. However, no pictures are more important to the bride and groom than the engagement photo and formal portraits. The engagement portrait is often used in newspapers and local magazines to announce the couple's wedding day, and it is a portrait that can enrich the wedding photogra-

pher's profits significantly. These portraits may be (and usually are) made in advance of the wedding day, providing the much needed time to get something really spectacular. An additional benefit of a pre-wedding session is that, by the wedding day, the couple and the photographer are familiar with each other before the big day.

The formal portraits of the bride and groom together, and of each alone, are also significant images that demand special time allotted to them and an understanding of for-

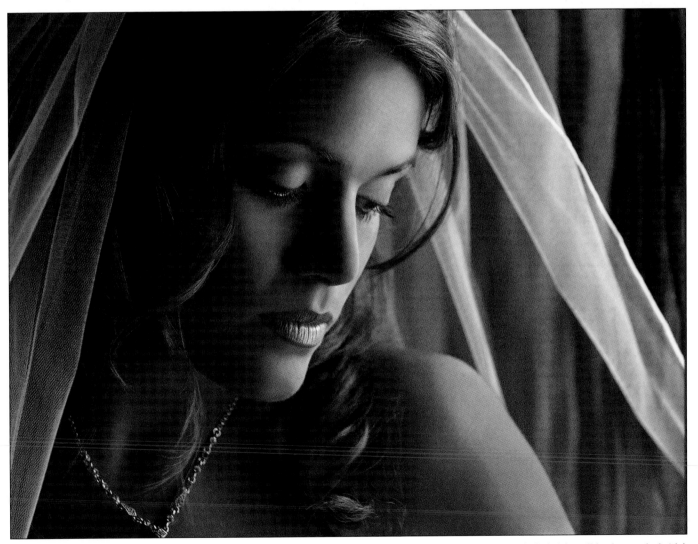

The main light defines the lighting pattern on the face. Here, the main light is actually sunlight reflected off a light brick wall back onto the bride's face. No fill source was used to keep the lighting ratio strong. Photograph by Fran Reisner.

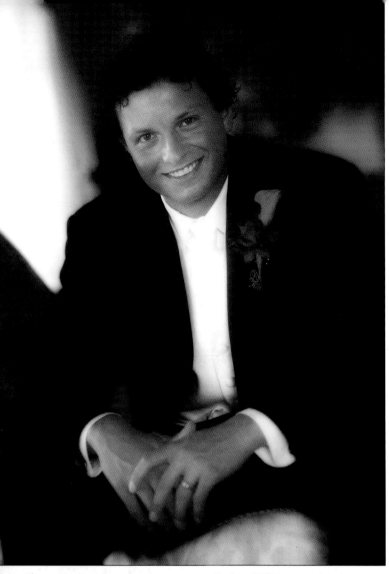

On location, sometimes you can find a fill light, sometimes one must manufacture it. Here, Joe Photo needed a fill source to counteract the strong window light. He used on-camera strobe bounced into a side wall to fill shadow side of the face.

mal posing and lighting techniques. Often the photographer will arrange to make the formal portraits on the day of the wedding, but several hours before the day's schedule commences. Couples relish the alone time and it is another good opportunity for the photographer to break the ice with the couple.

Because of the importance of these images, it is essential that the wedding photographer be skilled in studio portraiture, which is quite different but related to the techniques normally employed on the wedding day. The key to understanding good lighting and creating it in your photographs is to understand the concept of "single-light" lighting. The sun is the primary light source in all of nature, and all lighting emanates from the sun. While there may be secondary light sources in nature, they are all subservient to the sun. So it is in the studio.

Most photographers opt for studio strobes—either self-contained monolight-type strobes or systems using a single power pack into which all lights are plugged. Some use a combination of the two types. A full system of reflectors and diffusers is required with any studio lighting system.

■ THE FIVE LIGHTS

Basic portrait lighting can be done with as few as two lights, but to get the full effect, five lights with stands and parabolic reflectors are often used. The five lights are: the main light; the fill light; the hair light; the background light; and the optional kicker, a backlight used for shoulder or torso separation.

Main and Fill Lights. The main and fill lights should be high-intensity light sources. These may be used in parabolic reflectors that are silver-coated on the inside to reflect the maximum amount of light. However, most photographers don't use parabolic reflectors anymore. Instead, they opt to use diffused key- and fill-light sources. If using diffusion, either umbrellas or softboxes, each light assembly should be supported on its own sturdy light stand.

The main light, if undiffused, should have barn doors affixed. These are black, metallic, adjustable flaps that can be opened or closed to control the width of the beam of the light. Barn doors ensure that you light only the parts of the portrait you want lighted. They also keep stray, flare-causing light off the camera lens.

The fill light, if in a reflector, should have its own diffuser, which is nothing more than a piece of frosted plastic or acetate in a screen that mounts over the reflector. The fill light should also have barn doors attached. If using a diffused light source, such as an umbrella or softbox for a fill light, be sure that you do not spill light into unwanted areas of the scene, such as the background or onto the camera's lens. All lights, whether in reflectors or diffusers, should be feathered by aiming the core of light slightly away from the subject, employing the more useful edge of the beam of light.

Care must be taken when placing the fill light. If it is too close to the subject, it will produce its own set of specular highlights that show up in the shadow area of the face, making the skin appear excessively oily. To solve the problem, move the camera and light back slightly or move the fill light laterally away from the camera slightly. You might also feather the light into the camera a bit. This method of

limiting the fill light is preferable to closing down the barn doors to lower the intensity of the fill light.

The fill light often creates a second set of catchlights (small specular highlights) in the subject's eyes. This gives the subject a directionless gaze, so the effect is usually removed later in retouching. When using a large diffused fill light, there is usually not a problem with dual catchlights. Instead, the fill produces a large, milky highlight that is much less objectionable.

Hair Light. The hair light is a small light. Usually it takes a scaled-down reflector with barn doors for control. Barn doors are a necessity, since this light is placed behind the subject to illuminate the hair; without barn doors, the light will cause lens flare. The hair light is normally adjusted to a reduced power setting, because hair lights are almost always used undiffused.

Background Light. The background light is also a low output light. It is used to illuminate the background so that the subject and background will separate tonally. The background light is usually used on a small stand placed directly behind the subject, out of view of the camera lens. It can also be placed on a higher stand or boom and directed onto the background from either side of the set.

Kicker. Kickers are optional lights that are used in much the same way as hair lights. These add highlights to the sides of the face or body to increase the feeling of depth and richness in a portrait. Because they are used behind the subject, they produce highlights with great brilliance, as the light just glances off the skin or clothing. Since kickers are set behind the subject, barn doors should be used to control the light.

Tom Muñoz loved this location. The alcove blocked the overhead light and gave him a natural portrait light. The fill light was created by a diffused flash aimed at the bride (several stops less than the daylight exposure). The flash is only meant to fill the scene, lightening the shadows created by the main light. This image was photographed in RAW mode so that Tom could adjust the color balance and contrast which were dictated by the stucco walls.

■ BROAD AND SHORT LIGHTING

There are two basic types of portrait lighting. Broad lighting means that the main light is illuminating the side of the face turned toward the camera. Broad lighting is used less frequently than short lighting because it flattens and de-emphasizes facial contours. It is often used to widen a thin or long face.

Short lighting means that the main light is illuminating the side of the face that is turned away from the camera. Short lighting emphasizes facial contours and can be used to narrow a round or wide face. When used with a weak fill light, short lighting produces a dramatic lighting with bold highlights and deep shadows.

■ BASIC LIGHTING SETUPS

Paramount Lighting. Paramount lighting, sometimes called butterfly lighting or glamour lighting, is a lighting

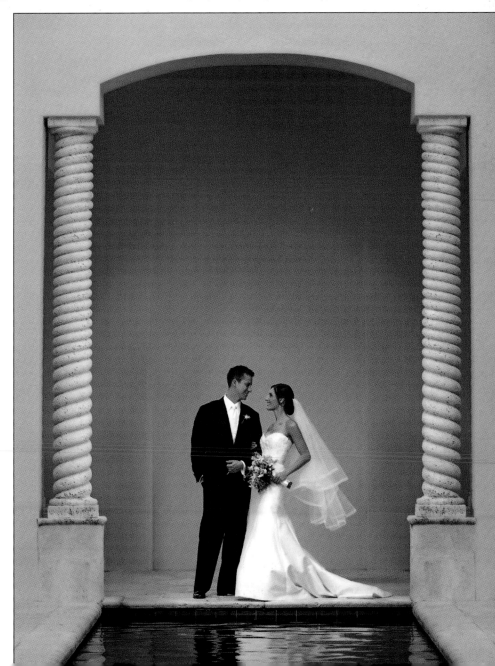

LEFT—*The natural lighting pattern is overhead and from behind. Notice how the groom's hair is expertly lit as the overhead main light is acting like a hair light. In order to manage the light on his face, photographer Joe Photo fired a flash at several stops less than the daylight reading to fill in both sides of the face for a detailed exposure. Notice that because the secondary light is subtle and much weaker than the daylight, the tell-tale double catchlights are not visible in the subject's eyes.* RIGHT—*Fran Reisner created this delicate bridal formal in her studio using north light from a bay window as the main light. The light is soft and wraps around the bride, requiring no fill except the light bouncing off the light-colored interior walls of the studio. Fran worked the image in Painter to create the brush strokes, stippled background, and details.* FACING PAGE—*In big cities, the light is overhead in nature because it filters down between the tall buildings. Joe Photo harnessed this light outside Tiffany's and produced a near-Paramount lighting pattern without fill.*

pattern that produces a symmetrical, butterfly-shaped shadow directly beneath the subject's nose. It emphasizes cheekbones and good skin. It is rarely used on men because it hollows out the cheeks and eye sockets too much.

For this style, the main light is placed high and directly in front of the subject's face, parallel to the vertical line of the subject's nose. Since the light must be high and close to the subject to produce the wanted butterfly shadow, it should not be used on women with deep eye sockets, or very little light will illuminate the eyes. The fill light is placed at the subject's head height directly under the main light. Since both the main and fill lights are on the same side of the camera, a reflector must be used opposite these lights and in close to the subject to fill in the deep shadows on the neck and shaded cheek.

The hair light, which is always used opposite the main light, should light the hair only and not skim onto the face of the subject. The background light, used low and behind the subject, should form a semi-circle of illumination on the seamless background (if using one) so that the tone

of the background grows gradually darker toward the edges of the frame.

Loop Lighting. Loop lighting is a minor variation of Paramount lighting. The main light is lowered and moved more to the side of the subject so that the shadow under the nose becomes a small loop on the shadow side of the face. This is one of the more commonly used lighting setups and is ideal for people with average, oval-shaped faces.

The fill light is moved to the opposite side of the camera from the main light in loop lighting. It is used close to the camera lens. In order to maintain the one-light character of the portrait, it is important that the fill light not cast a shadow of its own. To determine if the fill light is doing its job, you need to evaluate it from the camera position. Check to see if the fill light is casting a shadow of its own by looking through the viewfinder.

In loop lighting, the hair light and background lights are used the same way they are in Paramount lighting.

Rembrandt Lighting. Rembrandt or 45-degree lighting is characterized by a small, triangular highlight on the

LEFT—*This is an interesting lighting scheme created by Tibor Imely. The bride is backlit, as if she were being posed in profile. There is very little fill light, which keeps the lighting ratio high, however there is good detail in the dress and in her neck area. This is caused by the soft nature of the overhead backlight. A background light can be seen illuminating the area behind the bride and a kicker is used from the opposite side and behind the bride to illuminate the veil.* RIGHT—*Mauricio Donelli created this beautiful formal by stretching the veil out as a foreground scrim to both shoot through and to soften the lighting on her face. He used a softbox close to the bride and directly in front of her for an elegant wraparound light. He used no fill light. Donelli often travels on location to weddings outfitted with portable studio strobe for just these occasions.*

shadowed cheek of the subject. It takes its name from the famous Dutch painter who used window light to illuminate his subjects. This lighting is dramatic and more often used with masculine subjects. Rembrandt lighting is often used with a weak fill light to accentuate the shadow-side highlight.

The main light is moved lower and farther to the side than in loop and Paramount lighting. In fact, the main light almost comes from the subject's side, depending on how far his or her head is turned away from the camera.

The fill light is used in the same manner as it is for loop lighting. The hair light, however, is often used a little closer to the subject for more brilliant highlights in the hair. The background light is in the standard position.

With Rembrandt lighting, kickers are often used to delineate the sides of the face and/or dark clothing. As with all front-facing lights, avoid shining them directly into the

lens. The best way to check is to place your hand between the subject and the camera on the axis of the kicker. If your hand casts a shadow on the lens, then the kicker is shining directly into the lens and should be adjusted.

Split Lighting. Split lighting is when the main light illuminates only half the face. It is an ideal slimming light. It can also be used with a weak fill to hide facial irregularities. Split lighting can also be used with no fill light for dramatic effect.

In split lighting, the main light is moved farther to the side of the subject and lower. In some cases, the main light may be slightly behind the subject, depending on how far the subject is turned from the camera. The fill light, hair light, and background light are used normally for split lighting.

Profile or Rim Lighting. Profile or rim lighting is used when the subject's head is turned 90 degrees away

from the camera lens. It is a dramatic style of lighting used to accent elegant features. It is used less frequently now than in the past, but it is still a stylish type of lighting.

In rim lighting, the main light is placed behind the subject so that it illuminates the profile of the subject and leaves a polished highlight along the edge of the face. The main light will also highlight the hair and neck of the subject. Care should be taken so that the accent of the light is centered on the face and not so much on the hair or neck.

The fill light is moved to the same side of the camera as the main light and a reflector is used for fill. An optional hair light can be used on the opposite side of the main light for better tonal separation of the hair from the background. The background light is used normally.

■ AVOID OVERLIGHTING

In setting the lights, it is important that you position the lights gradually, studying their effect as you use more and more light aimed at the subject. If you merely point the light directly at the subject, you will probably overlight the person, producing pasty highlights with no detail.

Adjust the lights carefully, and observe the effects from the camera position. Instead of aiming the light so that the core of light strikes the subject, feather the light so that you employ the edge of the light to light the subject. The trick is to add brilliance to your highlights. This is achieved by the use of careful lighting. The highlights, when brilliant, have minute specular (pure white) highlights within the main highlight. This further enhances the illusion of great depth in a portrait.

Sometimes feathering won't make the skin "pop" (show highlight brilliance) and you'll have to make a lateral adjustment to the light or move it back from its current position. A good starting position for your main light is 8–12 feet from the subject.

■ LIGHTING RATIOS

The term "lighting ratio" is used to describe the difference in intensity between the shadow and highlight side of the face. It is expressed numerically. A 3:1 ratio, for example, means that the highlight side of the face has three units of light falling on it, while the shadow side has only one unit of light falling on it. Ratios are useful because they determine how much local contrast there will be in the portrait. They do not determine the overall contrast of the scene; rather, lighting ratios determine how much contrast you will give to the lighting of the subject(s).

As a reflection of the difference in intensity between the main light and the fill light, the ratio is an indication of how much shadow detail you will have in the portrait. Because the fill light controls the degree to which the shadows are illuminated, it is important to keep the lighting ratio fairly constant. A desirable ratio for outdoor group portraits in color is 3:1; it is ideal for average faces.

Determining Lighting Ratios. There is considerable debate and confusion over the calculation of lighting ratios. This is principally because you have two systems at work, one arithmetical and one logarithmic. F-stops are in themselves a ratio between the size of the lens aperture and the focal length of the lens, which is why they are expressed as f/2.8, for example. The difference between one f-stop and the next full f-stop is either half the light or double the light. F/8 lets in twice as much light through a lens as f/11 and half as much light as f/5.6.

However, when we talk about light ratios, each full stop is equal to *two* units of light. Therefore, each half stop is equal to one unit of light, and each quarter stop is equivalent to half a unit of light. This is, by necessity, arbitrary, but it is a practical system for determining the difference between the highlight and shadow sides of the face.

The groom's white tux acts as the perfect high-key fill, illuminating all of the shadows on the bride's face and in her eyes, creating a very low lighting ratio. Photograph by Bruno Mayor.

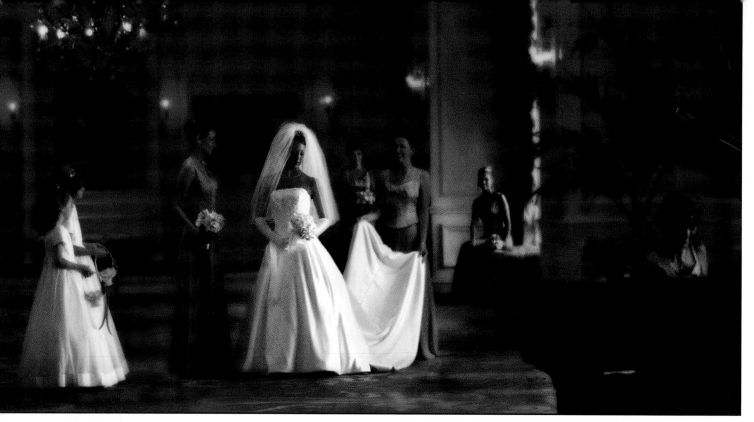

Al Gordon created this lighting masterpiece on location. The scene is lit with mixed lighting, with a predominance of window light and tungsten lighting from the candelabras. Al picked that spot for the bride because the window light was about a stop brighter—a result of that window being larger than the rest. His assistant held a Monte Illuminator (a silver reflector) to camera left to kick in a little fill light and open up the folds of the dress. Scenes like this require very careful metering and white balance settings. Ironically, he had a softbox on hand that he did not use because the light was perfect.

In lighting of all types, from portraits made in the sunlight to portraits made in the studio, the fill light is always calculated as one unit of light because it strikes both the highlight and shadow sides of the face. The amount of light from the main light, which strikes only the highlight side of the face, is added to that number. For example, imagine you are photographing a small group of three and the main light is one stop greater than the fill light. These two lights are metered independently and separately. The one unit of the fill (because it illuminates both the shadow and highlight sides of the faces) is added to the two units of the main light, thus producing a 3:1 ratio.

Lighting Ratios and Their Unique Personalities. A 2:1 ratio is the lowest lighting ratio you should employ. It shows only minimal roundness in the face and is most desirable for high key-effects. High-key portraits are those with low lighting ratios, light tones, and usually a light background.

In a 2:1 lighting ratio, the main and fill light sources are the same intensity. One unit of light falls on the shadow and highlight sides of the face from the fill light, while an additional unit of light falls on the highlight side of the face from the main light—1+1=2:1. A 2:1 ratio will widen a narrow face and provide a flat rendering that lacks dimension.

A 3:1 lighting ratio is produced when the main light is one stop greater in intensity than the fill light. One unit of light falls on both sides of the face from the fill light, and two additional units of light fall on the highlight side of the face from the main light—2+1=3:1. This ratio is the most preferred for color and black & white because it will yield an exposure with excellent shadow and highlight detail. It shows good roundness in the face and is ideal for rendering average-shaped faces.

A 4:1 ratio (the main light is 1½ stops greater in intensity than the fill light—3+1=4:1) is used when a slimming or dramatic effect is desired. In this ratio, the shadow side of the face loses its slight glow and the accent of the portrait becomes the highlights. Ratios of 4:1 and higher are appropriate for low-key portraits, which are characterized by dark tones and, usually, a dark background.

A 5:1 ratio (the main light is two stops greater than the fill light—4+1=5:1) and higher is considered almost a high-contrast rendition. It is ideal for creating a dramatic effect and is often used in character studies. Shadow detail is minimal at the higher ratios and as a result, they are not

recommended unless your only concern in the image is highlight detail.

Most seasoned photographers have come to instantly recognize the subtle differences between lighting ratios. For instance, a photographer might recognize that with a given width of face, a 2:1 ratio does not provide enough dimension and a 4:1 ratio is too dramatic, thus he or she would strive for a 3:1 ratio. The differences between ratios are easy to observe with practice, as are the differences between fractional ratios like 3.5:1 or 4.5:1, which are reproduced by reducing or increasing the fill light amount in quarter-stop increments.

■ STUDIO LIGHTING ON LOCATION

One of the great advantages of working in a studio, as opposed to working on location, is that you can adjust the ambient light level of the studio to a low level, thus making the studio lighting stand out. On location, you must deal with the existing ambient light, which occurs at different levels than you would prescribe for the studio.

For example, imagine a courtyard where the main light is diffused daylight coming in through an archway or doorway. Your ambient fill level would be very low, because there are no auxiliary light sources nearby. Unless your goal was to produce high-contrast lighting (not that great for brides), you would need to raise the level of the ambient or fill light. This might be accomplished locally (i.e., on the subject via a silver reflector), or it might be accomplished more universally by raising the overall interior light level by using ceiling-bounce strobes.

This solution would allow you to shoot in a number of locations in the area, not just the one closest to the arch. The point of the example is that you must be able to react to the lighting situation with the tools at your disposal.

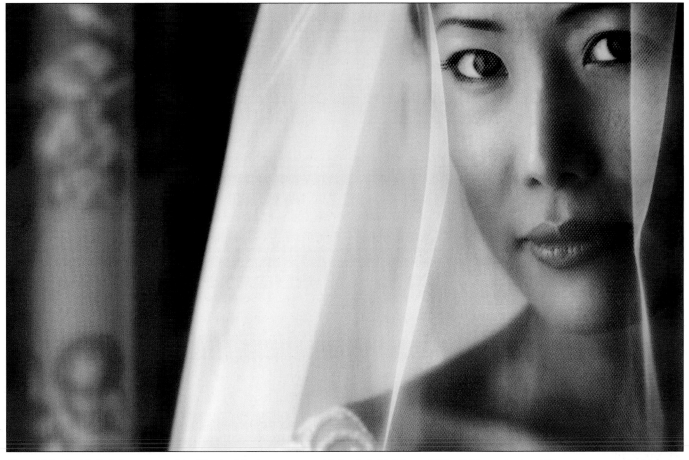

Beautiful soft side lighting was used by Charles Maring to create this lovely bridal formal. The light required no fill and even wrapped around the bride's nose to illuminate the shadow side of her face. The wedding photographer must not only be skilled at creating lighting, he or she must be equally skilled at finding good light.

7. OUTDOOR AND MIXED LIGHTING

Weddings are photographed in almost every kind of light you can imagine—open shade, bright sun, dusk, dim room light, and every combination in between. Savvy wedding photographers must feel at home in all these different situations and know how to get great pictures in them. Their ability to work with outdoor lighting is really what separates the good wedding photographers from the great ones. Learning to control, predict and alter these various types of light will allow the photographer to create great wedding pictures all day long.

■ AVAILABLE LIGHT

There are many occasions when the available light cannot really be improved. Such situations might arise from window light or open shade or sometimes the incandescent light found in a room. It is a matter of seeing light that is important. Learn to evaluate light levels as well as lighting patterns, both inside and out. The better you can see light, the more advanced and refined your photographs will be.

Direct Sunlight. Sometimes you are forced to photograph wedding groups in bright sunlight. While this is not the best scenario, it is still possible to get good results. Begin by turning your group so the direct sunlight is backlighting or rim lighting them. This negates the harshness of the light and prevents your subjects from squinting. Of course, you need to fill in the backlight with strobe or reflectors and be careful not to underexpose. It is best to give your exposure another ⅓ to ½ stop of exposure in backlit portraits in order to "open up" the skin tones.

Don't necessarily trust your in-camera meter in backlit situations. It will read the

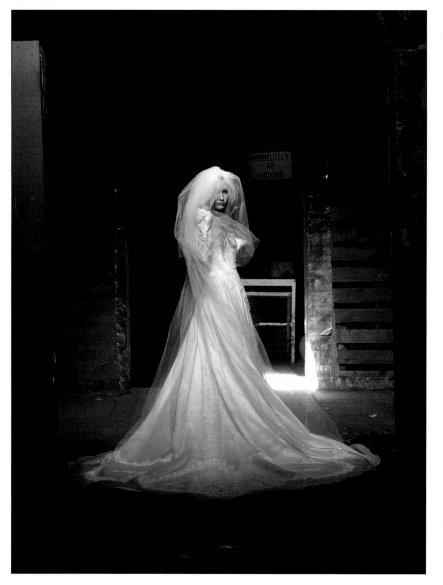

John Poppleton likes to photograph his brides in architecturally challenged areas. Here, a beautiful blond bride is lit with direct sunlight coming through a hole in the roof of a dilapidated warehouse. Notice that where the full strength of the sun falls behind the bride a hot spot is formed that is roughly three to four stops greater than the base exposure. The effect is not dissimilar to feathering a light source to take advantage of the more functional edge of the light, as opposed to its core.

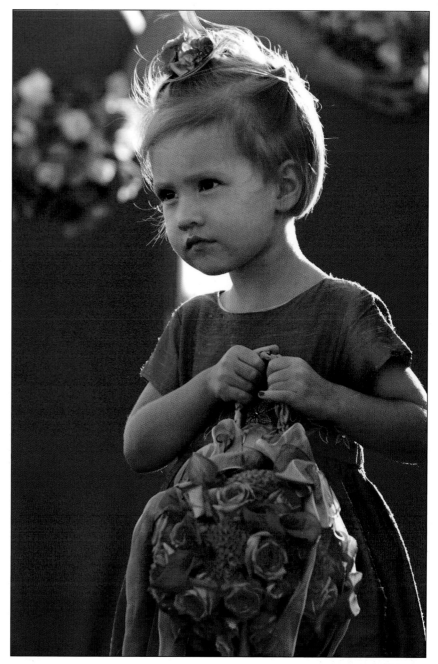

Backlighting with direct sunlight can create a beautiful edge highlight as was done here. Becker photographed this beautiful and intense young flower girl readying herself for her job. The background of the red bridesmaids' dresses makes this shot even more festive. Becker used a Fuji Finepix S2 Pro and 80–200mm f/2.8 lens set to 145mm. The ISO was set to 160 and the exposure was ¹/₃₅₀ second at f/4.

bright background and highlights instead of the exposure on the face. If you expose for the background light intensity, you will silhouette the subject. As usual, it is best to use the handheld incident meter in these situations. Shield the meter from any backlight, so you are only reading the light on the faces. Alternatively, take a test exposure and verify on the camera's LCD if the backlight underexposes the frame. If so, move to manual exposure mode and adjust the settings appropriately.

If the sun is low in the sky, you can use cross lighting to get good modeling on your subjects. You must be careful to position the subjects so that the sun's side lighting does not hollow out the eye sockets on the highlight sides of their faces. Subtle repositioning will usually correct this. You'll need to use fill light on the shadow side to preserve detail. Try to keep your fill-flash output about ½ to one stop less than your daylight exposure.

Images made in bright sunlight are unusually contrasty. To lessen that contrast, try using telephoto lenses, which have less inherent contrast than shorter lenses. If shooting digitally, you can adjust your contrast preset to a low setting or shoot in RAW mode, where you can fully control image contrast postcapture.

Open Shade. Open shade is light reflected from the sky on overcast days. It is different than shade created by direct sunlight being blocked by obstructions, such as trees or buildings. Open shade can be particularly harsh, especially at midday when the sun is directly overhead. In this situation, open shade takes on the same characteristics as overhead sunlight, creating deep shadows in the eye sockets and under the noses and chins of the subjects.

Open shade can, however, be tamed and made useful by finding an overhang, like tree branches or a porch, which blocks the overhead light, but allows soft shade light to filter in from the sides, producing direction and contouring on the subject. This cancels out the overhead nature of the light and produces excellent modeling on the faces.

If forced by circumstance to shoot your subjects out in unobstructed open shade, you must fill in the shade with a frontal flash or reflector. If shooting the bride or the bride and groom, a reflector held close to and beneath your subjects should suffice for filling in the shadows created by open shade. If photographing more than two peo-

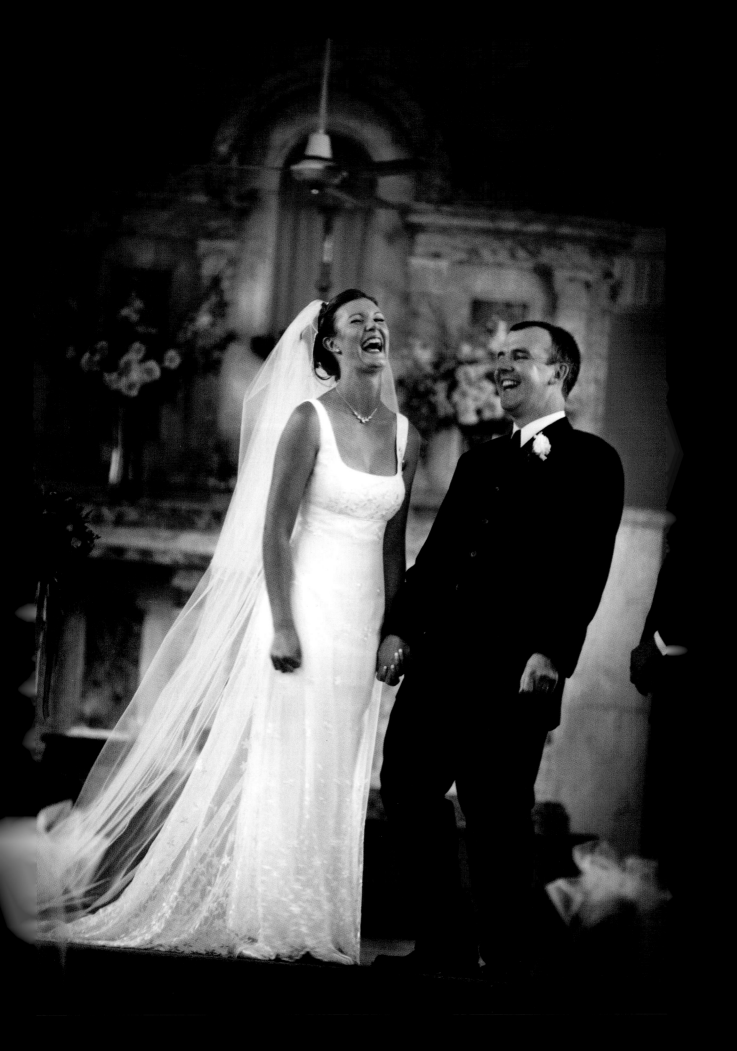

ple, then fill-flash is called for. The intensity of the light should be about equal to the daylight exposure.

Even experienced photographers sometimes can't tell the direction of the light in open shade, particularly in mid-morning or mid-afternoon. A simple trick is to use a piece of gray or white folded card—an index card works well. Crease the card in the middle to form an open V shape. Hold the card vertically with the point of the V pointed toward the camera, then compare the two sides of the V. The card will tell you if the light is coming from the right or left and how intense the ratio between highlight and shadow is. Held with the fold horizontal and pointed toward the camera, the card will tell you if the light is coming from above. Sometimes, this handy tool can help you gauge when a slight adjustment in subject or camera position will salvage an otherwise unusable location.

Twilight. The best time of day for great pictures is just after sunset when the sky becomes a huge softbox and the lighting on your subjects is soft and even with no harsh shadows.

There are three problems with working with this great light. First, it's dim. You will need to use medium to fast films or ISO settings combined with slow shutter speeds, which can be problematic. Working in subdued light also restricts your depth of field, as you have to choose wider apertures. The second problem in working with this light is that twilight does not produce catchlights. For this reason, most photographers augment the twilight with some type of flash, either barebulb flash or softbox-mounted flash that provides a twinkle in the eyes. Third, twilight is difficult to work with because it changes so rapidly. The minutes after sunset (or before sunrise, when similarly beautiful lighting conditions also exist) produce rapidly changing light levels. Meter often and adjust your flash output, if using fill-flash, to compensate.

Window Light. One of the most flattering types of lighting you can use is window lighting. It is a soft light that minimizes facial imperfections, yet it is also highly directional light, for good facial modeling with low to moderate contrast. Window light is usually a fairly bright light and it is infinitely variable, changing almost by the minute. This allows a great variety of moods, depending on how far you position your subjects from the light.

Since daylight falls off rapidly once it enters a window, and is much weaker several feet from the window than it is closer to the window, great care must be taken in deter-

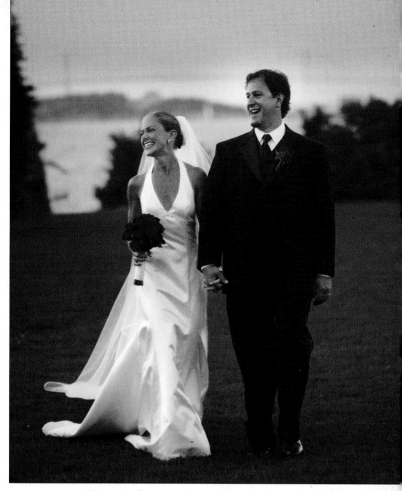

FACING PAGE—*Marcus Bell managed to capture this priceless moment by available light. Daylight streams in from either side of the church, but the light level is very low. This is where image stabilization lenses come in handy, allowing you to shoot as slow as 1/15 or 1/8 second in low light.* ABOVE—*Twilight is a beautiful and open light. Just turn your subjects toward the twilight and it will act like a huge softbox. Photograph by Charles Maring.*

mining exposure—particularly with groups of three or four people. You will undoubtedly need to use reflectors to balance the light overall when photographing that many people in a group. There are a couple of other problems, namely that you will sometimes have to work with distracting backgrounds and uncomfortably close shooting distances.

The best quality of window light is the soft light of mid-morning or mid-afternoon. Direct sunlight is difficult to work with because of its intensity and because it will often create shadows of the individual windowpanes on the subject.

Diffusing Window Light. If you find a nice location for a portrait but the light coming through the windows is direct sunlight, you can diffuse the window light with some acetate diffusing material taped to the window frame. It produces a warm golden window light. Light diffused in

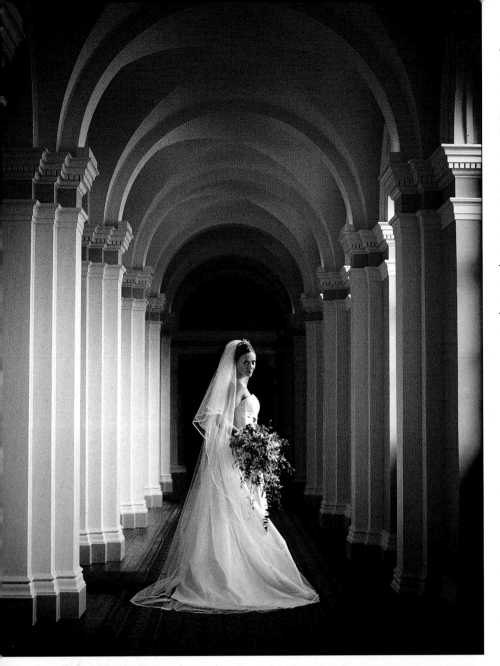

this manner has the warm feeling of sunlight but without the harsh shadows.

If the light is still too harsh, try doubling the thickness of the acetate for more diffusion. Since the light is so scattered by the diffusers, you may not need a fill source, unless working with a larger group. In that case, use reflectors to kick light back into the faces of those farthest from the window.

■ MAIN LIGHT

A Single Main Light—Always. It is important to have only one main light in your images. This is fundamental. Other lights can modify the main light, but there should always be a single defining light source. Most photographers who shoot a lot of outdoor portraits subscribe to the use of a single main light for groups, indoors or out, and fill the shadows of the main light with one or more flash units.

Flash on Overcast Days. When the flash exposure and the daylight exposure are identical, the effect is like creating your own sunlight. This technique works particularly well on overcast days when using barebulb flash, which is a point light source like the sun. Position the flash to the right or left of the subject(s) and raise

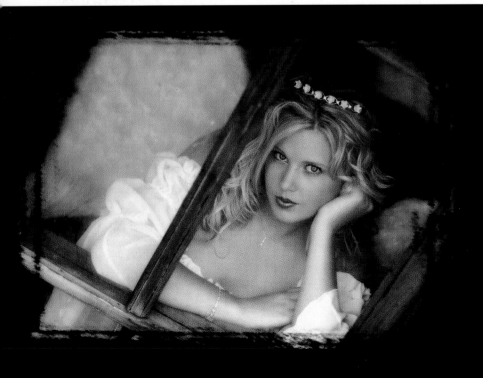

it up for better modeling. If you want to accentuate the lighting pattern and darken the background and shadows, increase the flash output to ½ to one stop greater than the daylight exposure and expose for the flash. Do not underexpose your background by more than a stop, however, or you will produce an unnatural nighttime effect.

Many times this effect will allow you to shoot out in open shade without fear of hollow eye sockets. The overhead nature of the diffused daylight will be overridden by the directional flash, which creates a distinct lighting pattern.

Flash-Sync Speeds. If using a focal-plane shutter as found in 35mm SLRs, you have an X-sync shutter speed setting. You cannot use flash and employ a shutter speed faster than the X-sync speed. Otherwise, your files or negatives will be only half exposed. You can, however, use any shutter speed slower than the X-sync speed. Your strobe will fire in synchronization with the shutter, and the longer shutter speed will build up the ambient light exposure. The latest generation of DSLRs, like the Nikon D1X and Canon EOS 1-Ds, use flash-sync shutter speeds of $\frac{1}{500}$ second, making daylight flash sync at almost any aperture possible.

Straight Flash. On-camera flash should be avoided altogether for making wedding portraits—except as a fill-in source. Straight flash is too harsh and flat and it produces no roundness or contouring. Since light falloff is extreme, it produces cavernous black backgrounds—unless the shutter is left open for a longer time to expose the ambient room light.

When you diffuse on-camera flash, you get a reasonably soft frontal lighting. While diffused flash is still a flat lighting and frontal in nature, the softness of the light produces much better contouring than direct, undiffused

flash. Lumiquest offers devices like the Pocket Bouncer, which redirects light at a 90-degree angle from the flash to soften the quality of light and distribute it over a wider area. There are also frosted acetate caps that fit over the flash reflector to soften the direct flash and these can be effective as well. Most of these accessories can be used with your flash in auto or TTL mode, making exposure calculation effortless.

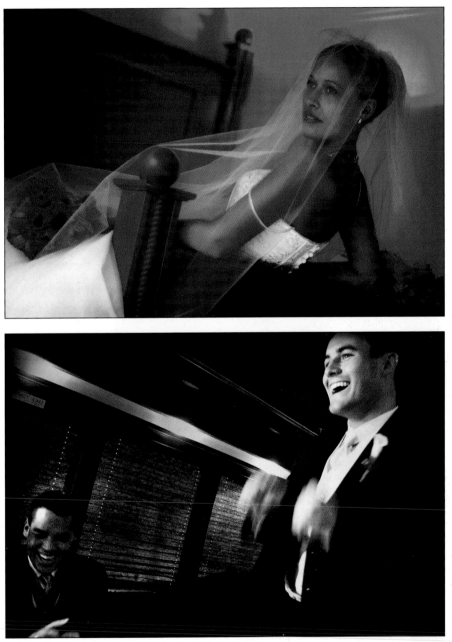

One of the best facets of shooting digitally is the ability to shoot virtually anywhere under almost any lighting situation. Both of these shots are by Anthony Cava and were made with a Nikon D100 at exposures of $\frac{1}{320}$ second at f/1.7. In the image of the bride, Anthony set the white balance for shade so the tungsten lights would go yellow-red. In the shot of the groom on the train, he set the white balance for tungsten, even though there was a mix of tungsten, fluorescent, and daylight. In each instance he could have color corrected the scene but opted for a more creative approach to the color balance.

ABOVE—*Melanie Nashan captured these two lovely bridesmaids against a weathered barn by available light. Note that the overhang above the girls blocks the overhead shade and a lighting pattern emerges coming in from the left, where there is no overhang. Photograph made with a Canon D60.* FACING PAGE, TOP—*Joe Photo uses bounce flash all the time indoors to augment the room's available light. He does this primarily to avoid any dead spots in the frame where no light exposes an image. Here he used his Nikon D1X and a 17–35mm f/2.8D ED-IF AF-S Zoom-Nikkor lens at an exposure of ¹⁄₆₀ second at f/2.8 with bounce flash.* FACING PAGE, BOTTOM—*A technique perfected by many of the Australian wedding photographers is working by available light in such low-light environs as pubs—frequent haunts of the bridal party in the time between the wedding and the reception. Here, Jerry Ghionis uses a small video light, held by an assistant, to light the couple from the left. The intensity or distance of the light is varied to match the ambient light exposure of the room.*

Many photographers, especially those shooting 35mm systems, prefer on-camera TTL flash, which features a mode for TTL flash-fill that will balance the flash output to the ambient-light exposure for balanced fill-flash. Most of these TTL flash systems are adjustable so that you can vary the flash output in fractional increments, thus provid-

EVALUATING FLASH OUTPUT

One of the best means of evaluating flash output, lighting ratios, and the balance between flash illumination and daylight or room light is by using the DSLRs LCD monitor. While the LCD may not be the perfect tool to evaluate subtle exposure effects, it is quite effective in evaluating how well your bounce flash is performing. You can see at a glance if you need to increase or decrease flash output.

ing the means to dial in the precise ratio of ambient-to-fill illumination. They are marvelous systems and, of more importance, they are reliable and predictable. The drawback to these systems is that they are camera-mounted—although many such systems also allow you to remove the flash from the camera via a TTL remote cord.

Bounce Flash. Portable flash units do not have modeling lights, so it is impossible to see beforehand the lighting effect produced. However, there are certain ways to use a camera-mounted flash in a predictable way to get excellent lighting—especially at the reception.

Bounce flash is an ideal type of portrait light. It is soft and directional. By bouncing the flash off the ceiling, you can achieve an elegant, soft light that fully illuminates your subjects. You must learn to gauge angles and distances when using bounce flash. Aim the flash unit at a point on the ceiling that will produce the widest beam of light reflecting back onto your subjects. You should never use color film when bouncing flash off colored ceilings or walls—the light reflected back onto your subjects will be the same color as the walls. Even if shooting digitally, you may not be able to compensate with custom white balance for the green-colored bounce flash coming off of a green ceiling.

TTL flash metering systems and autoflash systems will read bounce-flash situations fairly accurately, but factors such as ceiling distance, color, and absorption qualities can affect proper exposure. Although no exposure compensation is necessary with these systems, operating distances will be reduced.

You don't necessarily have to use your flash-sync speed when making bounce flash exposures. If the room-light exposure is within a stop or two of your bounce-flash exposure (¹⁄₁₂₅ second at f/4, for example), simply use a slower shutter speed to record more of the ambient room light. If the room light exposure is ¹⁄₃₀ second at f/4, for example, expose the bounce-flash photos at ¹⁄₃₀ second at

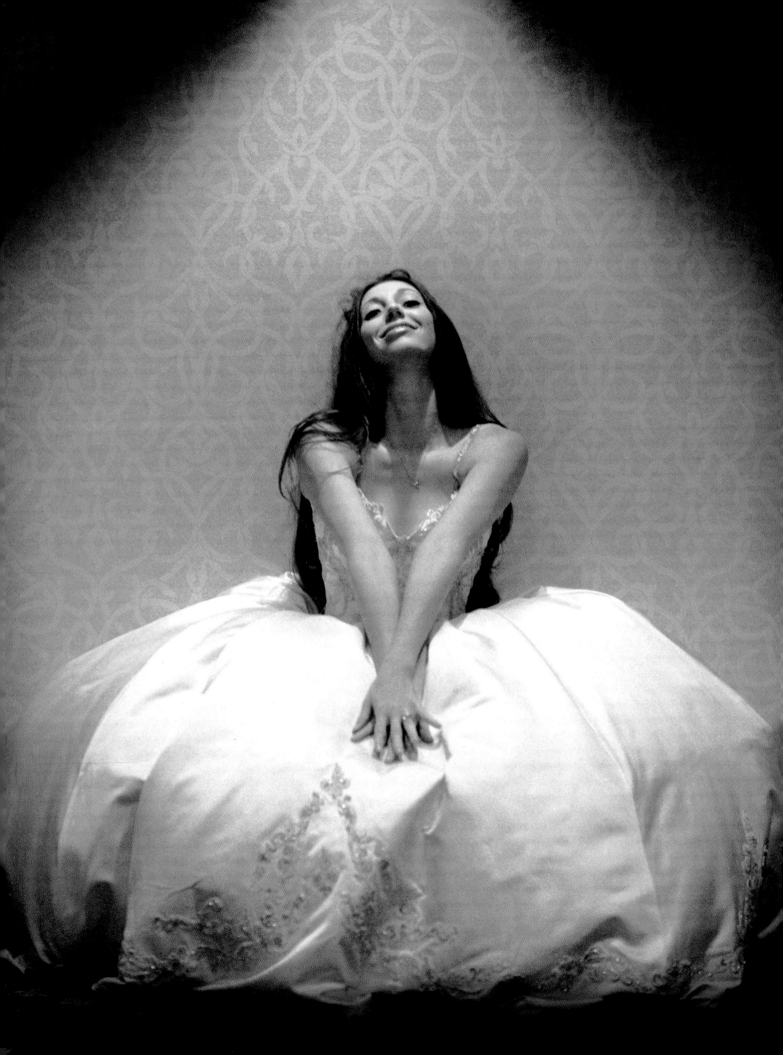

f/4 for a balanced flash and room-light exposure. Be wary of shutter speeds longer than ⅟₁₅ second, as you might incur camera movement or subject movement in the background (the flash will freeze the nearer subject although the longish shutter speed might produce "ghosting" if your subject is moving). These effects are actually quite interesting visually and many photographers incorporate a slow shutter speed and flash to record a sharp image over a moving one for a painterly effect.

■ FILL LIGHT

Reflectors. It is a good idea to take a selection of portable light reflectors to every wedding. Reflectors should be fairly large for maximum versatility. Light discs, which are reflectors made of fabric mounted on flexible and collapsible circular frames, come in a variety of diameters and are a very effective means of providing fill-in illumination. They are available from a number of manufacturers and come in silver (for maximum fill output), white, gold foil (for a warming fill light), and black (for blocking light from hitting a portion of the subject). In most instances, an assistant is required to position and hold the reflector for maximum effect.

When the shadows produced by diffused light are harsh and deep—or even when you just want to add a little sparkle to the eyes of your subjects—use a large reflector or several reflectors. As mentioned, it really helps to have an assistant so that you can precisely set the reflectors and see their effect from the viewfinder. Be sure to position reflectors outside the frame. With foil-type reflectors used close to the subject, you can sometimes overpower the daylight.

Be careful about bouncing light in from beneath your subjects. Lighting coming from under the eye/nose axis is generally unflattering. Try to "focus" your reflectors (this really does require an assistant), so that you are only filling the shadows that need filling in.

Flash Fill. A more predictable form of shadow fill-in is electronic flash. As mentioned, many photographers shooting weddings use barebulb flash, a portable flash unit with a vertical flash tube, like a beacon, that fires the flash a full 360 degrees. You can use as wide a lens as you own and you won't get flash falloff with barebulb flash. Barebulb flash produces a sharp, sparkly light, which is too harsh for almost every type of photography except outdoor fill. The trick is not to overpower the daylight. It is

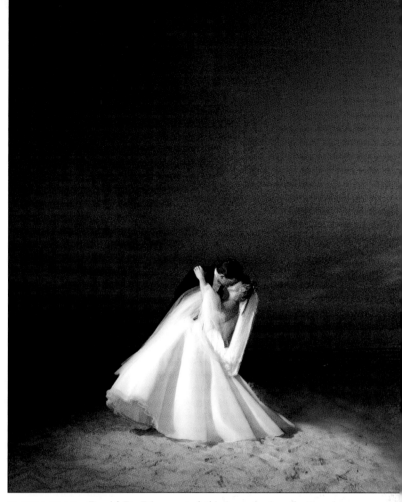

FACING PAGE—*David De Dios created this image using the found light of an overhead hotel ceiling "can." He had his bride tilt her head up to light her face and later darkened the shadow pattern on the wall in printing. This portrait is evidence that, with a little inventiveness, you can make a great picture almost anywhere.* ABOVE—*Al Gordon created a studio at sunset by using a studio flash and softbox on a light stand for flash fill. In this image, the flash became the main light, overpowering the daylight, as the photographer underexposed the background by about 1½ stops in order to saturate the colors of the sunset. Getting the light up and to the side gives modeling and dimension to the couple's form.*

most desirable to let the daylight or twilight backlight your subjects, capitalizing on a colorful sky background if one exists, and use barebulb flash to fill the frontal planes of your subjects.

Some photographers like to soften their fill-flash using a softbox. In this situation, it is best to trigger the strobe cordlessly with a radio remote trigger. This allows you to move the diffused flash out to a 30- to 45-degree angle to the subjects for a dynamic fill-in. For this application, it is wise to equal or overpower the daylight exposure slightly so that the off-angle flash acts more like a main light, establishing a lighting pattern. For large groups, it may be necessary to use several softboxes or to use a single one close to the camera for more even coverage.

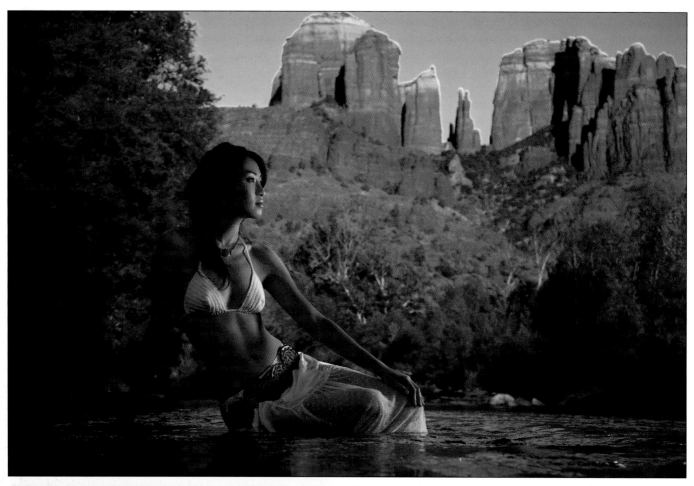

Bruce Dorn has come up with a remote softbox that he uses on location called the Strobe Slipper (available from his website, www.idcphotography.com). As you can see from the setup shot (left), the Photoflex softbox is small and maneuverable and uses a Canon (or Nikon) Speedlight mounted to a stainless steel plate, which also holds a Pocket Wizard receiver. The transmitter is mounted in the hot-shoe of Dorn's Canon EOS DSLR. The image, titled Caroline in Oak Creek *(above), was made with a Strobe Slipper except the light is used facing the model and allowed to wrap around her with no reflector. The strobe exposure is, naturally, balanced with the daylight exposure for a perfect combination of daylight and studio strobe.*

Metering and Exposure. Here is how you determine accurate fill-flash exposures every time. First, meter the daylight with an incident flashmeter in "ambi" mode. Say, for example, that the metered exposure is ⅟₃₀ second at f/8. Next, meter the flash only. It is desirable for the flash output to be one stop less than the ambient exposure. Adjust the flash output or flash distance until your flash reading is f/5.6. Set the camera to ⅟₃₀ second at f/8. That's it. You can set the flash output from f/8 to f/5.6 and you will not overpower the daylight, you will only fill in the shadows created by the daylight and add sparkle to the eyes.

If the light is fading or the sky is brilliant and you want to shoot for optimal color saturation in the background, overpower the daylight with the flash. Returning to the situation above, where the daylight exposure was ⅟₃₀ second at f/8, adjust your flash output so your flashmeter reading is f/11, a stop more powerful than the daylight. Set your camera to ⅟₃₀ second at f/11. The flash is now the main light and the soft twilight is the fill light. The

problem with this technique is that you will get shadows from the flash. This can be acceptable, however, since there aren't really any shadows coming from the twilight. As described previously, this technique works best when the flash is diffused and at an angle to the subjects so there is some discernable lighting pattern.

It is also important to remember that you are balancing two light sources in one scene. The ambient light exposure will dictate the exposure on the background and the subjects. The flash exposure only affects the subjects.

When you hear of photographers "dragging the shutter" it refers to using a shutter speed slower than X-sync speed in order to expose the background properly.

Flash-Fill Variation. Backlit subjects allow you to work in bright light as long as you fill the shadows. One of the outdoor techniques master photographer Monte Zucker uses is to position his single flash on a light stand as if it were a studio light, raised and to the right or left of the subjects, usually at a 30- to 45-degree angle. He uses his single flash at the same output as his daylight exposure,

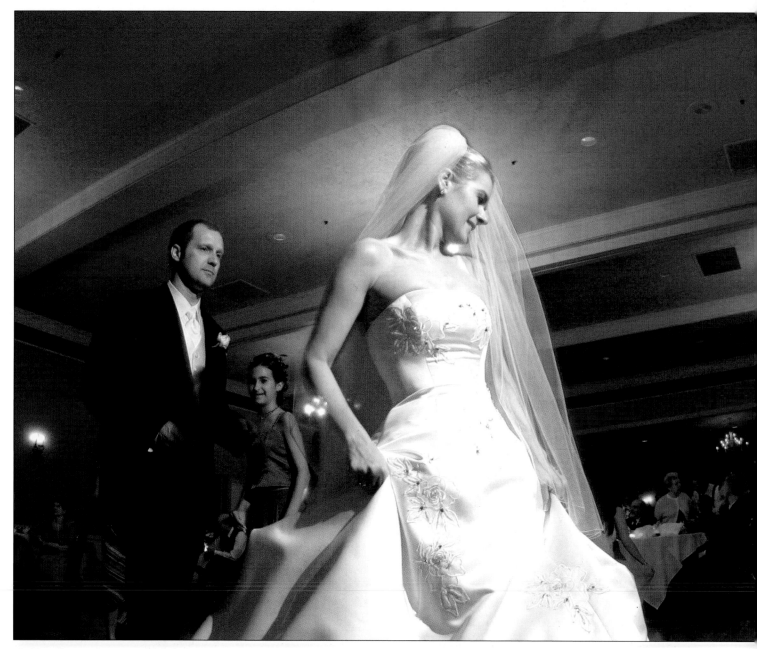

Cal Landau used a Metz 45CL flash on camera and another Metz 45CL on a stand to the right. Both flash units were bounced into the ceiling. The halo effect on the bride happened because she passed between Cal and a spotlight in the ceiling. Asked about this shot he said, "I would like to say that I planned it that way, but the truth is, I was shooting from near the floor without looking through the viewfinder." Cal used a Canon EOS 10D and 15mm lens. ISO was set to 400 and the exposure was 1/25 second at f/5.6.

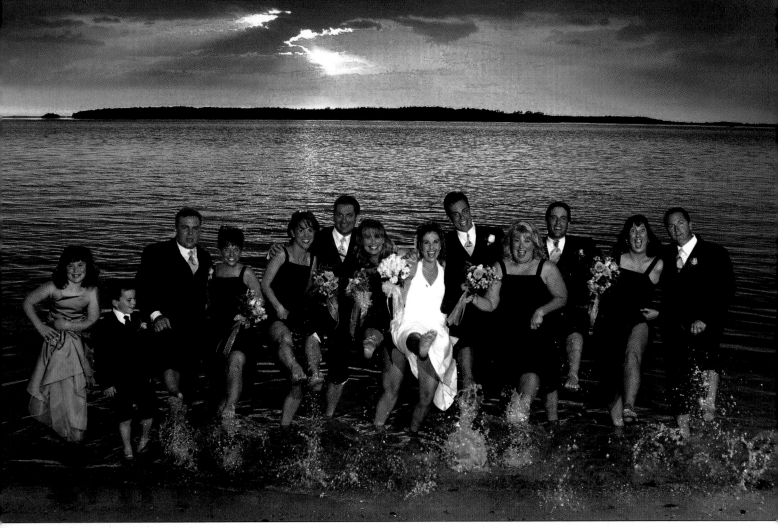

Al Gordon is a virtuoso of flash fill. Here he waited until the perfect moment at sunset to create this fun wedding party photo. Note that both the flash and ambient exposures are perfect. As if to increase the difficulty factor, he had the group splash with their feet so he could freeze the water with his flash. Also note his higher-than-head-height vantage point and perfect arrangement of the group. Yet for all of its control, there is spontaneity and fun in the image.

which may be as bright as f/16. The effect is to fill the shadows with dynamic light that rounds and sculpts each face. The effect is similar to the studio lighting involving a strong backlight and single main light. Ambient daylight provides the fill-in.

Remember that electronic flash falls off in intensity rather quickly, so be sure to take your meter readings from the center of your group and then from either end to be sure the illumination is even. With a small group of three or four, you can get away with moving the strobe away from the camera to get better modeling—but not with larger groups, where the light falloff is too great. You can, however, add a second flash of equal intensity and distance to help widen the light.

Monte uses a similar technique for formal groups where a single flash would fall off too rapidly, leaving one half of the group unlighted. He adds a second light at the same angle as the first, but spaced so that it will light the

FLASH COMMANDER

The latest development in electronic flash is Nikon's SU-800 Wireless Speedlight Commander. This device enables you to wirelessly coordinate the independent operation of two groups of Nikon Speedlights in close-up mode, or three groups (A, B, C) of compatible Speedlights in commander mode. In either mode, the commander manages flash output with exceptional precision, automatically delivering the light level dictated by the camera's metering systems and supporting automatic balanced fill-flash with compatible cameras. Further, the Nikon D200 features a built-in flash commander that allows the on-board flash to control the output of two groups of flash units remotely to a distance of 66 feet. In use, the Flash Commander is remarkable because you can easily control the output and ratio between flashes and verify the results on the camera's LCD. With an assistant or attendee helping you, you can light scenes with multiple flash wirelessly and easily control the output of each flash so that you can shoot groups at the reception, or special moments like the first dance or cake cutting with sophisticated TTL flash lighting.

half of the group that is farthest away. He feathers both lights so they don't overlight the middle of the group. This technique allows you to create big wide groups—even use wide-angle lenses—and still attain elegant lighting.

■ AREA LIGHTING

Umbrellas. Often, you will need to light an area, such as the dance floor or dais at a reception. Stationary umbrellas that are "slaved" to your camera or on-camera flash are the ideal way to accomplish even lighting over a large area. It is important to securely tape all cords and stands to the floor in as inconspicuous a manner as possible to prevent anyone from tripping over them. Once positioned, you can adjust the umbrellas so that you get even illumination across the area. To do that, focus the umbrellas.

Umbrellas fit inside a tubular housing inside most studio electronic flash units. The umbrella slides toward and away from the flash head, and is anchored with a set-screw or similar device. The reason the umbrella-to-light-source distance is variable is because there is a set distance at which the full amount of strobe light hits the full surface of the umbrella, depending on the diameter of the umbrella and type of reflector housing used on the flash head. This is the optimal setting. If the umbrella is too close to the strobe, much of the beam of light is focused in the center portion of the um-

brella, producing light with a "hot-spot" center. If the strobe is too far away from the umbrella surface, the beam of light is focused past the umbrella surface, wasting a good amount of light. When setting up, use the modeling light of the strobe to focus the distance correctly so the outer edges of the light core strike the outer edges of the umbrella for maximum output.

Umbrellas also need to be "feathered" to maximize the coverage of the umbrella's beam of light. If you aim a light source directly at the area you want illuminated then meter

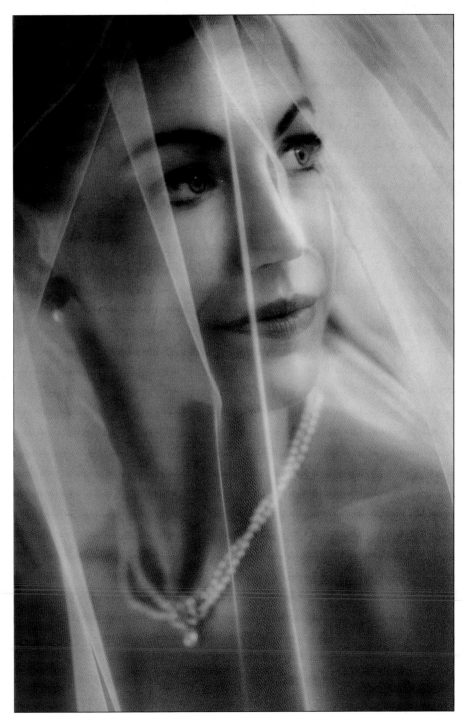

One might think this is a studio portrait, but it was created on location at the wedding by Charles Maring using a Nikon D1X and 85mm f/1.4 lens. His exposure, in the subdued window light, was $\frac{1}{40}$ second at f/1.4. Using a wide-open aperture like this on very fast lenses produces a razor-thin band of focus—in this case, the bride's eyes and lips and part of the veil. Even her nose is not fully in focus. The effect is soft and dreamy. The lighting is expertly handled to provide a studio type of loop lighting, a popular portrait lighting. The veil provided a natural fill in on the bride's face.

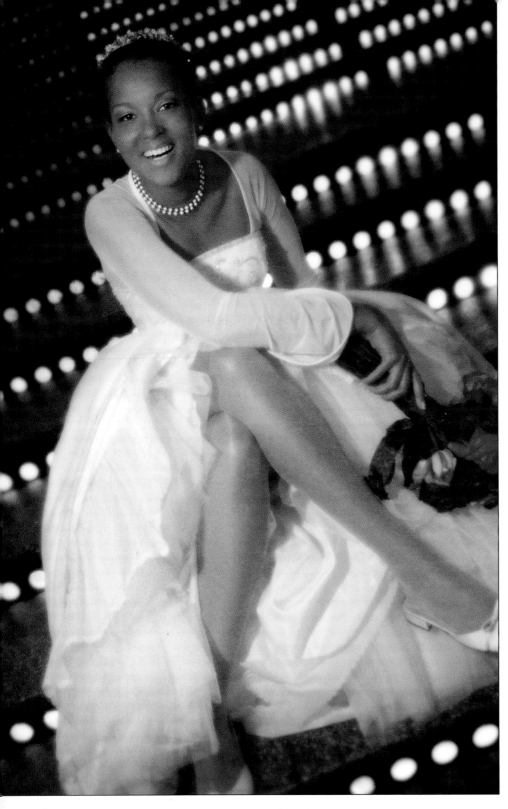

Parker Pfister created this lovely portrait of a bride using diffused tungsten illumination. He photographed the scene with a Nikon D1X and 24mm lens at 1/30 second at f/2.8. The back-illuminated steps add a cool graphic element to the photograph.

less diffused the farther back you move it. Triggering is best accomplished with a radio transmitter set to fire only those strobes.

Handheld Video Lights. Many photographers use small handheld video lights to augment existing light at a wedding. David Williams, for example, glues a Cokin Filter holder to the front of the light and places a medium blue filter (a 025 Cokin filter) in it. The filter brings the white balance back from tungsten to about 4500K, which is still slightly warmer than daylight. It is the perfect warm fill light. If you want a warmer effect, or if you are shooting indoors with tungsten lights, you can remove the filter.

These lights sometimes have variable power settings. Used close to the subject (within ten feet) they are fairly bright, but can be bounced or feathered to cut the intensity. David uses them when shooting wide open, so they are usually just used for fill or accent.

The video light can also be used to provide what David calls a "kiss of light." He holds the light above and to the side of the subject and feathers the light back and forth while looking through the viewfinder. The idea is to produce just a little warmth and light on something that is either backlit or lit nondescriptly.

Sometimes he will use an assistant to hold two lights, which cancel out the shadows of one another. He often combines these in a flash-bracket arrangement with a handle. His video light has a palm grip attached to the bottom to make it more maneuverable when he has a camera in the other hand.

the light, you'll find that it is falling off at the ends of the area—despite the fact that the strobe's modeling light might trick you into thinking that the lighting is even throughout. Feathering the light past the area you want illuminated will help more evenly light your scene because you are using the edge of the light. Another trick is to move the light source back so that is less intense overall but covers a wider area. The light will become harsher and

reparation is critical when photographing a once-in-a-lifetime event that is as complicated as a wedding. With lots of people, places, and events to document, getting all the details and formulating a game plan before the wedding will help ensure you're ready to capture every moment.

■ PRE-WEDDING PREPARATIONS

Arrange a meeting with the couple at least one month before the wedding. Use this time to take notes, formulate detailed plans, and get to know the couple in a relaxed setting. This will be time well spent and allows you a month after the meeting to check out the locations, introduce yourself to the people at the various venues (including the minister, priest, or rabbi), and go back to the couple if there are any problems or if you have questions. This initial meeting also gives the bride and groom a chance to ask any questions of you that they may have.

Tell the couple what you plan to photograph and show them examples. Ask if they have any special requests or special guests who may be coming from far away. Avoid creating a list of required photographs, as it may not be

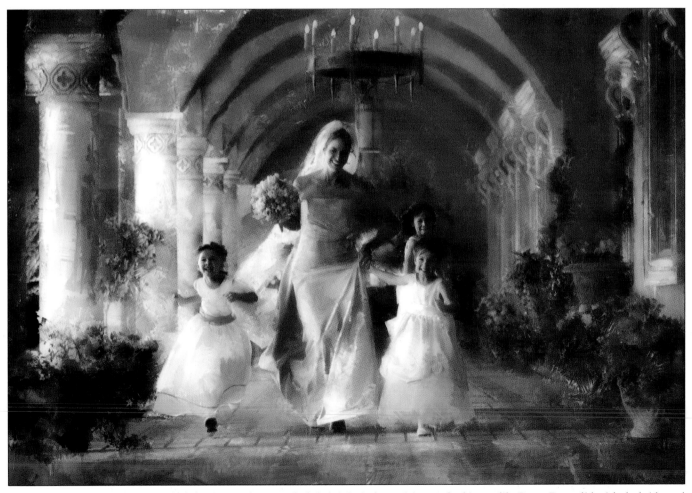

Knowing the minute to minute schedule of events lets you schedule brief windows of time to do things—like Bruce Dorn did with the bride and her flower girls. This could not have been made in one take; a location had to be predetermined, a knowledge of the young participants was required, and time had to be available so that this shot could be captured. It is a masterpiece.

possible to adhere to one. Make a note of the names of the parents and also of all the bridesmaids, groomsmen, the best man, and maid of honor so that you can address each by name. Also make notes on the color scheme, the supplier of the flowers, the caterer, the band, and so on. You should contact all of these people in advance, just to touch base. You may find out interesting details that will affect your timetable or how you make certain photos.

At many religious ceremonies, you can move about and even use flash—but it should really be avoided in favor of a more discreet, available-light approach. Besides, available light will provide a more intimate feeling to the images. At some churches you may only be able to take photographs from the back, in others you may be offered the chance to go into a gallery or the balcony. You should also be prepared for the possibility that you may not be able to make pictures at all during the ceremony.

Armed with information from the briefing meeting, you need to visit the couple's wedding venues. Try to visit at the same times of day as the wedding and reception, so that you can check lighting, make notes of special locations, and catalog any potential problems. Also, you should make note of the walls and types of ceilings, particularly at the reception. This will affect your ability to use bounce flash. It is useful to produce an "A" list and a "B" list of locations. On the A list, note the best possible spots for your images; on the B list, select alternate locations in case your A locations don't work out on the wedding day.

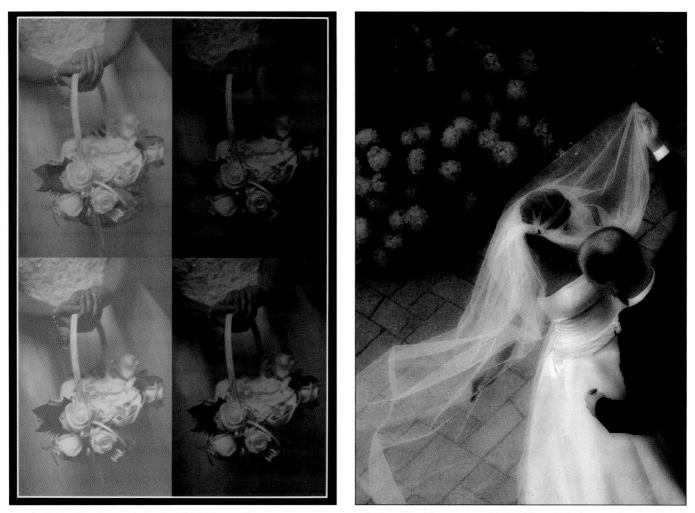

LEFT—*Part of your post-production thinking may be to prepare a montage of prints like this one created by Joe Photo. It is the same image printed in varying intensities of green and brown.* RIGHT—*David Beckstead, in his wedding coverage, always takes time to get some overheads of the bride and groom. Here he stole a moment of the bride and groom dancing all by themselves.*

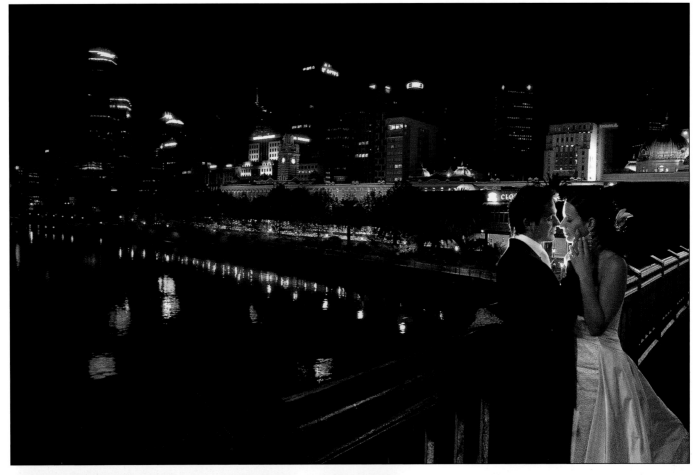

ABOVE—*Budgeting the time to create a portrait like this takes advance planning. Jerry Ghionis created this image with a ½ second exposure, two flash exposures (one frontal and one behind the couple) and a 17mm lens at f/4.* LEFT—*When venues are either special or unusual, it's a good idea to get a few shots for album pages or simply to supply to vendors later. Here, on site for a Charles Maring wedding, Jennifer Maring took the time to create a wonderful image of the boat house/reception hall. The image was made with a tripod-mounted Nikon D1X, and 17mm lens. The image was exposed for ¹⁄₁₀ second at f/2.8.*

■ CREATING A MASTER SCHEDULE

Planning your schedule is essential to smooth sailing on the wedding day. The couple should know that if there are delays, adjustments or deletions will have to be made to the requested pictures. Good planning and an understanding of exactly what the bride and groom want will help prevent any problems.

You should know how long it takes for you to drive from the bride's home to the ceremony. Inform the bride that you will arrive at least a 45 minutes to an hour before she leaves. You should arrive at church at about the same time as or a little before the groom, who should arrive about a half-hour before the ceremony. At that time you can make portraits of the groom and his groomsmen and

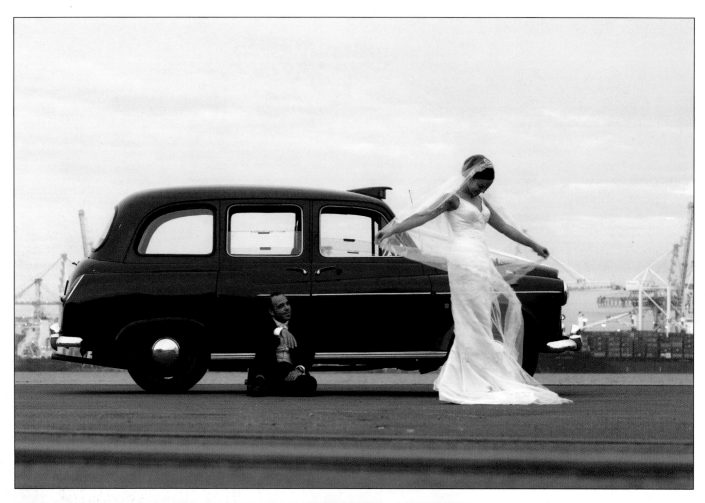

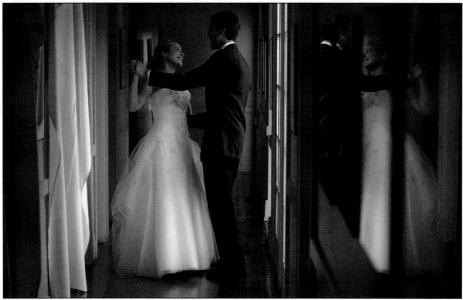

ABOVE—*This image, by Brett Florens, encapsulates the infatuation this couple has with one another. Brett recognized the classic elements: a retro car, an unusual environment, and a playful moment.* LEFT—*David Beckstead captured lightning in a bottle as the bride and groom danced together.* FACING PAGE—*This is the* People *magazine moment, when the beautiful bride and handsome groom exit the church brimming with confidence and happiness. Sometimes the photographer will luck out and be able to use the TV/videographer's lights. Photographer Mauricio Donelli also fired a fill flash to be sure of the exposure. This is the shot you don't want to miss.*

his best man. Bridesmaids will arrive at about the same time. You need to determine approximately how long the ceremony will last. One formula is to plan to spend up to twenty minutes on groups at the church, and about the same amount of time on portraits of the couple at the reception.

If the ceremony is to take place at a church or synagogue where you do not know the customs, make sure you visit the minister beforehand. If you are unfamiliar with the customs, ask to attend another wedding as an observer. Such experiences will give you invaluable insight into how you will photograph the wedding.

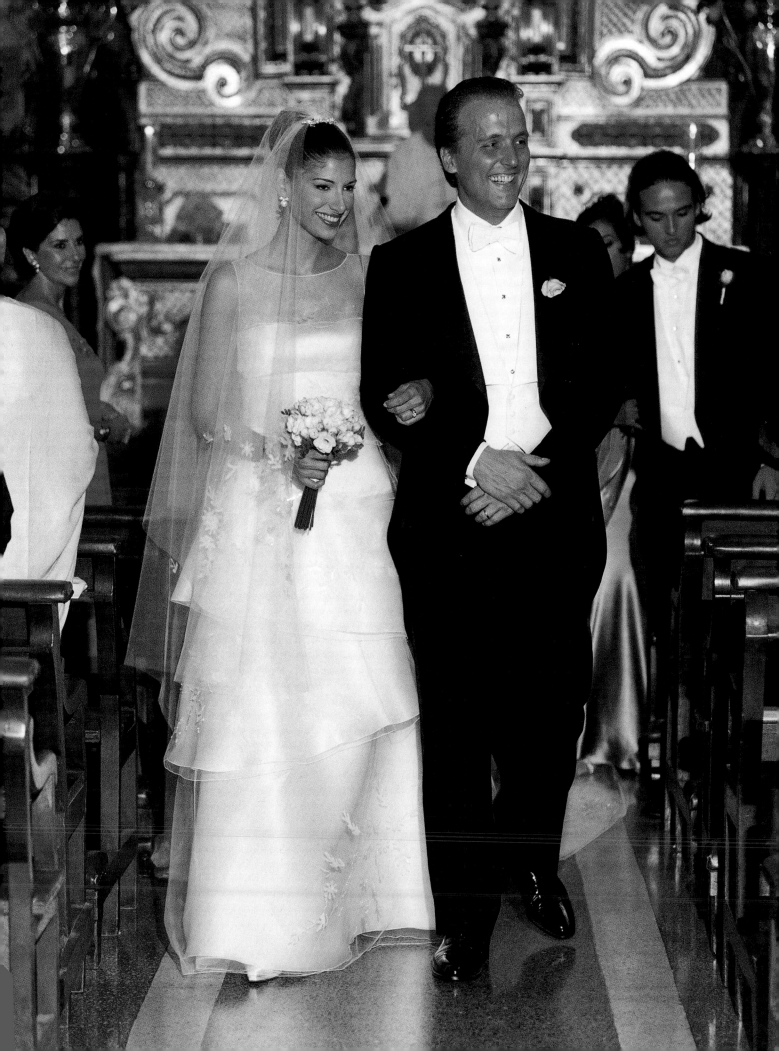

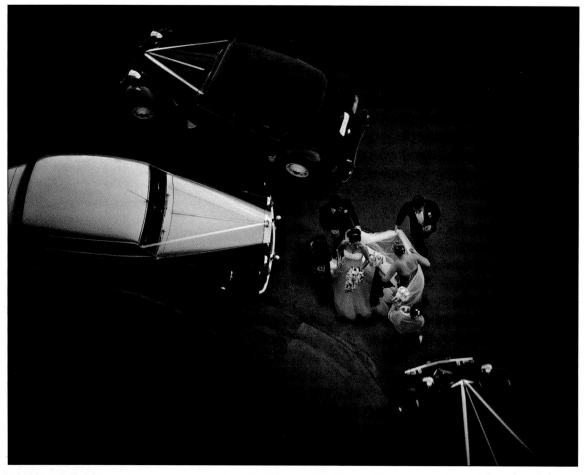

Working with assistants frees you up to make imaginative shots like this one. Shooting from the roof, Marcus Bell created a wonderful graphic image involving the amazing antique cars used for the wedding.

■ THE OTHER VENDORS

As the photographer, you are part of the group of wedding specialists who will ensure that the bride and groom have a great day. Be friendly and helpful to all of the people on the team—the minister, the limo driver, the wedding coordinator, the banquet manager, the band members, the florist, and other vendors involved in the wedding. They are great sources of referrals. Get the addresses of their companies so that you can send them a print of their specialty after the wedding.

■ ASSISTANTS

An assistant is invaluable at the wedding. He or she can run interference for you, change or download CF cards, organize guests for a group shot, help you by taking flash readings and predetermining exposure, tape light stands and cords securely with duct tape, and tackle a thousand other chores. Your assistant can survey your backgrounds looking for unwanted elements—even become a moveable light stand by holding your secondary flash or reflectors.

An assistant must be trained in your posing and lighting. The wedding day is not the time to find out that the assistant either doesn't understand or, worse yet, approve of your techniques. You should both be on the same page; a good assistant will even be able to anticipate your next need and keep you on track for upcoming shots.

Most assistants go on to become full-fledged wedding photographers. After you've developed confidence in an assistant, he or she can help with the photography, particularly at the reception, when there are too many things going on at once for one person to cover. Most assistants try to work for several different wedding photographers to broaden their experience. It's not a bad idea to employ more than one assistant so that if you get a really big job you can use both of them—or if one is unavailable, you have a backup assistant.

Assistants also make good security guards. I have heard too many stories of gear "disappearing" at weddings. An assistant is another set of eyes whose priority it should be to safeguard the equipment.

*A*s part of the wedding photography, there are some key images that every bride and groom will expect to see. Including these is important for creating an album that tells the whole story of the couple's special day. The following are a few tips on what to shoot and some ideas for making the most of each moment as it happens.

■ **ENGAGEMENT PORTRAIT**

The engagement portrait is made prior to the hectic wedding day, providing the time to get something spectacular. Many photographers use this session as an opportunity to get to know the couple and to allow the couple to get to know them. Engagement portraits may involve great creativity and intimacy and are often made in the photographer's studio or at some special location.

■ **AT THE BRIDE'S HOUSE**

Typically, weddings begin with the bride getting ready. Find out what time you may arrive and be there a little early. You may have to wait a bit—there are a million details for the bride to attend to—but you might find ample opportunity for still lifes or family shots. When you get the okay to go up to the bedrooms, realize that it may be tense

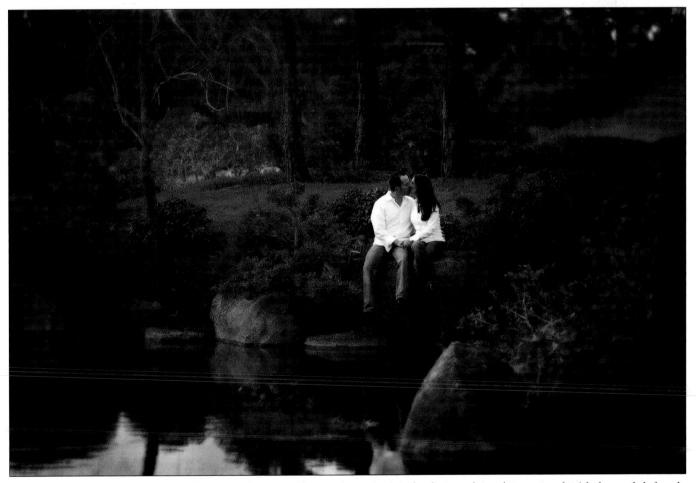

The engagement portrait has become an integral part of wedding packages. It gives the photographer a chance to work with the couple before the big day so that the trio may get used to each other. Photograph by Tom Muñoz.

THE KEY SHOTS 89

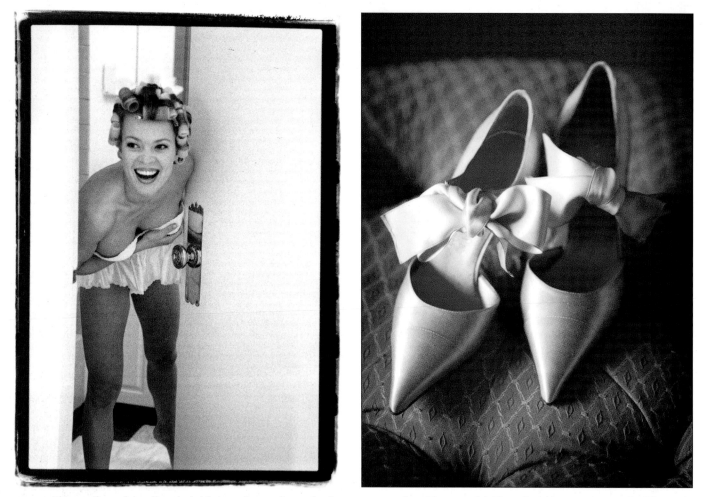

LEFT—*Being a fly on the wall as the bride is getting ready can lead to some great shots. Photograph by Ron Capobianco.* RIGHT—*Joe Photo tries to get a shot of the bride's shoes as she's getting ready. Few things are as special to a women as shoes and the wedding day produces some classics. Be sure to make a nice shot like this if at all possible.* FACING PAGE—*Sometimes the most amazing things happen without you planning them. Here Marcus Bell waited for the bride and groom to exit the altar of this massive church and the three flower girls, whom Marcus referred to as "having their own little party," provided the perfect foreground element. He said he had to wait throughout most of the ceremony to get this shot. Marcus used a tungsten white-balance setting and photographed the scene with an EOS 1DS and 35mm f/1.4 lens.*

in there. Try to blend in and observe. Shots will present themselves, particularly with the mother and daughter or the bridesmaids.

■ BEFORE THE WEDDING

You do, of course, want to photograph the groom before the wedding. Some grooms are nervous, while others are gregarious—like it's any other day. Regardless, there are ample picture opportunities before anyone else arrives. It's also a great opportunity to do formal portraits of the groom, the groom and his dad, and the groom and his best man. A three-quarter-length portrait is a good choice—and you can include the architecture of the church or building if you want.

When photographing men, always check that the ties are properly knotted. If they are wearing vests, make sure

that they are correctly buttoned and that the bottom button is undone.

■ THE CEREMONY

Regardless of whether you're a wedding photojournalist or a traditionalist, you must be discrete during the ceremony. Nobody wants to hear the "ca-chunk" of a camera or see a blinding flash as the couple exchange their vows. It's better by far to work from a distance with a tripod-mounted 35mm camera with the motor off (or in quiet mode, if the camera has one), and to work by available light. Work quietly and unobserved—in short, be invisible. (Of course, it should be noted that recent SLRs—especially DSLRs—are much quieter than past cameras.)

Some of the events you will need to cover are: the bridesmaids and flower girls entering the church, the bride

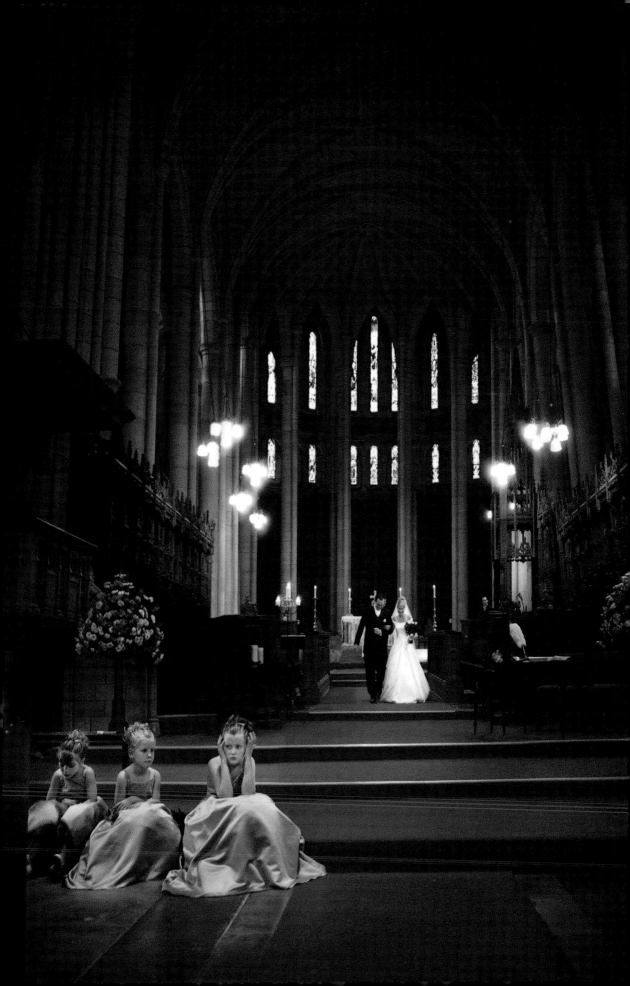

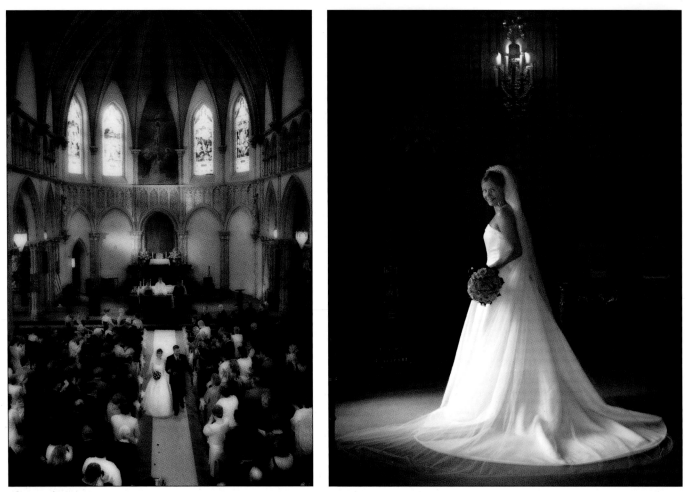

LEFT—*Working as a pair or trio of photographers allows one of you to get up in the choir loft and make an incredible shot such as this. Photograph by Charles Maring.* RIGHT—*David Worthington is a master of the formal bridal portrait. This image was made with window light and a small reflector with a Fuji FinePix S2 Pro and 37mm lens at ISO 200 at $\frac{1}{45}$ second at f/3.3. The room lights add low-key accents throughout the background of the image.*

entering the church, the parents being escorted in, the bride's dad "giving her away," the first time the bride and groom meet at the altar, the minister or priest talking with them, the ring exchange, the exchange of vows, the kiss, the bride and groom turning to face the assembly, the bride and groom coming up the aisle, and any number of two dozen variations—plus all the surprises along the way. Note that this scenario applies only to a Christian wedding. Every religion has its own customs and traditions that you need to be familiar with before the wedding.

Some churches don't allow any photography during the ceremony. You will, of course, know this if you've taken the time to visit the church prior to the wedding.

Regardless of your style of coverage, family groups are pictures that will be desired by all. You must find time to make the requisite group shots, but also be aware of shots that the bride may not have requested, but expects to see. The bride with her new parents and the groom with his are great shots, according to Monte Zucker, but are not ones that will necessarily be "on the list."

■ FORMALS

Following the ceremony, you should be able to steal the bride and groom for about ten minutes—no more, or you will be taking too much of their time and the others in attendance will get a little edgy. Most photographers will get what they need in less than ten minutes.

In addition to a number of formal portraits of the couple—their first pictures as man and wife—you should try to make whatever obligatory group shots the bride has asked for. This may include a group portrait of the wedding party, a portrait with the bride's family and the groom's family, and so on.

If there are too many "must" shots to do in a short time, arrange to do some after the ceremony and some at the reception. This can be all thought out beforehand.

■ THE BRIDE AND GROOM

Generally speaking, this should be a romantic pose, with the couple looking at one another. While a formal pose or two is advisable, most couples will opt for the more romantic and emotional formal portraits. Be sure to highlight the dress, as it is a crucial element to formal portraits. Take pains to show the form as well as the details of the dress and train, if the dress has one. This is certainly true for the bride's formal portrait, as well.

Make at least two formal portraits, a full-length shot and a three-quarter-length portrait. Details are important, so pose the couple. Make sure the bouquet is visible and have the bride closest to the camera. Have the groom place his arm around his bride but with his hand in the middle of her back. Have them lean in toward each other, with their weight on their back feet and a slight bend to their forward knees. Quick and easy!

■ THE BRIDE

To display the dress beautifully, the bride must stand well. Although you may only be taking a three-quarter-length or head-and-shoulders portrait, start the pose at the feet. When you arrange the bride's feet with one foot forward of the other, the shoulders will naturally be at their most flattering, one higher than the other. Have her stand at an angle to the lens, with her weight on her back foot and her front knee slightly bent. The most feminine position for her head is to have it turned and tilted toward the higher shoulder. This places the entire body in an attractive S-curve, a classic bridal pose.

Have the bride hold her bouquet in the hand on the same side of her body as the foot that is extended. If the bouquet is held in the left hand, the right arm should come in to meet the other at wrist level. She should hold her bouquet a bit below waist level to show off the waistline of the dress, which is an important part of the dress design. Take photos showing the dress from all angles.

■ THE WEDDING PARTY

This is one formal group that does not have to be formal. I have seen group portraits of the wedding party done as a panoramic, with the bride, groom, bridesmaids, and groomsmen doing a conga line down the beach, dresses held high out of the water and the men's pant legs rolled up. And I have seen elegant, formal pyramid arrangements, where every bouquet and every pose is identical

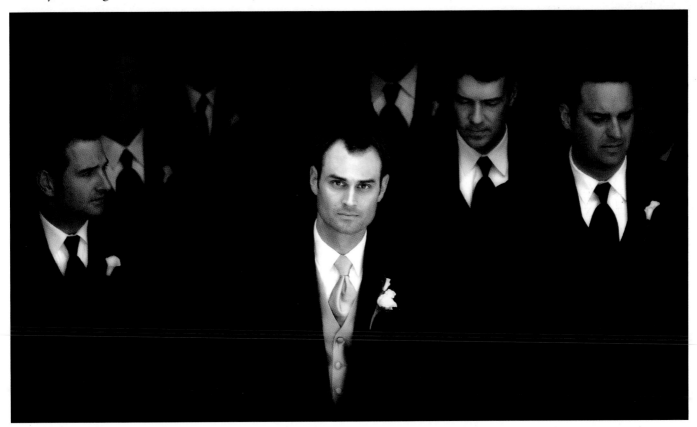

Titled The Pall Bearers, *this image by J.B. Sallee is a tongue-in-cheek portrait of what the groom and his groomsmen might term "his last day of freedom." In postproduction, the groomsmen were darkened to make the groom stand out.*

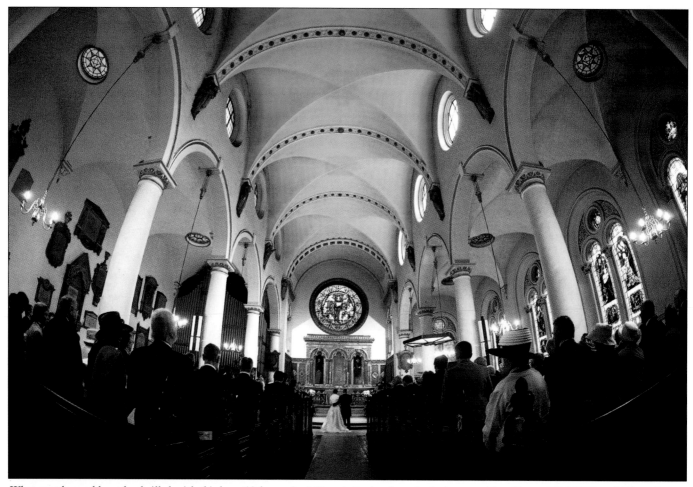

What couple would not be thrilled with this beautiful overview? Dennis Orchard made the image with a Canon EOS-1DS and 15mm lens at ISO 400 at an exposure of ¹/₁₅ second at f/2.8. He used a custom white balance to blend the daylight and tungsten light sources.

and beautiful. It all depends on your client and your tastes. It should be a portrait that you have fun doing. Most photographers opt for boy–girl arrangements, with the bride and groom somewhere central in the image. As with the bridal portrait, the bridesmaids should be in front of the groomsmen in order to highlight their dresses.

■ LEAVING THE CHURCH

Predetermine the composition and exposure and be ready and waiting as the couple exits the church. If guests are throwing confetti or rice, don't be afraid to choreograph the event in advance. You can alert guests to get ready and "release" on your count of three. Using a slow (¹/₃₀ second) shutter speed and flash, you will freeze the couple and the rice, but the moving objects will have a slightly blurred edge. If you'd rather just let the event happen, opt for a burst sequence using the camera's fastest frame rate—up to eight frames per second with high-end DSLRs—and a wide-angle to short-telephoto zoom. Be alert for the unexpected, and consider having a second

shooter cover events like this to better your odds of getting the key picture.

■ ROOM SETUP

Make a photograph of the reception site before the guests arrive. Photograph one table in the foreground and be sure to include the floral and lighting effects. Also, photograph a single place setting and a few other details. The bride will love them, and you'll find use for them in the album design. The caterers, decorators, and other vendors will also appreciate a print that reflects their efforts. Some photographers try to include the bride and groom in the scene, which can be tricky—but their presence *does* add to the shot. Before the guests enter the reception area, for instance, Ken Sklute often photographs the bride and groom dancing slowly in the background and it is a nice touch.

■ THE RECEPTION

This is the time when most of your photojournalistic coverage will be made—and the possibilities are endless. As

the reception goes on and guests relax, the opportunities for great pictures will increase. Be aware of the bride and groom all the time, as they are the central players. Fast zooms and fast telephoto lenses paired with fast film or high ISO settings will give you the best chance to work unobserved.

Be prepared for the scheduled events at the reception—the bouquet toss, removing the garter, the toasts, the first dance, and so on. If you have done your homework, you will know where and when each of these events will take place, and you will have prepared to light it and photograph it. Often, the reception is best lit with a number of corner-mounted umbrellas, triggered by your on-camera flash. That way, anything within the perimeter of your lights can be photographed by strobe. Be certain you meter various areas within your lighting perimeter so that you know what your exposure is everywhere on the floor.

The reception calls upon all of your skills and instincts. Things happen quickly, so don't get caught with an important event coming up and only two frames left or a CF card that's almost full. People are having a great time, so be cautious about intruding upon events. Try to observe the flow of the reception and anticipate the individual events before they happen. Coordinate your efforts with the person in charge, usually the wedding planner or banquet manager. He or she can run interference for you, as well as cue you when certain events are about to occur, often not letting the event begin until you are ready.

I have watched Joe Photo work a reception and it is an amazing sight. He often uses his Nikon D1X and flash in bounce mode and works quickly and quietly. His Nikon Speedlite is outfitted with a small forward-facing internal reflector that redirects some of the bounce flash directly onto his subject, making the flash both key and fill light at once. If he is observed and noticed, he'll often walk over and show the principals the image on the LCD, offer some thoughtful compliment about how good they all look, and quickly move on. Other times he just shoots, observes, and shoots some more. His intensity and concentration at the reception are keen and he comes away with priceless images—the rewards of good work habits.

■ RINGS

The bride and groom usually love their new rings and want a shot that includes them. A close-up of the couple's hands displaying the rings makes a great detail image in the album. You can use any type of attractive pose, but remember that hands are difficult to pose. If you want a really

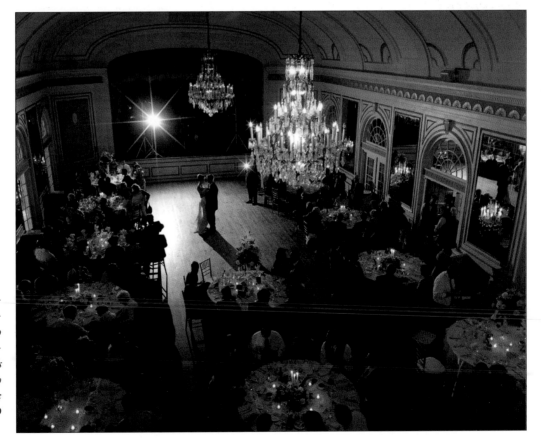

Cal Landau created this beautiful first-dance photo by shooting from overhead. He used two flash units from behind to spotlight the couple and lowered his ambient light exposure down to $^1/_{25}$ second at f/5.0 to make the shot. He used a Canon EOS 10D with a 17mm lens.

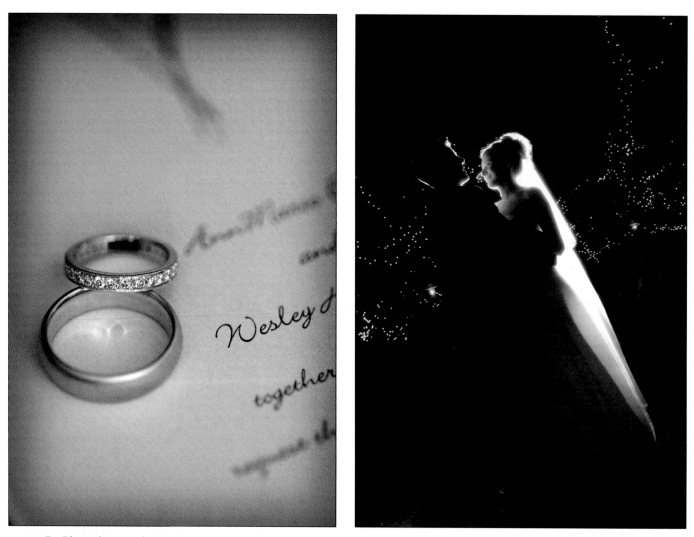

LEFT—*Joe Photo always makes it a point to photograph the rings with the wedding invitation. That makes it imperative to carry a macro lens.* RIGHT—*An outdoor reception with very little available light proved a challenge for capturing the bride and groom dancing. Parker Pfister wanted to record the twinkle lights in the background so he increased his ISO and lowered the exposure down to $\frac{1}{25}$ second at f/4.5 with a 20mm lens on his D1X. Spotlights illuminated the couple from behind and no fill light was used to retain the romantic feeling of the photograph.*

close-up image of the rings, you will need a macro lens, and you will probably have to light the scene with flash—unless you make the shot outdoors or in good light.

■ THE CAKE CUTTING

Cakes have gotten incredibly expensive—some cost more than $10,000! For this reason, a stand-alone portrait of the cake is a good idea, both for the cake-maker and for the bride and groom.

■ THE FIRST DANCE

One trick is to tell the couple beforehand, "Look at me and smile." That will keep you from having to circle the couple until you get both of them looking at you for the first-dance shot. Or you can tell them, "Just look at each other and don't worry about me, I'll get the shot."

Often, photographers will photograph the first dance by whatever available light exists (often spotlights) on the dance floor. This is possible with fast lenses and fast ISOs. Just as frequently, the photographer will use bounce flash and a slow shutter speed to record the ambient light in the room and the surrounding faces watching the couple's first dance. The bounce flash will freeze the couple but there is often some blurring due to the slow shutter speed.

■ THE BOUQUET TOSS

Whether you're a photojournalist or traditionalist, this shot looks best when it's spontaneous. You need plenty of depth of field, which almost dictates a wide-angle lens. You'll want to show not only the bride but also the faces in the background. Although you can use available light, the shot is usually best done with two flashes—one on the

bride and one on the ladies waiting for the bouquet. Your timing has to be excellent, as the bride will often "fake out" the group just for laughs. This might fake you out, as well. Try to get the bouquet as it leaves the bride's hands and before it is caught—and if your flash recycles fast enough, get a shot of the lucky lady who catches it.

■ TABLE SHOTS

Table shots don't usually turn out well, are rarely ordered, and are tedious to make. If your couple absolutely wants table shots, ask them to accompany you from table to table. That way they can greet all of their guests, and it will make the posing quick and painless. Instead of table shots, consider one big group that encompasses nearly everyone at the reception.

■ LITTLE ONES

A great photo opportunity comes from spending time with the smallest attendees and attendants—the flower girls and ring bearers. They are thrilled with the pageantry of the wedding day and their involvement often offers a multitude of memorable shots.

BELOW—J. B. Sallee saw this beautiful painting hanging over the bar and decided to duplicate it in a suitable manner by posing the bride across three bar stools. He used a 24mm lens on his D2X and an ISO of 640 and manually set the white balance to daylight so that the tungsten lighting would record with warmth.

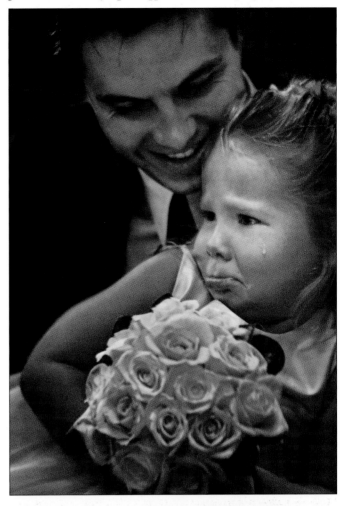

BELOW—The little ones are especially fragile on the wedding day and present some wonderful photo opportunities. Photograph by Marcus Bell.

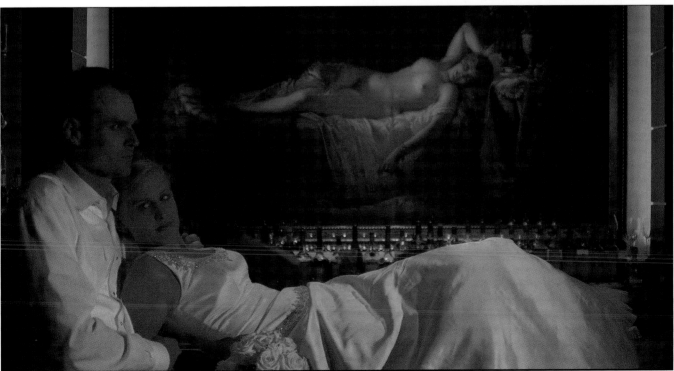

10. HELPFUL TIPS

*T*he following is a collection of tips and advice from accomplished wedding professionals. From helping brides into cars, to dealing with nerves and heightened emotions, to dealing with requests from guests, wedding photographers have seen it all—and figured out some very good solutions.

■ BIG GROUPS

You will need help to persuade all the guests to pose for a photo. Make it sound fun—which it should be. The best man and ushers, as well as your assistant, can usually be persuaded to do the organizing. Have the guests put their drinks down before they enter the staging area. Try to co-ordinate the group so that everyone's face can be seen and the bride and groom are the center of interest. Tell the group that they need to be able to see you with both eyes to be seen in the photo. Look for a high vantage point, such as a balcony or second-story window, from which you can make the portrait. Or you can use the trusty stepladder, but be sure someone holds it steady—particularly if you're at the very top. Use a wide-angle lens and focus about a third of the way into the group, using a moderate taking aperture to keep everyone sharply focused.

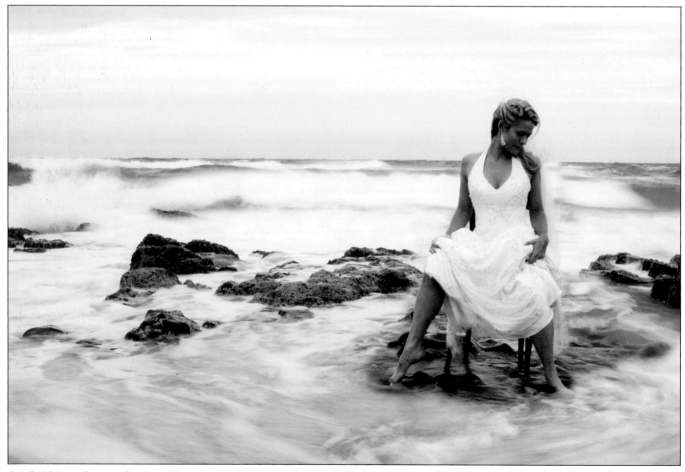

South African photographer Brett Florens wanted this portrait to look like a dream, so he used a long exposure that made the waves blur and bloom like cotton candy. He made the image with a Nikon D2X and a 20–35mm f/3.5–4.5 lens in RAW mode. He adjusted the tint and noise reduction in Adobe Camera Raw.

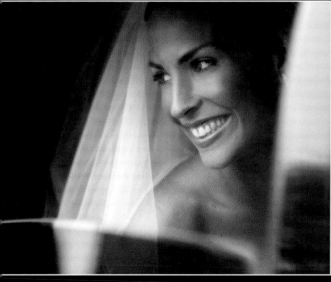

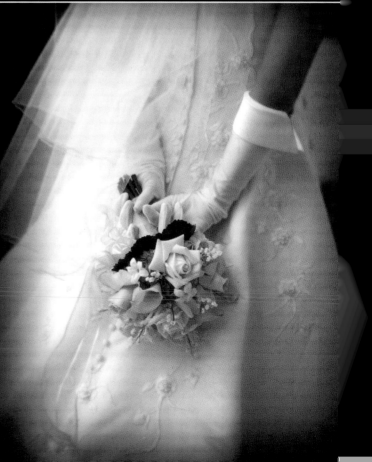

TOP—*Becker is great at shooting groups. This one was made with a 17mm rectilinear fisheye so you have very little distortion at the frame edges.* ABOVE—*You can never make too many images of the bride, especially ones including her veil or bouquet. This was spontaneous—a grab shot that Charles Maring captured in a split second.* RIGHT—*The bouquet should be the subject of at least one series of photographs. Here, Tibor Imely wanted to show the similarity between the bouquet's white roses and the white brocade roses in the wedding gown. The photograph is almost a still life. It is an award winner entitled* Simple Beauty.

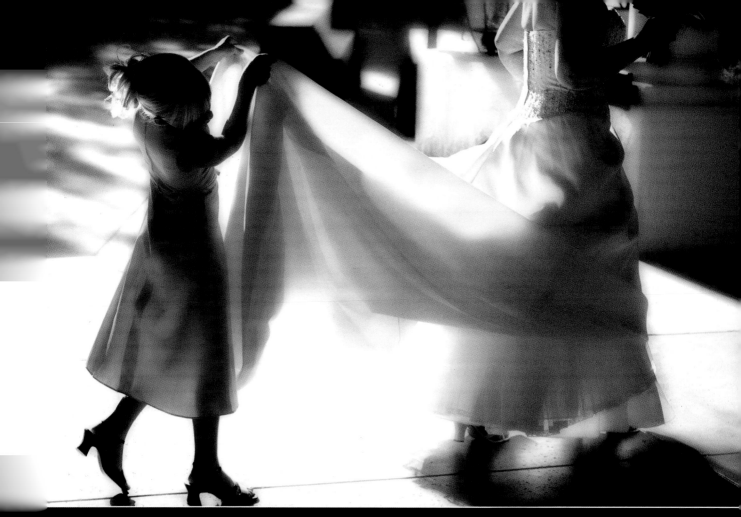
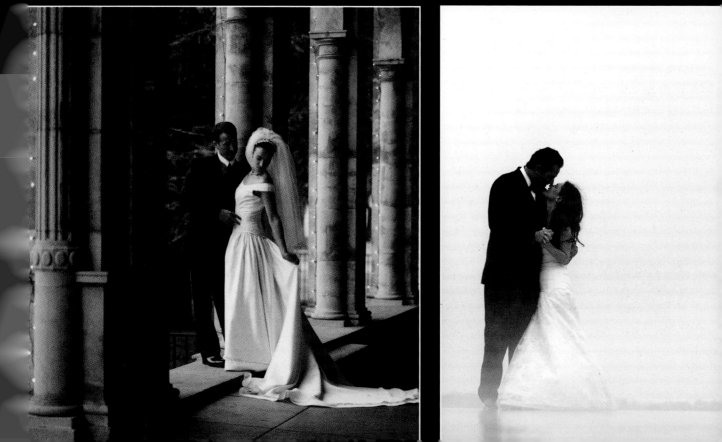

THE BOUQUET

Make sure a large bouquet does not overpower your composition, particularly in your formal portrait of the bride. The bride should look comfortable holding her bouquet and it should be an important and colorful element in the composition. Give the bride some guidance as to how she should hold her bouquet for the best effect. It should be placed in front with her hands behind it, making sure it is held high enough to put a slight bend in her elbows, keeping her arms slightly separated from her body.

THE BRIDE SHOULD BE CLOSEST

When you have a choice—and the photographer always has a choice—position the bride closer to the camera than the groom. This keeps the (usually) smaller bride in proper perspective and allows her dress to be better seen.

A CASE OF THE NERVES

The wedding day is usually a tense time and people tend to wear those emotions on their sleeves. Your demeanor and professionalism should be a calming and reassuring presence, especially to the bride. Be calm and positive, be funny and lighthearted—and above all, don't force the situation. If you can see that demanding to make a picture is going to really upset people, have the will power to hold off until later. Remember that positive energy is contagious, and can usually save a sticky situation.

THE DRESS

In most cases, the bride will spend more money on her wedding dress and more time on her appearance than for any other occasion in her entire life. She will often look more beautiful than on any other day. The photographs you make will be a permanent record of how beautiful she looked on her wedding day. Do not ignore the back of the dress—dress designers incorporate as much style and elegance in the back of the dress as the front. Be sure to get the bridesmaids' gowns as well.

DRESS LIKE A GUEST

This is award-winning photographer Ken Sklute's advice. A suit or slacks and a sports jacket are fine for men; and for women, business attire works well—but remember that you have to lug equipment and move freely, so don't wear restrictive clothing. Many wedding photographers (men and women) own a tux and wear it for formal weddings.

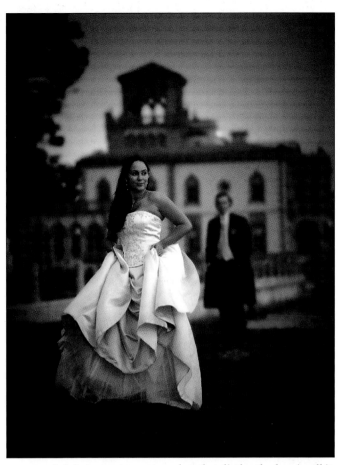

ABOVE—*It is important to capture shots that display the dress in all its splendor. Here, Tibor Imely used the beautiful rays of the setting sun to show the form and folds of the gown.* FACING PAGE TOP—*Little moments like this one make the overall coverage of the wedding day richer and more meaningful. Photograph by Bruce Dorn.* FACING PAGE BOTTOM LEFT—*Positioning the bride in front of the groom keeps the size relationship consistent and shows off the wedding gown. Photograph by Jerry D.* FACING PAGE BOTTOM RIGHT—*Brett Florens captured the couple by a pool and added mist rising from the water to give the image a very dreamy, romantic effect. He made the image with his Nikon D2X and 70–210mm f/2.8 lens.*

FLASH SYNC CHECK

Check and recheck that your shutter speed is set to the desired setting for flash sync. This is particularly important with focal-plane shutters, because if you set a speed faster than your X-sync, you will get half-frame images—a true nightmare. It has happened to everyone who has ever shot a wedding, but it's certainly preventable with a little vigilance. Check the shutter speed every time you change film, lenses, or CF cards. If you're like most photographers, you'll check it more often—every couple of frames.

GETTING THE BRIDE INTO A CAR

This tip is from Monte Zucker, who says, "I learned a long time ago how to help the bride sit in a car without wrin-

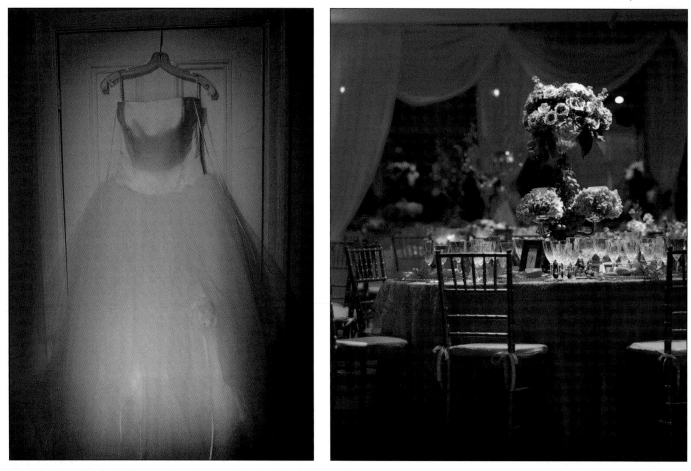

LEFT—*A popular shot is the gown hanging on the back of the bedroom door. Frank Cava captured this shot with the white balance set to daylight under the tungsten illumination to get a warmer rendition.* RIGHT—*Charles Maring is a master at photographing the decorations on wedding day. He employs a tripod, available light, and bounce flash and detailed post-production treatment.* FACING PAGE—*Here, Mauricio Donelli wanted to capture the textures of the gown and the rope in the bouquet, so he employed a softbox outdoors to give soft, side lighting. He overrode the daylight exposure (making the flash the main light) so that it looked more like dusk. He then posed his bride like a top model.*

kling her gown. I have her lift up the back of her gown and put it around her shoulders. This forms a sort of cape. It also picks up the back of the gown, so that when the bride sits down she's not sitting on her dress and wrinkling it. Here's the final trick. She has to back into the car. Now, even if she were to pick up some dirt as she enters, it would be on the underside and never show."

■ FLOWERS
While waiting around to go upstairs to photograph the bride getting ready at her home, don't just stare out a window. Arrange for the flowers to be delivered early and use the time to set up an attractive still life for the album while you wait.

■ LATE BRIDES
If the bride is late (as brides usually are), do not hold things up further. Simply make a series of photojournalis-

tic images of her arrival and plan to make the previously arranged shots later in the day.

■ THE KISS
Whether you set it up, which you may have to do, or wait for it to occur naturally, be sure to get the bride and groom kissing at least once. These are favorite shots and you will find many uses for them in the album. For the best results, get a good vantage point and make sure you adjust your camera angle so neither person obscures the other.

■ LIGHT BULBS
Many hotels use coiled fluorescent bulbs instead of tungsten-filament bulbs in the room lamps. Be on the lookout for them because these fluorescents will not have the same warming quality as tungsten bulbs and could turn things a bit green. You may have to change your white balance, or use automatic white balance in these situations.

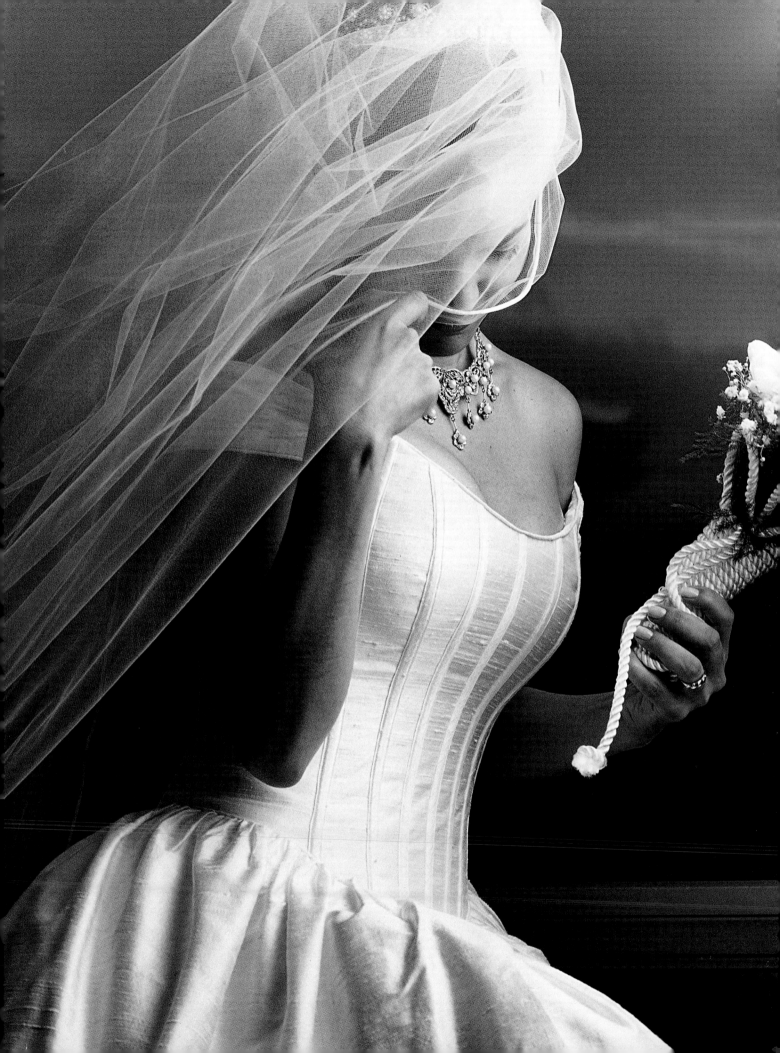

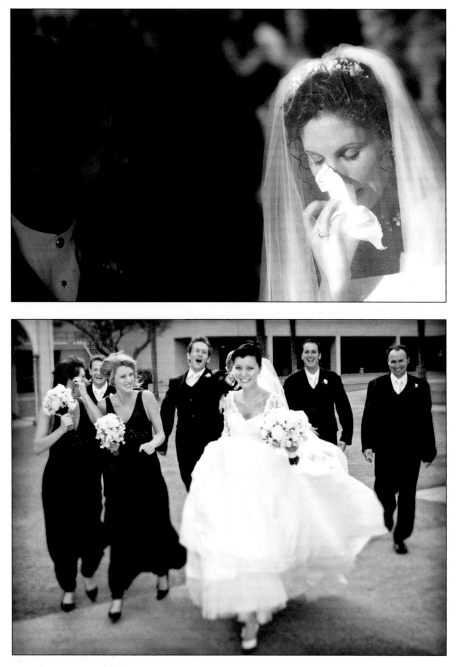

also avoid sitting on them, as this will also alter the shape of the coat. If he has shirt cuffs, they should be pulled down to be visible. And if sitting cross-legged, make sure his socks are pulled up high enough so that you don't see any of his bare leg.

■ SPEEDING UP YOUR GROUPS

One solution for making your formal groups is to make them at the church door as the couple and bridal party emerge. At this moment, everyone in the wedding party is present and the parents are nearby. If you don't have a lot of time to make these groups, this is a great way to get them all at once—in under five minutes.

■ REMEMBERING NAMES

Photographer Frank Frost believes that you should master the names of your clients and the wedding party. Photography is not just about the work, it also involves people skills. He says, "There can be twenty people in the wedding party and I'm able to call everybody by name. It makes a big impression and, by the end of the evening, everybody is my friend."

■ SEATED MEN

Whenever a man is seated, it's a good idea to check his clothes. He should have his jacket unbuttoned to prevent it from looking tight. If wearing a tux with tails, he should

■ STUDY WEDDING MAGAZINES

Top wedding photographers constantly review the editorial photography found in both national and regional bridal magazines. Every bride looks at these magazines, dreaming that her wedding will look just like what she sees in them. Styles, techniques, new trends, and the "coolest" poses are all there for you to review.

A good source of poses for men are the gentlemen's magazines, like *GQ* or *Esquire*. The range of poses runs from intellectual to macho and you'll pick up some good ideas, particularly for the groom's portrait and the groom and groomsmen group.

▪ THE TRAIN

Wedding dresses often include flowing trains. It is important to get several full-length portraits of the train draped out in front in a circular fashion or flowing behind. Include all of the train, as these may be the only photographs of her full wedding gown. If making a formal group, this might also be an appropriate time to reveal the full train pulled to the front. One way to make the train look natural is to pick it up and let it gently fall to the ground.

▪ THE VEIL

Make sure to get some close-ups of the bride through her veil. It acts like a diffuser and produces romantic, beautiful results. Lighting should be from the side rather than head-on to avoid shadows on the bride's face caused by the patterned mesh.

▪ GUEST PICTURES

Guests often approach the wedding photographer to have pictures made of themselves. These images rarely produce sales and can take the photographer's attention away from the paying clients: the bride and groom. This tip for dealing with such situations is from Monte Zucker. "What I do is to discuss this with the bride and groom prior to the wedding," he says. "I explain to them that it happens all the time, but I'd usually get stuck with the pictures afterwards, because the guest would never place an order. What I finally began doing is to either make the bride and groom responsible for paying for 'special-request' pictures, or I'd make financial arrangements directly with the guests before I would take the picture. Usually, they'd select the latter option."

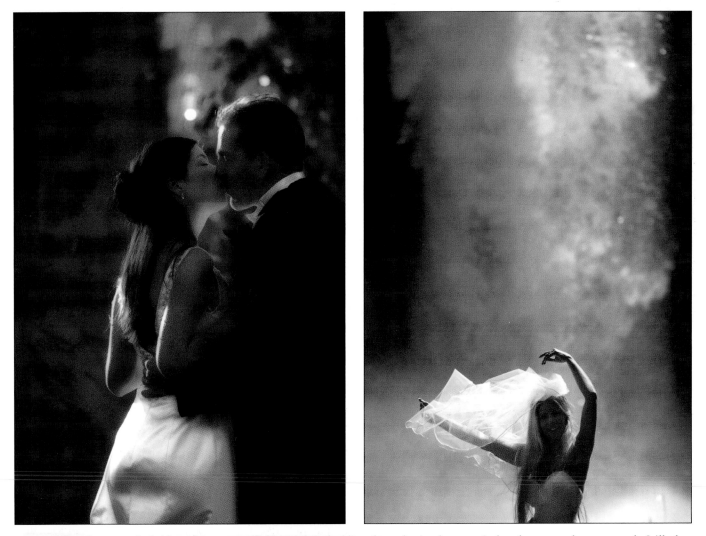

LEFT—*Believe it or not, the bride and groom rarely kiss on their wedding day—the simple reason is that they are too busy to smooch. Still, these shots remain very popular among brides. David Beckstead always makes sure he gets plenty of these images because they always sell and because he believes in capturing a romantic rendition of the day's events.* RIGHT—*The veil is an integral part of the wedding gown. David Beckstead highlighted the short veil by backlighting it and the bride against a waterfall. The effect is a very unusual but effective bridal portrait.*

11. PROOFING AND PRINTING

*T*here are many forms of proofing in use today. Regardless of the mode of presentation, though, editing is essential. Present only those proofs from the wedding that are high quality images. Concise editing will guarantee that the couple will be delighted with how great the pictures are. Because you're the pro, the couple will look to you for advice on those difficult picture decisions. Because you know the dif-

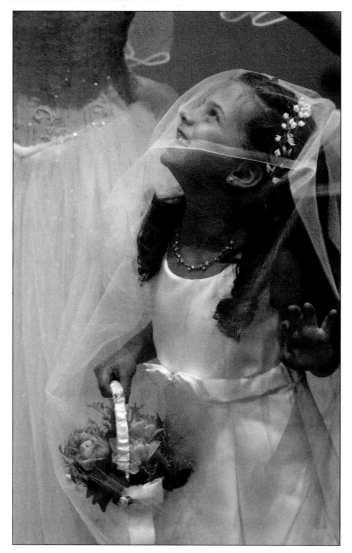

It's hard to imagine the bride and groom not ordering this wonderful shot of their little flower girl with her front tooth coming in. Photograph by David Beckstead.

ference between a good pose and bad, good lighting and bad and so on, your opinion will be important to them.

■ PROOFS

Paper Proofs. Until recently, paper proofs were the preferred method for reviewing a client's work. With paper proofs, you are offering a representation of the final image to the customer, but without the benefits of color correction, retouching, and print finishing. Paper proofs not only fail to reflect the quality of the final image, they are a liability in an age when everyone seems to own a scanner.

Multimedia Proofing. Some photographers take it a step further, producing a multimedia show of the wedding proofs. Brian and Judith Shindle have a very low-pressure, understated sales technique. After the wedding, the Shindles put on an elegant multimedia "premier night" party with catered food and fresh flowers and they invite guests from the wedding party. The event is held in the studio's elaborately decorated viewing room. This elegant event produces great sales success, because it doesn't resemble a sales session at all.

Other photographers use commercial software, such as the Montage® system, which produces projected images in a "suggested" album. First, the digital album images are brought into templates of any configuration, much like a page-layout program. The images are projected onto a large LCD screen already conceived as an album. Most couples, when they see the finished presentation, will want to buy the album with only minimal changes.

Digital Proofs. Charles Maring accepts the fact that clients copying proofs is a reality. Maring has his digital images printed by the family-owned lab, Rlab. Each 2½ x3½-inch photograph is numbered with the file number at the bottom right corner of the print. According to Maring, one might copy a wallet-size print, but it would be a hassle to cut out the image from the proof book. These contacts come bound in book form with matte board for the covers and the whole concept costs only $.25 per image.

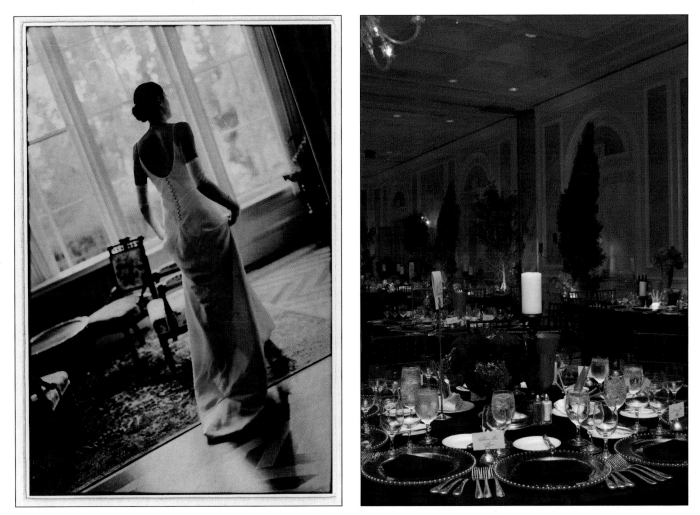

LEFT—*One of the reasons to create an image like this is so that it can be sold to the couple as fine art, over and above their print and album purchases. A fine image like this could hang in the couple's new home or either parent's home. Photograph by Becky Burgin. Fine art print made by Robert Cavalli.* RIGHT—*This image exemplifies why the successful wedding photographer is so handsomely rewarded: he or she must be an expert at many different photographic disciplines. Joe Photo makes sure to capture the place settings and table settings before the guests enter the reception area. He does this partially so he can reward the various vendors (who also help him network with other brides) with a print, but also so he can add depth and uniqueness to his albums. This lavish exposure was made with a tripod-mounted D1X and 28mm lens. The image was exposed for ⅙ second at f/4.5 to fully open up the shadows and record detail throughout the image. The "correct" color of the foreground table was achieved by firing a bounce flash during the long exposure.*

This system takes very little time. Instead of spending hours putting proofs in a proof album, the proofs come back deliverable and bound, book-style.

Maring then designs and prints a suggested wall portrait for the cover of the book. When they offered this concept to their couples instead of proofs, every couple preferred the smaller digital prints. No one wants to carry around a thousand full-size proofs in two full-size albums—and no photographer wants to pay for full-size proofs or proof albums, then spend hours on end organizing the images.

Other Options. Digital projection involves a LCD projector and slide show treatment or DVD of the proofs, which is then given to the clients to take home after viewing the show. Both of the above methods involve scheduling an appointment for the bride and groom to view the proofs. Once the images have been viewed, many photographers send their clients away with a digital proof book. Using your digital files, you can print contact sheets of the images (that include the file name and number). These can be placed in a small but nice proof album for the couple to take with them.

■ PRINTING

Many photographers have the equipment and staff to print their own wedding images in house. It gives them a level

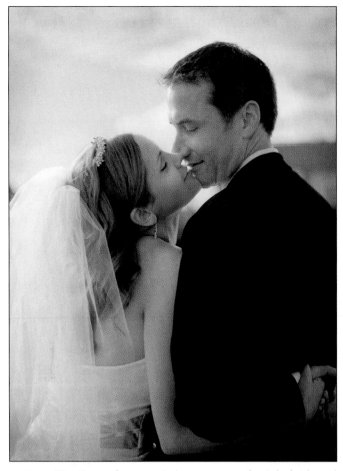

ABOVE—*Very few truly romantic images are made of the bride and groom on their wedding day. The reason is that the bride, groom, and photographer are usually too busy. This image by Natasha Staszak is a definite keeper for the bride and groom.* RIGHT—*This is an example of a 32x70-inch print made by David Williams' lab, the Edge. Note how there isn't a square inch of wasted space. The print is made on a Durst Lamda at 400dpi, to deliver the best photographic quality.*

of control over the process that even the best lab cannot provide.

Other photographers have devised interesting ways to save money by employing the lab's wide-format printers. David Anthony Williams, for example, uses a lab called The Edge, in Melbourne, Australia. The Edge uses a Durst Lamda Digital Laser Imager, which produces full continuous-tone images straight from Macintosh or PC files on photographic media. Williams prepares Photoshop files of finished album pages, panoramas, small prints and proofs on a 32-inch wide file (the width of the lab's Lamda), utilizing every square inch of space. The 32x32-inch, 32x50-inch, or 32x70-inch files are output at one time very inexpensively. The lab even trims all of the images for Williams, thus increasing his productivity and lowering his costs.

David follows the guidelines of the lab and works in the Adobe RGB (1998) color space at the gamma recommended for either PCs or Macs. The files may be TIFFS or JPEGs at 200 or 400dpi. The Edge will even provide a calibration kit on request to better coordinate your color space to that of the lab's.

The big payoff of the wedding day is the album. It's what every wedding photographer has worked so hard to produce and it is the object that the couple will cherish for a lifetime. The wedding album is changing drastically, as you will see. Still, album design is basically the same thing as laying out a book, and there are some basic design principles that should be followed.

Like any good story, a wedding album has a beginning, a middle, and an end. For the most part, albums are chronological. However, there are now vast differences in the presentation, primarily caused by the digital page-layout process. Often, events are jumbled in favor of themes or other methods of organization. There must be some logic to the layout, though, and it should be apparent to everyone.

■ ALBUM TYPES

Traditional Albums. Album companies offer a variety of different album-page configurations for placing horizontal or vertical images in tandem on a page, or combining any number of small images. Individual pages are post-mounted and the album can be as thick or thin as the number of pages.

TOP—*Magazine-style albums allow you to incorporate digitally designed composites on every page. Note that these pages are not bleed-mounted so that the pages can be handled more frequently without showing signs of wear. Photo courtesy of Albums Australia.* RIGHT—*Digital albums come in all sizes and bindings. Note the little "purse" albums, which go to work with the new bride instead of the priceless full-size album. Photo courtesy of Digicraft Albums.*

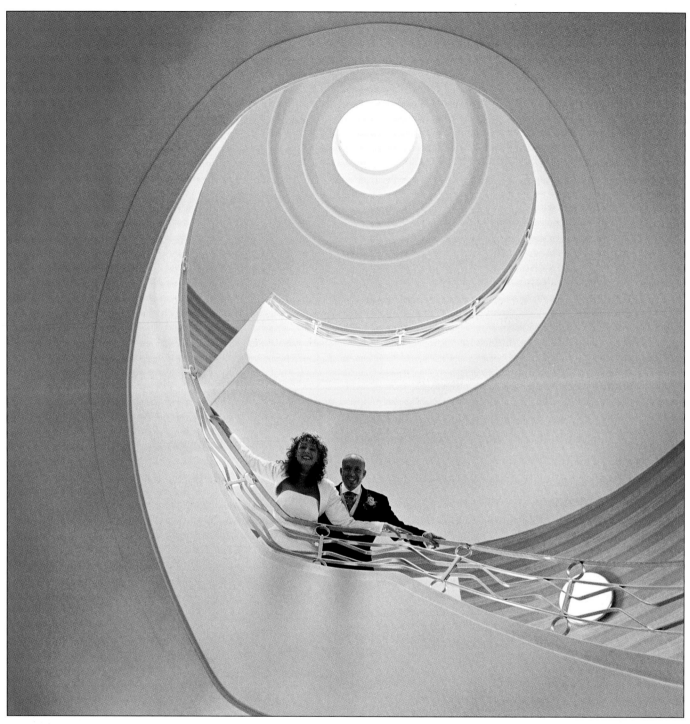

Learning to recognize shapes as page elements will make you a better designer. Here, a perfect C (or inverted-9) shape makes this an ideal left-hand page. As a single image it has uniqueness and strong design, but in a layout, the eye will follow the spiral staircase through to the right-hand page. Photo by David Worthington.

Bound Albums. In a bound album, the images are permanently mounted to each page and the book is bound by a bookbinder. These are elegant and very popular. Since the photos are dry-mounted to each page, the individual pages can support any type of layout from "double-truck" (two bleed pages) layouts to a combination of any number of smaller images.

Library Binding. Yet another type of album uses conventional photographic prints made to the actual page size. These prints are then mounted, trimmed and bound in an elegant leather album that is actually a custom-made book. If you want to create album pages with multiple images, your lab must prepare these prints to size before submitting them to the album company for binding.

Mini Albums. Australian wedding photographer Martin Schembri creates what he calls a mini-magazine book, a miniature version of the main album that is small enough for brides to pop in their handbags to show all of their friends. Being so portable, the mini albums get far more exposure than a large, precious album. It also works as a great promotion for the photographer.

Digital Output. Digital output allows the photographer or album designer to create backgrounds, inset photos, and output the pages as complete entities. Sizing the photos does not depend on what size mats you have available, as you can size the photo infinitely on the computer. Once the page files are finalized, any number of pages can be output simply and inexpensively. Albums can be completely designed on the computer in Photoshop using plug-ins that feature drag and drop templates.

■ DESIGN PRINCIPLES

Visual design has one and only one purpose only: to keep the viewer's eye and concentration on the page(s) for longer than it takes to digest the basic information. Design elements exist to coax the imagination of the eye/brain to play along with the designer's master plan. Most of what happens when you view a page is subliminal—you don't realize you are being manipulated in a sensory way. Some of the techniques are bold and demand your attention, some are subtle and create a pleasing response in the viewer. But make no mistakes, like any page-layout designer, the wedding album designer faces the same challenges—to keep the viewer amused and involved in the content.

Design Elements. *Left- and Right-Hand Pages.* Look at any well-designed book or magazine and study the images on the left- and right-hand pages. They are decidedly different but have one thing in common. They lead the eye into the center of the book, commonly referred to as the "gutter." These layouts use the same design elements photographers use in creating effective images—lead-in lines, curves, shapes, and patterns. If a line or pattern forms a C shape, it is ideal for the left-hand page, since it draws the eye into the gutter and across to the right-hand page. If an image is a backwards C shape, it is ideal for the right-hand page. Familiar shapes like hooks or loops, triangles or circles are used in the same manner to guide the eye into the center of the two-page spread and across to the right-hand page.

There is infinite variety in laying out images, text, and graphic elements to create this left-to-right orientation. A series of photos can be stacked diagonally, forming a line that leads from the lower left-hand corner of the left page to the gutter. That pattern can be mimicked on the right-hand page, or it can be contrasted for variety. The idea is

Sequences can be an effective means of telling a secondary story within the story in the wedding album. This beautiful triptych was made by Becky Bergin.

Three very simple images and a bold graphic set up the interplay of motion, tension and balance. This is gifted design. Notice how the small but bright red rose achieves visual prominence, but is balanced by the letter G, which not coincidentally, has the same tilt as the rose. Diagonals, which are powerful elements, contrast verticals and vie for your eye's attention. Photographs and design by Yervant.

to create visual motion—the eye follows logically arranged lines and shapes from one point to the next across two pages.

Greater interest can be attained when a line or shape that is started on the left-hand page continues through the gutter, into the right-hand page and back again to the left-hand page. This is the height of visual movement in page design. Visual design should be playful and coax the eye to follow paths through the visuals on the pages.

Direction. Remember that, in Western civilization, we read from left to right. We start on the left page and finish on the right. Therefore, good page design starts the eye at the left and takes it to the right—and it does so differently on every page.

Image Sizes. When you lay out your album images, think in terms of variety of size, sometimes called modulation. Some images should be small, some big. Some should extend across the spread. Some, if you're daring, can even be hinged and extend outside the bounds of the album. No matter how good the individual photographs

are, the effect of an album in which all the images are the same size is monotonous.

Variety. Variety can be introduced by combining black & white and color—even on the same pages. Try combining detail shots and wide-angle panoramas. How about a series of close-up portraits of the bride as she listens and reacts to the toasts on the left-hand page, and a right-hand page of the best man toasting the newlyweds? Don't settle for the one-picture-per-page theory. That's very old school and it's static and boring.

Visual Weight. You can create visual tension by combining dissimilar elements (big and small, straight and diagonal, color and black & white). Try different things. The more experience you get in laying out the images for the album, the better you will get at presentation. Study the albums presented here and you will see great creativity and variety in how images are combined and the infinite variety of effects that can be created.

Tension and Balance. Just as real and implied lines and real and implied shapes are vital parts of an effective de-

sign, so are the "rules" that govern them: the concepts of tension and balance. Tension is a state of imbalance within an image—a big sky and a small subject, for example, is a situation with visual tension. Balance is where two items, which may be dissimilar in shape, create a harmony within the photograph because they are have more-or-less equal visual strength.

Double-Trucks and Panoramic Pages. Using images in the panoramic format can add great visual interest, particularly if using the bleed-mount digital or library-type albums (see pages 110–11). Panoramics cannot be created as an afterthought, however, since the degree of required enlargement will be extreme. Panoramics must be planned and good camera technique is essential. If shooting a group as a panoramic, focus one-third of the way into the group for optimal depth of field and use a tripod to ensure the image is sharp. Make sure that you have enough depth of field to cover front to back in the group. If the bride and groom are the center of your panoramic shot, be sure to offset them so that they don't fall in the gutter of a panoramic or two-page spread.

Details. Contemporary wedding albums almost always feature many more images than a standard wedding album. These images are often combined, montage style, in an album or on a page to lend a sense of wealth and richness to the story. Image details make up the bulk of such colorful layouts. Once your mindset is established that these types of images will be part of the album, you begin to see them everywhere throughout the day. They can be of the wedding cake—a favorite—or the bride's shoes, or the bouquet, or dozens of other items seen on the wedding day. Often, the details are what make a wedding an elegant affair.

■ DESIGN TEMPLATES

Photographer Martin Schembri has created a set of commercially available design templates that come on four different CDs and help photographers create elegant

Yervant often uses graphic elements to balance pages. Here, he used a huge script letter T, for Tanya, that is suggestive of the pose of the actual Tanya on the right. The eye ping-pongs back and forth between the letter T and the bride.

album-page layouts in Photoshop. The design templates are drag-and-drop tools that work in Photoshop and four different palettes are available: traditional, classic, elegant, and contemporary. The tools are cross-platform, meaning that they can be used for Macs or PCs, and are customizable so that you can create any size or type of album with them. More information can be found at www.martin schembri.com.au.

Yervant's Page Gallery software has hundreds of different templates. These incorporate artistic designs and layout options designed by Yervant, one of the most high-profile wedding and portrait photographers of Australia. All you have to do is choose an image file, then the software will crop, resize, and position the image into your choice of layout design . . . all within minutes.

Page Gallery is strictly for use by photographic studios that become registered and licensed users. It is not available to labs except by special licensing arrangement, meaning that if you purchase the software, you will be assured that every other wedding photographer on the block won't be putting out similar albums. For more information, visit www.yervant.com.

■ CHARLES MARING: THE DIGITAL ALBUM

Charles Maring describes himself as a "nonfiction" wedding photojournalist. He's a patient, reactive photographer who records moments unfolding rather than dreaming up an idea and then acting upon it. He feels that every photographer has to please the families of the couple, so he and wife Jennifer segment a quarter- to half-hour of the day for family and couples' portraiture.

His shooting style is to stay quiet and observant—but with a flair. "What separates me from other photographers is not only the photography, but also my print quality and imagination," Maring explains. By imagination, he means the digital skills of post-capture manipulation. He continues, "For example, you can sample colors from within your photograph so that every image in your album has components of that complement. You can take the time to burn or dodge, blur or soften, 'impression-ize' or desaturate, color blend or color wash, and come up with a more personal artistic interpretation of a real moment. Portrait-quality candids will be the new standard of excellence for future years of album and print competition."

Maring relishes these new capabilities. He is able to detail his product above and beyond standard retouching and

This stunning page by Australian wedding photographer Yervant combines a bleed image (one that extends past the borders of the page) on the right with inset photos on the left. Yervant used the chiffon of the gown as a background for the insets. Notice how he used varying densities of the background to provide balance to the much larger image on the right.

Yervant's Page Gallery templates are flexible and efficient, helping you to design your albums without restriction. Built around drag-and-drop workflow, choosing from a built-in browser, the program is a joy to work with.

offer creative products. Today, every image that leaves his studio is digital. Whether they capture the images with Nikon DSLRs or scan the negatives taken with their Hasselblads, Maring says there is no substitute for print quality. "More than anything else, I watch my clients leave our studio feeling like they have finally received the product and the service that other studios simply failed to be able to offer." His clients are happier and so is he!

"There is only one problem: workflow. I was doing all of the work myself, and to top it off I had to pay a higher price for digital printing than analog." As a result, Charles Maring is now a graphic artist, photographer, designer, and printer. "A digital lab has little maintenance so I can hold my tolerances to a higher standard than a pro lab that is rushing to get orders out," he says. "Having a complete understanding of my capabilities has also raised the value of my work. The new photographer that embraces the

tools of design will simply be worth more than a mere cameraman or camerawoman," he says.

Here are some goals that Maring tries to use in his album designs.

Keep it Simple. Each page should convey a simple statement or story. Don't try to clutter pages with too many photos. Instead, narrow the focus and use those that make the best statement of the moment.

Dream a Little. With digital, we have tools like motion blur, Gaussian blur, and even smart blur, and film "looks" that we could never have used before. We have old films, new films, grainy films and ultrasharp films all within one digital capture—if you dream a little. Now, Maring says he thinks more like a cinematographer—he considers the moment he sees on the computer screen and creates what it truly looked like. This is not fiction, it is design around the best depiction of the moment.

Use Chapters. Every story has chapters. Maring uses scene setters that open and close each one. Within the chapters, he includes a well-rounded grouping of elements such as fashion, love, relationships, preparation, behind the scenes, and ambiance. These are the key elements that he keeps in mind at all times, both when documenting the day as well as when designing the story.

Become a Painter. Charles Maring has spent time studying both new and old painters. He discovered that the rules we apply to photography get destroyed in art because in art there are no rules. In some of the most incred-ible paintings with depth and dimension, for example, the artist would blow out the highlights of the scene, or possibly saturate small areas of the leaves in a tree, or maybe exaggerate an element to bring a statement to life. Artists think about the details. Maring now finds himself stepping out of the photographic box and using the painterly tools to work the print to its full potential.

Color Sampling. One of Charles Maring's tricks of the trade is to sample the colors of the images on his album pages in Photoshop. This is done using Photoshop's eyedropper tool. When you click on an area, the eyedropper reveals the component colors in the color palette. He then uses those color readings for graphic elements on the page he designs with those photographs, producing an integrated, color-coordinated design on the album page. If using a page-layout program like Adobe InDesign, those colors can be used at 100 percent or any lesser percentage for color washes on the page or background colors that match the Photoshop colors precisely.

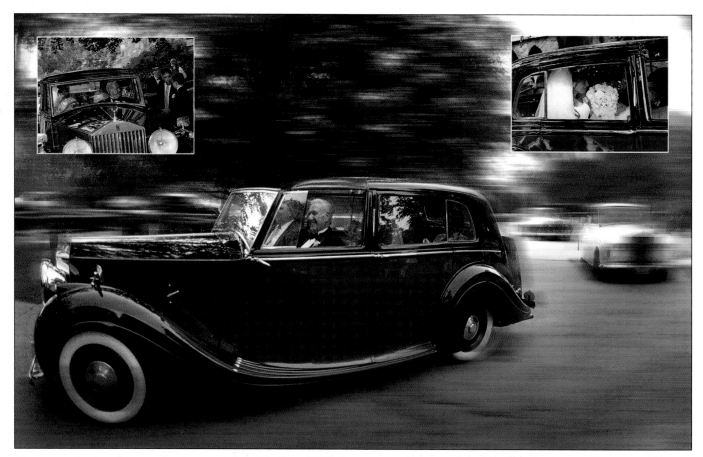

You can see the thought process in the page design. The fleet of Rolls-Royces passes the point where Charles is shooting and he shoots with a very wide-angle lens, bending and distorting the lines of the car to conform to a double-truck treatment. He enhanced the feeling of speed with motion blur in Photoshop. The spread is balanced with two detail insets, one per page. This is a terrific example of page layout. Photographs and design by Charles Maring.

David Williams puts together unique image constructions he calls "detail minis." Here is an album page using sixteen detail minis. There is crafty design work in the assembly of the images—the photographer/designer's goal always to keep the eye in motion and to keep the subject matter rich and interesting. He records all of these minis with a 50mm f/1.2 lens wide open to minimize depth of field and to speed up his shooting.

■ DAVID ANTHONY WILLIAMS: A MAJESTIC APPROACH

One of the elements David Anthony Williams brings to his albums is pure life. His album pages are living, moving entities. This design philosophy is the same as his theory about wedding photography. "If you've studied and practiced posing, observed lighting, and learned to assess an environment, you're halfway there. But how good are the images going to be if your priorities are with the technical, and not with the activity and life happening before you?"

Williams is practiced at the art of image construction. He says, "Advertising photographers deal with them every day. But still we come back to the essential of a people picture that goes far beyond technique. And that is the photographer giving life to the creation they have assembled."

His image constructions, for example, might be of the many faces of the bride's emotions, with the wedding dress as a blurry backdrop and inset photos defining her many moods. Or he might do a montage of details—the ring, the flowers, the fabric of her dress—and combine them with a pensive portrait of the bride, imagining these things.

Williams also uses the technique of providing a series of eight or sixteen identically sized images across two pages— a window-frame effect. The pages are laid out in perfect, brutal symmetry. However, the motion and direction come from the elements within the pictures or the content of the pictures.

He will also contrast this symmetry by creating a series of vertical image constructions within the horizontal space of the album page. Almost like raindrops, these panels de-

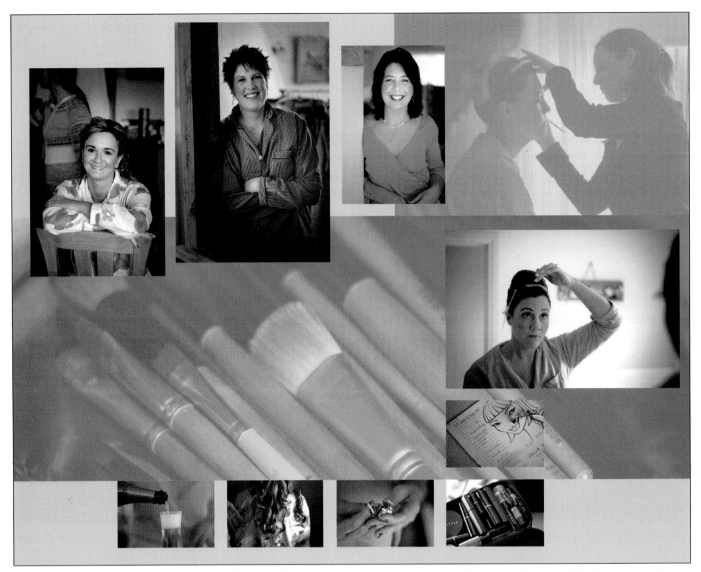

David Williams brings sophistication to his albums, employing transparency, overlapping, and lots of visual motion. He like to use small color images to balance large monotone areas and he uses a very light gray panel on each page of the album to help provide a consistent style and uniformity throughout.

mand your attention—to examine both the content of the images and the overall flow of the design. They contrast the starkness of the white horizontal space, giving the page a startling quality.

Williams studies the great editorial portraits of our time, citing *Vanity Fair* as the ultimate in this genre. He says these portraits teach us the importance of interaction and communication between photographer and subject. He sums up his outlook this way: "The coming together of all our abilities makes us great photographers. But the absence or minimization of life in our subjects makes us professionally adequate."

P hotographers who refused to accept the demeaning label of "weekend warrior" and organizations like WPPI, whose primary goal was to raise the status and proficiency of wedding photography, can feel proud that the genre is now at the top of the heap. Photographers who are friends of mine confide that their fee structure for weddings is doubling, sometimes tripling from one year to the next.

Although some might see this prosperity as cyclical, there is no doubt that wedding photography will continue to change. The way that wedding photojournalism has evolved from strict noninterference with the events to a more directed, choreographed discipline in just a few short years is proof that the evolution will be ongoing. My guess is that editorial photography, fashion photography, and wedding photojournalism will continue to intermingle, producing new and interesting styles.

There is no doubt that the wedding day is one of the most appealing days in anyone's life. Large sums of money and many months of preparations go into making it a once-in-a-lifetime affair. And with major celebrities like Oprah sponsoring "million dollar weddings," the popularity of big, expensive weddings does not seem to be slowing down at all.

There is no doubt that digital technology is responsible for the creative explosion in today's wedding photography. One-of-a-kind digital albums have become so popular with brides and families that traditional wedding albums seem almost a thing of the past. Digital is so pervasive that only purists will continue to shoot film. Workflow models to cope with the additional time required by digital capture and design will no doubt keep pace and evolve as well, and so will the software and hardware needed to make the job easier and more efficient.

Will the wedding photographer remain among the upper echelon of the photographic elite? Nobody knows. But one thing is for sure, wedding photographers and their art form will never return to the days of second-class citizenship.

THE PHOTOGRAPHERS

*T*o illustrate this book, I have called upon some of the finest wedding photographers in the world. Most of them have been honored repeatedly by the country's top professional organizations, the Professional Photographers of America (PPA) and Wedding and Portrait Photographers International (WPPI). I want to take the opportunity to thank all of these great photographers for their participation in this book. Without them, this book would not have been possible. While no book can equal years of wedding photography experience, it is my hope that you will learn from these masters how the best wedding photography is created—with style, artistry, technical excellence, and professionalism.

Stuart Bebb—Stuart Bebb is a Craftsman of the Guild of Photographers (UK) and has been awarded Wedding Photographer of the Year in both 2000 and 2002, with exciting and innovative wedding albums. In 2001, Stuart won *Cosmopolitan Bride's* Wedding Photographer of the Year, in conjunction with the Master Photographers Association. He was also a finalist in the Fuji Wedding Photographer of the Year competition. Stuart works with his wife Jan, who creates and designs all their albums.

Becker—Becker, who goes by only his last name, is a gregarious wedding photojournalist who operates a successful studio in Mission Viejo, CA. He has been a featured speaker at WPPI and has also competed successfully in international print competition.

David Beckstead—David Beckstead has lived in a small town in Arizona for over twenty years. With help from the Internet, forums, seminars, WPPI, Pictage, and his artistic background, his passion has grown into an international wedding photography business. He refers to his style of wedding photography as "artistic photojournalism."

Marcus Bell—Marcus Bell's creative vision, natural style, and sensitivity have made him one of Australia's most revered photographers. It is this talent, combined with his natural ability to make people feel at ease in front of the lens, that attracts so many of his clients. His work has been published in *Black White, Capture, Portfolio Bride,* and countless bridal magazines.

Joe Buissink—Joe Buissink is an internationally recognized wedding photographer from Beverly Hills, CA. Almost every potential bride who picks up a bridal magazine will have seen Joe Buissink's photography. He has done numerous celebrity weddings, including Christina Aguilera's 2005 wedding, and is a multiple Grand Award winner in WPPI print competition.

Becky and Erika Burgin, APM—Becky Burgin is the mother of Alisha Todd and Erika Burgin. All three are award-winning wedding photographers. While Alisha works with husband Brook Todd, Erika works with her mom Becky in another successful wedding photography business. Both Erika and Becky recently achieved their Accolades of Photographic Mastery from WPPI.

Ron Capobianco—Ron Capobianco is a commercial photographer whose work includes fashion, beauty, editorial, architectural, and annual-report images. This background is an asset in his wedding and portrait work, where he also strives to make people look their absolute best. His wedding work has been seen in *Modern Bride, Brides, Wedding Bells, Manhattan Bride,* and other bridal publications.

Anthony Cava, BA, MPA, APPO and Frank Cava—With his brother Frank, Anthony Cava owns and operates Photolux Studio, originally founded by their parents thirty years ago as a wedding and portrait studio. Anthony is one of the youngest Master of Photographic Arts (MPA) in Canada and won WPPI's Grand Award with the first print that he ever entered in competition. Frank is a successful and award-winning wedding and portrait photographer. Both are members of the Professional Photographers of Canada and WPPI and reside in Ottawa, Ontario, Canada.

Jerry D—Jerry D owns and operates Enchanted Memories, a successful portrait and wedding studio in Upland,

CA. Jerry has been highly decorated by WPPI and has achieved numerous national awards since joining.

David De Dios—When David De Dios was five, a man with a strange box asked him to look into it and smile. David was fascinated when the box created an image of him. His passion for photography was sparked and he wanted to do the same for other people. When David is not photographing weddings, he is photographing editorial and fashion. David's studio is located in Phoenix, AZ.

Mauricio Donelli—Mauricio Donelli is a world-famous wedding photographer from Miami, FL. His photographs have been published in *Vogue, Town & Country,* and many national and international magazines. Mauricio has photographed weddings around the world.

Bruce Dron and Maura Dutra—Bruce Hamilton Dorn of iDC Photography has twenty years of Hollywood filmmaking experience, which has shaped his cinematic-style wedding day coverage. As a member of the Director's Guild of America, Bruce has worked with clients like McDonald's, Sony, Budweiser, ATT, Ford, Kirin, Chevrolet, Mitsubishi, and Coca-Cola. With his artistic partner and wife Maura Dutra, Bruce now offers this award-winning expertise to a very select group of artistically-inclined wedding clients.

Scott Eklund—Scott Eklund makes his living as a photojournalist for the *Seattle Post-Intelligencer.* He specializes in sports, spot news, and feature stories, but recently got interested in photographing weddings, deciding that his skill set was "portable." He has now won numerous awards for his wedding photography, which relies on a newspaperman's sense of timing and story-telling.

Brett Florens—Having started his career as a photojournalist, Brett Florens has become a renowned international wedding photographer, traveling from his home in South Africa to Europe, Australia and the U.S. for the discerning bridal couple requiring the ultimate in professionalism and creativity. His exceptional albums are fast making him the "must have" photographer around the globe.

Jerry Ghionis—Jerry Ghionis of XSiGHT Photography and Video has established himself as one of Australia's leading photographers. In 1999, he was honored with the AIPP (Australian Institute of Professional Photography) award for best new talent in Victoria. In 2002, he won the AIPP Victorian Wedding Album of the Year award, and in 2003 he repeated that award and also earned the Grand Award in the Album competition at WPPI. He has won the Album Competition several times since then.

Greg Gibson—Greg Gibson's has worked for some of the largest news organizations in the world, documenting three Presidential campaigns, the Monica Lewinsky scandal, the Gulf War, numerous Super Bowls, and much more. Greg has twice received the highest award in journalism: the Pulitzer Prize. Despite numerous offers to return to journalism, Greg is happy shooting weddings, finding it is the perfect genre to continually test his skills.

Alfred Gordon—Recognized as one of Florida's top-ten photographers in 2001, 2002, and 2003, Al Gordon has photographed weddings throughout the Southeast. He holds the Master Photographer and Photographic Craftsman degrees from the PPA. He is also a Certified Professional Photographer from the PPA, and has earned the AOPA degree from WPPI. He received the coveted Kodak Trylon Gallery Award twice, and has images in the coveted ASP Masters Loan Collection.

Steven Gross—Steven Gross owns Real Life Weddings and Steven E. Gross & Assoc. Photography in Chicago, IL. His images have been featured on ABC's *Good Morning America, Esquire,* and in the intro for NBC's *Three Sisters.* He has published three books: *Zhou Brothers* (Oxford University Press, 1995), *In the Studio* (Oxford University Press, 1995), and *Black and White: Defining Moments of Weddings and Marriage* (Mohawk Paper, 2002).

Tibor Imely—Imely Photography is one of the most prestigious studios in the Tampa Bay area. Tibor has won numerous awards, including his most recent: the Accolade of Photographic Mastery and Accolade of Outstanding Achievement from WPPI. Tibor was also recently presented with a Fujifilm New Approach Award for new and innovative solutions to tried-and-true photographic methods.

Kevin Jairaj—Kevin Jairaj is an award winning wedding and portrait photographer whose creative eye has earned him a stellar reputation in the Dallas/Fort Worth, TX, area. He is formerly a fashion photographer who uses skills learned in that discipline when shooting his weddings and portraits. His web site is www.kjimages.com.

Cal Landau—After spending thirty years trying to become a professional racing driver, Cal Landau got his start in wedding photography when someone who crewed for his racecar asked him to shoot his wedding. Cal turned him down a few times before he finally gave in. "Of course, everyone knows the rest of the story. I fell in love with this job so, at 54, I am a very late bloomer and I pinch myself every day for how good I have it."

Charles and Jennifer Maring—Charles and Jennifer own Maring Photography Inc. in Wallingford, CT. Charles is a second-generation photographer, his parents having operated a successful New-England studio for many years. His parents operate Rlab (www.resolution lab.com), a digital lab for discriminating photographers needing high-end digital work. Charles Maring is the winner of the 2001 WPPI Album of the Year Award.

Cliff Mautner—After fifteen years as a photojournalist with the *Philadelphia Inquirer,* Cliff Mautner has experienced just about every situation a photographer could possibly encounter—from shooting in Liberia, to covering spelunking in Central Pennsylvania. Yet, he never dreamed that he would be enjoying wedding photography as much as he does. His images have been featured in *Modern Bride, Elegant Wedding, The Knot,* and various other wedding publications.

Bruno Mayor—Bruno Mayor is third-generation French photographer living in Corsica. He is a member of the French trade union of photographers, the GNPP (Groupement National des Photographes Professionnels), and recently finished second overall in the French National portrait competition. You can see more of Bruno's images at his web site: www.espaceimage.com.

Mercury Megaloudis—Mercury Megaloudis is the owner of Megagraphics Photography in Strathmore, Victoria, Australia. The Australian Institute of Professional Photography awarded him the Master of Photography degree in 1999. He has won numerous awards in Australia and has recently begun winning competitions in the U.S. as well.

Tom Muñoz—Tom Muñoz is a fourth-generation photographer whose studio is located in Fort Lauderdale, FL. Tom upholds the classic family traditions of posing, lighting, and composition, yet is 100% digital in the studio operation. He believes that the traditional techniques blend perfectly with exceptional quality of digital imaging.

Melanie Nashan—Melanie Maganias Nashan, founder of Nashan Photographers, Inc. in Livingston, MT, specializes in weddings but also photographs portraits, commercial work, and architecture. Her striking images have been published in *Martha Stewart Weddings, The Knot, Bride's, Modern Bride,* and *Sunset Magazine.* In 2003, she was chosen as one of America's top fifteen wedding photographers by *Photo District News.*

Dennis Orchard—Dennis Orchard is an award-winning photographer from Great Britain. He has been a speaker and an award winner at WPPI conventions and print competitions. He is a member of the British Guild of portrait and wedding photographers. His unique lifestyle wedding photography has earned many awards, including UK Wedding Photographer of the Year, International Wedding Photojournalism Print of the Year, and WPPI's highest honor, the Accolade of Lifetime Photographic Excellence.

Parker Pfister—Parker Pfister, who shoots weddings locally in Hillsboro, OH, as well as in neighboring states, is quickly developing a national celebrity. He is passionate about what he does and can't imagine doing anything else (although he also has a beautiful portfolio of fine-art nature images). Visit him at www.pfisterphoto-art.com

Norman Phillips, AOPA—Norman Phillips has been awarded the WPPI Accolade of Outstanding Photographic Achievement (AOPA). He is a registered Master Photographer with Britain's Master Photographers Association, a Fellow of the Society of Wedding & Portrait Photographers, and a Technical Fellow of Chicagoland Professional Photographers Association. He is a frequent contributor to photographic publications and the author of numerous books including *Wedding and Portrait Photographers' Legal Handbook* (Amherst Media, 2005).

Joe Photo—Joe Photo is the rock star of the wedding photography world. His stunning wedding images have been featured in numerous books and magazines, as well as on NBC's *Life Moments,* the Lifetime channel's *Weddings of a Lifetime,* and Lifetime's reality show *My Best Friend's Wedding.*

John Poppleton—Utah photographer John Poppleton delights in urban decay—lathe and plaster, peeling paint, and weathered wood. However, he also loves to create people photography—especially uniquely feminine portraiture. When the architecture of urban decay combines with elegant brides, the startling result is Poppleton's unique style.

Ray Prevost—Ray Prevost worked for almost thirty years as a medical technologist in the Modesto, CA, area. He was always interested in photography, but it wasn't until his two daughters were in college that he decided to open up his studio full time. He received Certification from PPA in 1992, and his masters degree in 1996.

Fran Reisner—Fran Reisner is a Brooks Institute graduate and has twice been named Dallas Photographer of the Year. She is a past president of the Dallas Professional Photographers Association. She runs a successful portrait and wedding business from the studio she designed and built

on her residential property. She has won numerous state, regional, and national awards.

J.B. and DeEtte Sallee—J.B and DeEtte Sallee are a photographic team from Dallas, TX. Their studio, Sallee Photography, has only been in business since August 2003, but both photographers have already earned numerous awards including Dallas Photographer of The Year, Wedding Photographer of The Year, Best Album Designer of The Year, and Best Folio of The Year.

Martin Schembri, M.Photog. AIPP—Martin Schembri has been winning national awards in his native Australia for twenty years. He has achieved a Double Master of Photography with the Australian Institute of Professional Photography. He is an internationally recognized portrait, wedding, and commercial photographer and has conducted seminars worldwide on his unique style of photography.

Michael Schuhmann— Michael Schuhmann of Tampa Bay, FL, is a highly acclaimed wedding photojournalist who believes in creating weddings with the style and flair of the fashion and bridal magazines. He has been the subject of profiles in *Rangefinder* and *Studio Photography & Design.*

Ken Sklute—Beginning his wedding photography career at sixteen in Long Island, NY, Kenneth quickly advanced to shooting an average of 150 weddings a year. About ten years ago, he moved to Arizona, where he enjoys a thriving business. Kenneth is much decorated, having been named Long Island Wedding Photographer of the year fourteen times and PPA Photographer of the Year. In addition, he has earned numerous Fuji Masterpiece Awards and Kodak Gallery Awards.

Natasha Staszak—Natasha originates from Sydney, Australia, but now lives on Long Island, NY. Her background includes a BA in visual communication, for which she majored in photography. Her studies brought her to the Rochester Institute of Technology, and the home of Kodak soon became her home when she met and later married her husband. Over the years, Natasha has developed a popular wedding photography business through word of mouth.

Deanna Urs—Deanna Urs lives in Parker, CO, with her husband and children. She has turned her love and passion for the camera into a portrait business that has created a following of clientele nationally as well as internationally. She often works in her client's environment to add a personal touch to her portraits.

Marc Weisberg—A graduate of University of California–Irvine with a degree in fine art and photography, Marc also attended the School of Visual Arts in New York City before relocating to Southern California in 1991. His interest in the culinary arts has led Marc to create numerous images for marketing and public relations campaigns as well as images featured in *Wines and Spirits, Riviera, Orange Coast,* and *Where Los Angeles.*

David Anthony Williams (M.Photog. FRPS)—David Anthony Williams owns a wedding studio in Ashburton, Victoria, Australia. In 1992 he achieved the rare distinction of Associateship and Fellowship of the Royal Photographic Society of Great Britain on the same day. Through the annual Australian Professional Photography Awards system, Williams achieved the level of Master of Photography with Gold Bar—the equivalent of a double master. In 2000, he was awarded the Accolade of Outstanding Photographic Achievement from WPPI, and has been a Grand Award winner at their annual conventions in both 1997 and 2000.

David Worthington—In a recent book celebrating the best professional photography the last fifty years, David was honored to have one of his images chosen—only fifty photographs were chosen from entries sent from around the world. Two of David's most recent awards include the 2003 Classical Wedding Photographer of the Year (UK, Northwest Region) and the 2003 Licentiate Wedding Photographer of the Year (UK, Northwest Region).

Yervant Zanazanian, M. Photog. AIPP, F.AIPP—Yervant was born in Ethiopia, then lived and studied in Venice, Italy prior to settling in Australia. His passion for photography began at a very young age, when he worked after school and during school holidays at the photography business owned by his father, photographer to the Emperor Hailé Silassé of Ethiopia. Yervant owns a prestigious photography studio and services clients nationally and internationally. He has been named Australia's Wedding Photographer of the Year three of the past four years.

Monte Zucker—Monte Zucker has been bestowed every major honor the profession can offer, including WPPI's Lifetime Achievement Award. In 2002, Monte received the International Portrait Photographer of the Year Award from the International Photography Council, a nonprofit organization of the United Nations. In his endeavor to educate photographers at the highest level, Monte, along with partner Gary Bernstein, has created an information-based web site for photographers, www.Zuga.net.

INDEX

LIGHTING TECHNIQUES FOR
HIGH KEY PORTRAIT PHOTOGRAPHY

Norman Phillips

Learn to meet the challenges of high key portrait photography and produce images your clients will adore. $29.95 list, 8½x11, 128p, 100 color photos, order no. 1736.

THE ART OF BLACK & WHITE PORTRAIT PHOTOGRAPHY

Oscar Lozoya

Learn how master photographer Oscar Lozoya uses unique sets and engaging poses to create black & white portraits that are infused with drama. Includes lighting strategies, special shooting techniques, and more. $29.95 list, 8½x11, 128p, 100 duotone photos, order no. 1746.

PROFESSIONAL DIGITAL PORTRAIT PHOTOGRAPHY

Jeff Smith

Because the learning curve is so steep, making the transition to digital can be frustrating. Author Jeff Smith shows readers how to shoot, edit, and retouch their images—while avoiding common pitfalls. $29.95 list, 8½x11, 128p, 100 color photos, order no. 1750.

WEDDING PHOTOGRAPHY WITH ADOBE® PHOTOSHOP®

Rick Ferro and Deborah Lynn Ferro

Get the skills you need to make your images look their best, add artistic effects, and boost your wedding photography sales with savvy marketing ideas. $29.95 list, 8½x11, 128p, 100 color images, index, order no. 1753.

THE ART OF BRIDAL PORTRAIT PHOTOGRAPHY

Marty Seefer

Learn to give every client your best and create timeless images that are sure to become family heirlooms. Seefer takes readers through every step of the bridal shoot, ensuring flawless results. $29.95 list, 8½x11, 128p, 70 color photos, order no. 1730.

DIGITAL PHOTOGRAPHY FOR CHILDREN'S AND FAMILY PORTRAITURE

Kathleen Hawkins

Discover how digital photography can boost your sales, enhance your creativity, and improve your studio's workflow. $29.95 list, 8½x11, 128p, 130 color images, index, order no. 1770.

PROFESSIONAL STRATEGIES AND TECHNIQUES FOR DIGITAL PHOTOGRAPHERS

Bob Coates

Learn how professionals—from portrait artists to commercial specialists—enhance their images with digital techniques. $29.95 list, 8½x11, 128p, 130 color photos, index, order no. 1772.

LIGHTING TECHNIQUES FOR
LOW KEY PORTRAIT PHOTOGRAPHY

Norman Phillips

Learn to create the dark tones and dramatic lighting that typify this classic portrait style. $29.95 list, 8½x11, 128p, 100 color photos, index, order no. 1773.

PORTRAIT PHOTOGRAPHY

THE ART OF SEEING LIGHT

Don Blair with Peter Skinner

Learn to harness the best light both in studio and on location, and get the secrets behind the magical portraiture captured by this legendary photographer. $29.95 list, 8½x11, 128p, 100 color photos, index, order no. 1783.

PLUG-INS FOR ADOBE® PHOTOSHOP®

A GUIDE FOR PHOTOGRAPHERS

Jack and Sue Drafahl

Supercharge your creativity and mastery over your photography with Photoshop and the tools outlined in this book. $29.95 list, 8½x11, 128p, 175 color photos, index, order no. 1781.

POWER MARKETING FOR WEDDING AND PORTRAIT PHOTOGRAPHERS

Mitche Graf

Set your business apart and create clients for life with this comprehensive guide to achieving your professional goals. $29.95 list, 8½x11, 128p, 100 color images, index, order no. 1788.

DIGITAL INFRARED PHOTOGRAPHY

Patrick Rice

The dramatic look of infrared photography has long made it popular—but with digital it's actually *easy* too! Add digital IR to your repertoire with this comprehensive book. $29.95 list, 8½x11, 128p, 100 b&w and color photos, index, order no. 1792.

WEDDING AND PORTRAIT PHOTOGRAPHERS' LEGAL HANDBOOK

N. Phillips and C. Nudo, Esq.

Don't leave yourself exposed! Sample forms and practical discussions help you protect yourself and your business. $29.95 list, 8½x11, 128p, 25 sample forms, index, order no. 1796.

DIGITAL PHOTOGRAPHY BOOT CAMP

Kevin Kubota

Kevin Kubota's popular workshop is now a book! A down-and-dirty, step-by-step course in building a professional photography workflow and creating digital images that sell! $34.95 list, 8½x11, 128p, 250 color images, index, order no. 1809.

BLACK & WHITE PHOTOGRAPHY

TECHNIQUES WITH ADOBE® PHOTOSHOP®

Maurice Hamilton

Become a master of the black & white digital darkroom! Covers all the skills required to perfect your black & white images and produce dazzling fine-art prints. $34.95 list, 8½x11, 128p, 150 color/b&w images, index, order no. 1813.

PROFESSIONAL MARKETING & SELLING TECHNIQUES

FOR DIGITAL WEDDING PHOTOGRAPHERS, SECOND EDITION

Jeff Hawkins and Kathleen Hawkins

Taking great photos isn't enough to ensure success! Become a master marketer and salesperson with these easy techniques. $34.95 list, 8½x11, 128p, 150 color photos, index, order no. 1815.

MARKETING & SELLING TECHNIQUES

FOR DIGITAL PORTRAIT PHOTOGRAPHY

Kathleen Hawkins

Great portraits aren't enough to ensure the success of your business! Learn how to attract clients and boost your sales. $34.95 list, 8½x11, 128p, 150 color photos, index, order no. 1804.

HOW TO CREATE A **HIGH PROFIT** PHOTOGRAPHY BUSINESS

IN ANY MARKET

James Williams

Whether your studio is located in a rural or urban area, you'll learn to identify your ideal client type, create the images they want, and watch your financial and artistic dreams spring to life! $34.95 list, 8½x11, 128p, 200 color photos, index, order no. 1819.

PROFESSIONAL PORTRAIT LIGHTING

TECHNIQUES AND IMAGES FROM MASTER PHOTOGRAPHERS

Michelle Perkins

Get a behind-the-scenes look at the lighting techniques employed by the world's top portrait photographers. $34.95 list, 8½x11, 128p, 200 color photos, index, order no. 2000.

BEGINNER'S GUIDE TO ADOBE® PHOTOSHOP®, 3rd Ed.

Michelle Perkins

Enhance your photos, create original artwork, or add unique effects to any image. Topics are presented in short, easy-to-digest sections that will boost confidence and ensure outstanding images. $34.95 list, 8½x11, 128p, 80 color images, 120 screen shots, order no. 1823.

MASTER'S GUIDE TO WEDDING PHOTOGRAPHY

CAPTURING UNFORGETTABLE MOMENTS AND LASTING IMPRESSIONS

Marcus Bell

Learn to capture the unique energy and mood of each wedding and build a lifelong client relationship. $34.95 list, 8½x11, 128p, 200 color photos, index, order no. 1832.